UNHOLY
BUSINESS

⊙ Smithsonian Books

COLLINS
An Imprint of HarperCollinsPublishers

UNHOLY BUSINESS

[A True Tale of
Faith, Greed, and Forgery
in the Holy Land]

NINA BURLEIGH

HarperCollins books may be purchased for educational, business, or sales promotional use. For information, please write: Special Markets Department, HarperCollins Publishers, 10 East 53rd Street, New York, NY 10022.

FIRST EDITION

Designed by Kate Nichols

Library of Congress Cataloging-in-Publication Data

Burleigh, Nina
 Unholy business: a true tale of faith, greed, and forgery in the holy land/Nina Burleigh,
—1st ed.
 p.cm.
 ISBN 978-0-06-145845-3
 1. Forgery of antiquities—Israel. 2. Israel—Antiquities. 3. Archaeology—Israel.
4. Moussaieff, Shlomo 5. Golan, Oded. 6. Ganor, Amir. I. Title.
 CC140.B87 2008
 933—dc22

2008023425

08 09 10 11 12 OV/RRD 10 9 8 7 6 5 4 3 2 1

For Erik

Acknowledgments

SINCERE THANKS to my agent Deborah Clarke Grosvenor, for support in the early stages, and to my editor Elisabeth Dyssegaard, who enthusiastically saw the project to fruition. Journalist Matthew Kalman in Israel contributed much in the way of translation and explication. My assistant Laura Neilson in New York was, I must admit, worth more than she was paid. David Smith at the New York Public Library was, as always, the indispensable man.

I am especially grateful to Ed Silver for his advice on the history of religion, the Bible, and Israel. Jonathan Reed (who we hope will someday produce an opus called Swimming Holes of the Holy Land), introduced me to biblical archaeology on the ground and probably kept me from unwittingly driving into war zones. I am grateful to all the people I interviewed in Israel, who so generously shared their time and knowledge. Many of them are quoted in the book. I am

indebted to Kathryn Antony, Nadia Bandak, David Corn, Israel Finkelstein, Patti Gerstenblith, Sy Gitin, Betsy Gleick, Oded Golan, Marcia Isaacson, Oscar White Muscarella, Aran Patinkin, Christopher A. Rollston, Alon Tuval, Lenny Wolfe, Joe Zias, and, of course, Amir Ganor and Jonathan Pagis, who didn't have to talk to me, but did.

Erik, Felix, and Lulu were champs, as usual.

We are a civilized people, and of what use is
civilization if it doesn't help us to deceive and
to be deceived in order to make life
more worth the living?

—EMILE ZOLA

✦

There are two different types of people
in the world, those who want to know, and
those who want to believe.

—FRIEDRICH NIETZSCHE VIA JOE ZIAS

Contents

UNHOLY BUSINESS

A Woman with Many Cats

October 2001

> *Do not consider it proof just because it is written*
> *in books, for a liar who will deceive with his tongue*
> *will not hesitate to do the same with his pen.*
>
> —Maimonides

ATS OF MANY COLORS prowl the sunken courtyard at the epigrapher's door on the edge of Jerusalem. At least a dozen of them—tabbies, orange and gray tigers, green-eyed blacks, and piebald whites—slither up and over the garbage bins, sprawl on garden furniture, and purr against my ankles as I press the rusty buzzer and wait. The occupant takes a very long while to answer, as if perhaps the doorbell isn't working properly. I press it again, and hold it down. Finally a woman pulls the door open, chiding me for being ten minutes late. She has striking pale blue eyes, red lipstick, and dyed black hair pulled back into a 1950s sock-hop-style ponytail. Her gap-toothed smile and sleepy eyes suggest the sultry actress Ellen Barkin, but this woman is in her seventies and no entertainer. She is expert in one of the most arcane fields of scholarship in the world—an epigrapher—analyst of ancient Hebrew, Aramaic, and Phoenician writing from the time of Jesus

Christ and before, from the Old Testament era. Museums and collectors worldwide have asked her to compare and decipher inscribed lamps, seals, and pottery for three decades. She is considered one of Israel's leading authorities on Semitic scripts.

Ancient Semitic epigraphy is a rare—but not a lucrative—pursuit, and Ada Yardeni lives modestly in a two-room garden apartment crammed with books, papers, and the collected mementos of a long life. She lives alone; her children are grown and her beloved mother recently died. Right away she apologizes for the condition of her cramped dwelling. "This is my office, and it's my house. You think it's nice, but I used to live in Rehavia. But things happen in life." An air mattress is nestled on the floor behind the dining room table, at the foot of a wall-size bookcase and a small desk. Candles, papers, and yellow plastic flowers in a vase crowd the kitchen table. Walls and surfaces are decorated in a motley style—kitten pictures, posters of Errol Flynn, snapshots of children and grandchildren, and two large, dramatic canvases of a younger Ada in a summer hat, with the desert in the background. Ada's daughter painted them in a modern style that seems lifted straight from David Hockney's bright realism. Bookshelves bend under fat tomes in Hebrew and English such as *Textbook of Aramaic Hebrew and Nabatean* and *Documentary Texts from the Judaean Desert.* The books she herself has written are never less than three inches thick, and include *Book of Hebrew Script* and *Textbook of Aramaic and Hebrew Documentary Texts from the Judaean Desert.*

Ancient language and literature was the family vocation. Ada's father, Menachem Zulei, born in Galicia (now Poland) emigrated to Israel and spent his entire life bushwhacking through a massive trove of Hebrew liturgical writing, called a *geniza,* found in a Cairo synagogue—two hundred thousand books and manuscripts in all, dating from 1000 CE to the nineteenth century. Ada was born in Jerusalem and married young, but she was widowed at age twenty-eight.

A young mother with two small daughters, she had to move away from the leafy, posh neighborhood called Rehavia—the most charming part of Jerusalem, home to Israeli dignitaries like Bibi Netanyahu and moneyed Europeans and Americans—and set up house in this dustier, Spartan neighborhood, across the street from a car repair shop. But her whole life still lay ahead. She returned to university and studied under a great Israeli epigrapher named Joseph Naveh. She fell in love with him and with the work. They never married, or lived together, but he has been her mentor for nearly forty years.

Ada is both a calligrapher—who can write the ancient languages—and a decipherer of ancient scripts. She has filled hundreds of book pages with carefully copied individual ancient letters, arranged so that students may compare tiny differences in handwriting between sects, kingdoms, eras, regions. Her expertise extends to knowing how writing differed from hand to hand, as scribes scratched words into limestone tablets and ossuaries, clay and bronze seals, and mostly on ostraca (shards of pottery used by the ancients as notebook or scratch paper of sorts). She is a meticulous worker, as one would expect. When someone brings her an object or a photograph of an inscribed object, she pulls out a magnifying glass and carefully traces the inscription onto plastic tracing paper, then draws it elsewhere, larger, in thick black ink, the better to see every divot, curl, and anomaly. "I have to be very precise with the letters, in order to confirm my readings," she says. Her work depends on her access to actual ancient objects and that is why she is always happy to look at pieces from collectors—who also pay her a small fee to decipher their finds. She reckons she has examined thousands of ostraca. "You see, I have copied all these documents from the original," she says, pulling out a manila folder of her current work. She riffles through pages covered with large Hebrew letters. "I have seen a lot of material. Joseph Naveh gave a nice example that I love to repeat. If you come to an ear doctor, and he has seen fifty

ears, that's not the same as when you go to a doctor who has seen five thousand ears, correct? So I have seen five thousand!"

When I arrived to talk about how she became a witness in an archaeological forgery trial Israeli cops had called "the fraud of the century," she was well prepared. Ada is the sort of woman who keeps detailed records of her days in small annual diaries. At the end of each year, she tucks them—filled with her tiny Hebrew script, tied with a white ribbon—into a cardboard box, and these boxes are now the piled-up story of her years. Opening a box, she easily found the diaries she needed, because they bristled with yellow Post-it notes, marking the pages she had referred to during interviews with the police and then at the court. She proceeded to leaf through each page, reading from right to left, entries highlighted with pink highlighter.

Her annual diaries always start in October, the beginning of the Jewish year. The series of events she needed to remember began in October 2001. That's when she got the first call from a Tel Aviv collector named Oded Golan, a wealthy aficionado of Bible-era archaeology whom she'd heard of but never met. Because of her reputation and experience, it was not unusual for Ada to receive calls from people she didn't know, offering to pay for her opinion, and she was always meticulous about recording her business affairs. Thumbing through her book, she turned to the first Post-it note.

"Exactly the twenty-fourth of October, 2001. You see? I wrote it down. Afterwards I made it red because they asked me about it all the time, so I marked it. He phoned me and asked me to decipher some ostraca. On the first of November, he came here and brought pictures of twelve Idomean ostraca. One with a strange Jewish script. And an inscription on an ossuary [depository for the bones of the dead] in a cursive Jewish script, difficult to read. And he showed me a bowl and I couldn't identify the script. Perhaps Arabic or Idomean. I didn't know. He promised to let me draw the ostraca from the original."

Just two weeks after his first phone call, Ada received a call from a second stranger, a deliberately mysterious man who identified himself as a member of the Israeli Secret Service, the Shin Bet. It was early November 2001, and the man told her he had a very important object in his possession—very old, inscribed in ancient Hebrew—and would she be willing to have a look at it?

"He wanted me to write an official opinion," she recalled. "And he had already been to Naveh." In her diary, she wrote, "Maybe it is a forgery." She hadn't seen it yet, but the fact that the man was seeking an official opinion from her after having shown it to Naveh, the master, made her suspicious. Still, she agreed to have a look. "The situation was suspicious to me," she recalled. "I don't know why . . . a Shin Bet will show *me* an inscription? That was somehow suspicious."

Like any Bible-era epigrapher, Ada was no stranger to fakes. Inscribed objects from the ancient Hebrew and Phoenician people are much less common than the prolific hieroglyphs left by the Egyptians or the cuneiform (writing composed of wedge-shaped characters) of the Babylonians. Whenever an inscription appears in biblical—or as the academics call it, Syro-Palestinian—archaeology, it is by definition an important piece, not least because of its scarcity. Experts—from archaeologists to epigraphers—know to be on their guard for forgeries, especially when the object is not from an official excavation. Ada's mentor, Naveh, had published warnings about forged inscriptions.

A week later, according to her diary, she spoke with Naveh, and her suspicion was confirmed. The old professor told her that the same Shin Bet agent had shown him the tablet inscription and that he thought it was fake. And the circumstances had been equally mysterious. Naveh had been summoned to a Jerusalem hotel room to see the tablet. There he met two people, a man who introduced himself as Tzur and "an Arab youth who never opened his mouth

the entire time, so I don't know his name," Naveh later recalled. Tzur told him the tablet was found in a Muslim cemetery outside the Old City in Jerusalem, and speculated that it had actually come from the inner sections of the Temple Mount, a politically charged and religiously important location for Israelis and Palestinians. Tzur, Naveh said, "made me promise not to mention [the tablet] or talk about it with anyone, because the life of the Palestinian who found and sold it would be endangered." According to Ada's diary, on the same day Naveh told her the tablet was forged, the mysterious man phoned her again, and offered to send her photographs. She told him she wanted to see the original object, not a picture.

As she related this, she squinted at her diary. "And I called Oded Golan that same day. For what, why did I call him? For the pictures he had promised to let me make, of the ostraca." Eventually he did bring them to her house. He was in a terrible hurry. She promised to finish copying them quickly.

On the twentieth of November 2001, the mysterious agent finally came to her door with photos of the inscribed tablet. He introduced himself as Tzuriel, an ancient Hebrew name that means rock of God. Ada remembered the inscription, but the man's face left almost no impression. "That was very strange, because they asked me later, 'What does he look like?' I remember he had a long face. I couldn't say more than that. Usually I have a good eye for faces. But I can't remember his face! And later they showed me a picture, and asked, 'Is this the man you saw?' I didn't know. It's interesting that there are faces that you can't remember. They are very . . . regular."

The mystery man with the forgettable face gave her the photograph of the inscribed stone, asked her to analyze the writing, and went away. The photograph showed a rectangular black stone tablet, with sixteen lines of perfectly legible ancient Hebrew. The inscription she does recall. "I thought that the letters were a little similar to the Tel Dan

inscription." The Tel Dan inscription is a basalt rock "stele" discovered in 1993 in northern Israel, in the region known as the Upper Galilee. It is theologically and historically significant as the first archaeological object ever found—dated before 500 BCE—confirming the existence of a monarchy claiming David as an ancestor. Ada thought the writing on the tablet looked like ancient Hebrew, but her gut told her something was not right. She could read the inscription, which seemed to refer to repairs to a building, but something about the style of the language itself struck her as wrong, and some individual letters seemed anachronistic. Still, she couldn't say for sure.

"Here," Ada pointed at her handwritten notes from that day's meeting, "here, I wrote that 'I feel that this is a forgery, but I can't prove it.'"

The very next day, Ada received a phone call from yet another man she didn't know, Shimon Ilani from a government agency called the Geological Survey of Israel. A geologist, Ilani too had been visited by the mysterious Tzuriel. "And he said he got my phone numbers from Oded Golan. He wanted to know what I thought. And I told him I had a feeling, but I didn't know, because the circumstances were very suspicious. The script was not bad. I could somehow put it between Phoenician and Hebrew and very early times."

Ada's date book indicates that from the twenty-sixth to the twenty-ninth of November, the mystery man phoned her three more times. He seemed to be in a great hurry, and yet was unwilling to cooperate with her request to see the actual tablet. Finally he relented. He carried into her kitchen a package containing a black stone tablet that looked old but was surprisingly clean and shiny. It was, in fact, a lovely piece. The man let her look at the tablet, but he refused to leave it with her. Ada took more notes and pointed out some suspicious letters she had already noticed in a photograph, in particular a Hebrew letter "hay" that looked suspiciously modern in style.

The next day Shimon Ilani from the Geological Survey of Israel called Ada again. "He was very concerned because I had told the man about the problems with the letter hay. Shimon Ilani tried to convince me that it was ancient. He said that he would come talk to me, but he didn't." Ada felt that the government geologist was trying to convince her, and she didn't like the pressure. "The mystery I didn't like! The whole circumstances were suspicious somehow. The phone calls, the: 'I bring you. I won't bring you.' 'I come to you. I show you.' . . . 'I take it with me. I can't leave it.' I didn't like the mystery." But she needed the money so she set to writing a report.

After conferring with Naveh, she decided she couldn't verify the inscription as genuine. But she made a comparative chart of the individual letters, and in her report Ada stated that she simply wasn't sure what to make of it. The man paid her 1,400 shekels (about $500) for her report. She never saw him again. She took the fee, and went on about her life, which at the time was heavy with imminent loss. Her beloved ninety-year-old mother was fast deteriorating, and while new grandchildren were being born, they were far away in Australia and she could not afford to visit them. Naveh, her emotional pillar and mentor, was also getting old and sick. For diversion, she had piles of ancient letters to trace and more and more strays on the doorstep to care for.

Ada would see Oded Golan again. (He brought her some inscribed seal impressions to trace in spring 2002, and he was again in a great hurry.) But she didn't connect the impatient Tel Aviv collector and his artifacts and the Shin Bet man with the forgettable face and his inscribed tablet, not at all, until three years later, when a policeman arrived among the myriad cats at her doormat. He carried photographs of men, not ancient letters, for her to compare and identify, and he leaned hard on her rusty, recalcitrant doorbell.

The Billionaire's Table

Spring 2002

That's the stuff that dreams are made of.

—HUMPHREY BOGART AS SAM SPADE
IN *THE MALTESE FALCON*

T SUNSET, the collector and his lucky guests can't help but notice the primal kaleidoscope in the heavens above the Mediterranean Sea. Three walls of floor-to-ceiling penthouse glass front the westward horizon, and every afternoon shades of vermilion and violet, pink and indigo streak the sky and sea. Anyone witnessing the celestial display from this vantage point feels enriched, but the old man who owns the view, Shlomo Moussaieff, is in fact one of the world's richest men.

People tell two versions of how Moussaieff made his billions, with a twist depending on whether the teller likes or dislikes the old man. The nice version is that for four decades he sold pricey jewelry to oil sheiks from a tiny shop on the ground floor of London's glittery Hilton Hotel, and also knew the prostitutes they employed. The sheiks paid the girls in jewelry because they deemed it more honorable to give their "girlfriends" presents than to pay them hard

cash. After these transactions, the unsentimental ladies rode the mirrored and gilt elevators downstairs and sold the jewelry back to Moussaieff, at prices far lower than what the sheiks had paid. Then Moussaieff sold the pieces again at full value. The nastier version of the story, told by men who think the old man has crossed them, is that the jeweler sold the sheiks precious jewelry and then the escorts stole the baubles and brought them back to the shop.

At eighty-five, Moussaieff's labyrinthine life story is made up of a thousand and one equally fantastic and unverifiable tales. As he tells it, an abusive rabbi father kicked him onto the streets of 1920s Jerusalem when he was a boy of twelve, so he slept in dank, ancient tombs on the Old City's edge with homeless Arab urchins, plucking his first Roman-era coins out of that hallowed dirt. He passed his teenage years lice ridden and deprived, sometimes sleeping rough in a synagogue where he overheard and memorized the Talmud, sometimes in an Arabic reform school memorizing the Koran, and sometimes in a Christian hospital. After fighting in Europe in World War II, he was briefly jailed by the Allies for attempting to smuggle valuable Judaica from synagogues the Nazis somehow hadn't plundered. He fought in the streets of Jerusalem's Old City during Israel's War of Independence, becoming friendly with general Moshe Dayan, another lover of antiquities. Together the men made forays into Gaza to acquire archaeological treasures. In London a few years later, he began amassing enormous wealth through intimacy with the world's richest Arab potentates. A stint in the Israeli Secret Service fits in somewhere. What is certain is that by the 1980s, he had created a colossal fortune from a jewelry business that landed him in the cosmopolitan upper echelon. One of his daughters is married to the president of Iceland.

These days, the old man spends less time making money and more time disbursing it to enlarge his vast collection of biblical antiquities.

He doesn't care what people say about him, either. His only interest in life now, besides smoking and flirting, he says, is "proving the Bible true"—an odd pursuit for an avowedly unreligious man, but an offshoot of an early obsession with finding God. He believes completely in the historical reality of biblical characters, but Yahweh remains beyond his reach. The antiquities inside his Tel Aviv apartment would keep a team of museum curators busy for decades. Among them are a pair of three-foot-high iron lions from what was supposedly the Queen of Sheba's palace in Yemen, chunks of long-demolished Syrian Jewish temples on the walls, whole slabs of Assyrian cuneiform from Iraq, vitrines packed with pre-Canaanite pagan cult figurines, intact tile friezes taken from Roman baths in Israel. But these artifacts are only a small sampling of the six hundred thousand Bible-era relics he has collected over the years and that he stores in warehouses in Geneva and his London townhouse. Almost all of them, he readily admits, were removed illegally from their countries of origin.

Moussaieff's collection, quirks, and financial might are well understood among the antiquities traders in Israel. On most nights when Moussaieff is in Tel Aviv, a revolving cast of dealers and collectors drop in to sell, buy, or simply sip Diet Coke, enjoy the sunset over the sea, and watch the old man in action. His guests may also include socialites, politicians, and scholars who are attracted by the money, collection, and mystique of one of Israel's most intriguing characters. A dyslexic who can barely read, he is by turns profane and refined. He tells filthy jokes, veers between Hebrew and Arabic as the mood suits him, slyly calls men and women *habibi*—the Arabic word for sweetie—and will recite, eyes half-closed, bits of Holy Land arcana he has photographically memorized from the Bible and Koran. He can wax at length on the characters whose heads are commemorated on tarnished bits of Roman coins or the significance of clay figurines representing pre-Canaanite gods and goddesses.

On a balmy spring evening in 2002, an elfin fellow named Oded Golan joined a half-dozen other men at the billionaire's long rectangular table, inhaling the fumes of the great collector's chain-lit Marlboro Lights. Golan, fifty-something, short, with oddly shaped, fleshy ear tips, and a shiny brown mop of hair over an impish face reminiscent of Joel Grey in the movie *Cabaret*, was and still is one of Israel's biggest collectors of Bible-era relics. But his collection is tiny by comparison with Moussaieff's. Besides collecting Israeli artifacts, Golan—who came from a wealthy and accomplished Tel Aviv family and studied industrial design in college—ran an architectural tour business, speculated in real estate, and was an amateur classical pianist. His calloused, short fingers attested to the fact that he also used his hands and his design training to lovingly restore the ancient items he collected.

Also at the table was the French scholar André Lemaire, an expert in ancient epigraphy at the Sorbonne. A tall, sallow, almost spectral presence, in his native French he might be described as *sec*—utterly dry and deeply restrained. One of eight sons of a provincial French Catholic farmer, born during World War II, he originally studied for the priesthood, and succumbed to the lure of Jerusalem and its antiquities after a youthful summer drive from France to Israel with a pair of seminarians. It was the late 1960s and he decided to stay in Jerusalem for a while, signing on to do research at the Ecole Biblique—an elegant, meditative, walled French Dominican monastery compound with a great library, Hellenistic columned courtyard, and towering cedars by the Old City. The scholars within were hard at work deciphering the Dead Sea Scrolls and related ancient documents. After a year there, Lemaire returned to France, dropped out of the seminary to get married, and entered the Sorbonne to study and eventually teach ancient Semitic epigraphy. In thirty years at that post, he has published hundreds of papers and dozens of books on obscure, rare

inscriptions in ancient Hebrew and Aramaic. (During Christ's life-time, Aramaic was the common language of the Jews.) Lemaire lives modestly in suburban Paris, but since the late 1970s, he has been a familiar figure among the antiquarians of Jerusalem and Old Jaffa.

Lemaire is personally inclined to believe in the possibility of unexpectedly finding something of great significance because of an incident in his own life. "We are completely sure that they [ancient Hebrews] kept precious or semiprecious objects in temple treasur-ies for centuries, for centuries," he told me during an interview at his Paris home. "And myself, I am perhaps more inclined to accept that, because I had an experience when I was young. I was maybe, I don't remember, sixteen or seventeen, and I visited the granary of my grandmother, near the farm where I lived with my parents. And in my grandmother's granary, I found among debris and so on, big sheets of paper. I took them outside, and finally, reading them a little bit, I realized that it was a French Bible from the end of the sixteenth century." The antique Bible contained a list of names of people from the nearby town who had owned it over the centuries. Lemaire never learned how or why the artifact found its way into the family silo, but he never forgot the fortuitous accident that recovered a piece of history.

In Jerusalem over the years, he combed the shops, hoping to dis-cover rare pieces and occasionally authenticating inscribed objects for owners and interested buyers. Lemaire's willingness to examine and write about objects in private collections had not endeared him to the archaeological academy, however. Professional archaeologists and inscription scholars view private collectors differently. Archaeol-ogists see collectors as encouraging the looting of archaeological sites because they pay for "unprovenanced" artifacts (archaeologyspeak for any object not found in situ). Scholars who study inscriptions are relatively more willing to look at unprovenanced material. Lemaire

was one scholar who wasn't above "publishing"—in academic parlance, writing about—objects whose origins were unknown.

In spring 2002, Lemaire was in Israel on one of his regular forays to the Holy Land to seek out newly discovered objects and strengthen his ties with local collectors, scholars, and antiquities dealers. Although Lemaire knew of Oded Golan and his large collection by name, and Golan knew Lemaire's scholarly reputation, the two men had never met, they claim, until that spring evening at Moussaieff's house.

As Moussaieff bargained with individual visitors, Lemaire and Golan talked. Golan told the French professor that he possessed an ossuary—a small limestone box in which Christ-era Jews stored the bones of their dead—with an ancient Hebrew inscription in cursive that he couldn't read. Ossuaries are quite common in Jerusalem. For about ninety years, Jews practiced ossilegium. This method of disposing of the dead involved first closing up the body in a cave for a year. After the flesh had fallen away, the bones were removed from the cave and closed up in a small box—an ossuary—which was sometimes inscribed with a design or a name. Scholars believe the practice was most common among the wealthy, as the peasants couldn't afford the boxes. Today, the ossuaries are so common that unadorned ones serve as planters in Jerusalem gardens, but those with inscriptions can be more valuable.

Golan, like any collector in Jerusalem interested in Bible-era objects, had collected a sizable number of inscribed ossuaries over the years. He asked if Lemaire would like to have a look at one with an inscription he couldn't read. The Frenchman said he would be happy to see it. Lemaire was, he now admits, a bit flattered by the man. "Oded more or less, maybe not using the words, but the meaning was clear, told me he knew my name," Lemaire recalled in an interview in Paris in 2007. "I didn't know him, but he told me he had

a collection and he had some inscription he should like to show me. And I told him, I am always interested to see new inscriptions. That's my job, my professional job!"

Two weeks later, Lemaire had the opportunity to follow up with Golan. He had made an appointment to visit Moussaieff, but Moussaieff was in the hospital, recovering from a minor heart attack. So the scholar called Golan, and the collector came in his car and fetched Lemaire, bringing him back into Tel Aviv and to his small, vitrine-filled apartment. "The vitrines, oh, he showed me very quickly the vitrines," Lemaire recalled. "I looked at a few things. And then he showed me pictures, mainly of his collection of ossuaries. He wanted to show me an inscription. It was in cursive and very difficult for him to read."

Golan laid out a series of photographs of ossuary inscriptions and pointed out the one in cursive ancient Hebrew that he couldn't decipher. While looking at that inscription, Lemaire spied another picture laid out on the table next to it. It was of another inscribed ossuary, and this particular inscription, Lemaire says, caught his eye instantly. In sloppily scrawled but easily decipherable Aramaic, it read, "Ya'akov bar Yosef achui Yeshua," translated as "James, son of Joseph, brother of Jesus." When Lemaire asked Golan about the inscription, the collector casually replied that he had never thought much of it—although he could read it. Lemaire was immediately intrigued because he was something of an expert in the biblical James, having written a book about the early Christian figure described in the Bible as Christ's brother. Golan maintained that he wasn't all that interested in it. For Lemaire, though, this other ossuary, the one that Golan had accidentally shown him, seemed by far the most interesting thing he'd seen in a long time. "Now it is considered the main point, but at this time for Oded, it was not the main point," Lemaire recalled. "That wasn't the ossuary he wanted to show me. That is very key. That is very key."

Lemaire had already made one historic discovery in the Jerusalem antiquities market some two decades before, one that had had profound significance for biblical archaeology, while also making a great deal of money for an anonymous owner. The discovery was so important that his name would have been well known to Oded Golan for that reason alone. In 1981, Lemaire noticed a tiny inscribed ivory pomegranate in a dealer's shop in Jerusalem. It read, "Holy to the priests, belonging to the "T' [illegible] h." Lemaire decided that the scratched away words between the Hebrew *T* and *h* were, translated, "Temple of Yahweh," and that the tiny hole through its base meant that the pomegranate was likely once an ornament for a small priest's scepter, used in Solomon's Temple.

According to the Bible, King Solomon built a fantastic temple in Jerusalem around 1000 BCE. Lined with gold, it housed the Ark of the Covenant, the container for God's written word to mankind. The Babylonians sacked the Temple in 800 BCE and burned it to the ground. No archaeological evidence of the Temple has ever been found. Also referred to as the "First Temple," Solomon's Temple was later replaced with what is known as the "Second Temple"—the remains of the platform that once supported this temple are known as the Wailing Wall or the Western Wall—Judaism's holiest place. Built by Herod, the Second Temple was destroyed by the Romans in 70 CE and never rebuilt. Muslims built a mosque there in the early days of Islam, the Al Aqsa Mosque, Islam's second-holiest place. The site is now one of the most hotly contested bits of turf in the Israeli-Palestinian conflict.

Any discoveries relating to the First Temple are enormously important not only for historians but also for religious Christians and Jews who seek verification of biblical history. They are also significant to Israeli nationalists, who are eager to lay permanent claim to all of Jerusalem, and especially what they call the Temple Mount.

Lemaire's pomegranate interpretation was thus both politically and archaeologically groundbreaking. No one had ever found an archaeological object linked to the First Temple. Lemaire's new interpretation instantly increased the value of the pomegranate, which was initially offered for sale for $3,000. An anonymous donor for the Israel Museum ultimately paid $550,000 to acquire the piece. By 2002, it had been on display at the museum for nearly twenty years, with a placard in both English and Hebrew explaining its significance.

After finding the pomegranate, Lemaire continued prowling the antiquities shops and collections of Israel, hoping against hope to stumble upon another rare piece. A man of science, he knew that the likelihood of finding another object of such great importance was slim. Most biblical scholars work all their lives and never unearth a single sherd (the archaeological term for a bit of broken pottery) or decipher a single phrase that interests the world beyond the academy. But Lemaire was deeply ambitious. Having tasted the fruits of spectacular discovery once, he longed to experience it again. When he spotted the picture of Golan's "James" ossuary, it is unlikely that his heart actually skipped a beat because Lemaire is a rather cool man, but he certainly felt an unusual amount of excitement. To find an ossuary with the names Jesus, Joseph, and James on it was almost too good to be true. Almost. But quite possibly it was both good and true.

Lemaire asked to see the ossuary itself, and Golan took him to another location in Tel Aviv, a warehouse where he stored antiquities that he didn't display in his Tel Aviv apartment. There, Lemaire examined the small, simple limestone box—twenty inches long, twelve inches high, and ten inches wide, decorated on one side with a small rosette and on the other with a scratched inscription—and found it much like the thousands of other such boxes around Jerusalem dating from the first century CE.

Back in France, armed with pictures of the box, the French scholar set to work researching the probability that the James on the box could be the New Testament James who was the leader of the Jerusalem branch of the early Christian Church, a martyr who died for his beliefs, and in certain interpretations of the Bible (mainly Protestant, which do not accept the Catholic dogma of the perpetual virginity of Mary) was the blood brother of Jesus Christ. He based his interpretation that it was the James on statistical calculations, which were in turn based on assumptions about the number of adult males living in Jerusalem during the ninety years when *ossilegium* was common. He determined that only twenty men in that time period who also had a father named Joseph and a brother named Jesus could have been named James. The clincher was that on only one other ossuary ever studied was a brother mentioned—indicating to Lemaire that the James whose bones had lain in this ossuary had had a very important brother indeed. Lemaire decided to date the box itself to 62 CE, the year the biblical James died.

When Lemaire told Golan that he wanted to publish a paper on the ossuary in French, Golan urged him to publish in English, "because," Lemaire recalled, "he doesn't read French." Lemaire chose to publish his first article about the ossuary in the popular English language magazine *Biblical Archaeology Review*—the same magazine that had published his interpretation of the ivory pomegranate twenty years prior.

Months later, when Lemaire's article was finally published, news of the box was touted in the world media as the first material proof of the existence of Jesus Christ—a man with a brother. The box was shipped to Canada and exhibited at a major museum with great fanfare. The faithful lined up by the tens of thousands to stand before it in silent prayer. A book was written. A documentary was filmed. By then, the saga that the Israeli police described three years later as

"the fraud of the century," involving a series of increasingly brazen archaeological forgeries designed to fool scholars and religious believers, was well under way.

✛

I FIRST READ about the curious case of the forged biblical artifacts in the *New York Times* around Christmas 2004. A story buried in the international section reported that Israeli police had indicted four men (they would soon add a fifth), accused of enhancing existing ancient artifacts, or fabricating entirely new ones, to make them appear to prove Bible stories. I am a nonreligious person, ever more mystified and fascinated by the religious mania erupting in my generation. The news from Israel intrigued me. My own religious training was nonexistent. As a child of the 1960s, I was weaned on a laissez-faire "figure it out when you grow up" attitude toward religious belief. What I know of believers comes mainly from the Mennonites who proselytized our family when we lived in a farmhouse in Michigan in the 1960s and 1970s. From them, I learned that there are some very decent people who live every waking minute in a state of unshakable faith in an otherworldly power. But their best efforts to lead us down that path were never sufficient to turn me into a believer.

As I read the article about the forgery scheme, I wondered what manner of men would deviously prepare objects to feed the desire for proof among people of faith, and why would faithful people—who by definition transcend materiality—want such proof in the first place? Eventually, my curiosity led me into a thriving, if murky subculture—that of the antiquities dealers who specialize in ancient Holy Land artifacts, the scholars who verify them, and the millionaires who collect expensive bits of cracked clay, stone, and bronze with the avidity and obsessiveness of boys collecting baseball cards. My research took me from the penthouses of Tel Aviv

and Fifth Avenue to the barricaded Arab cities of the West Bank, across the void of the Negev Desert, into dusty, sun-baked archaeological sites, and through pristine university laboratories where men and women of science struggle to carve a path of reason through a thicket of ambition, hype, and blind belief. Always, though, I found myself wandering back through the Arab throngs at the Damascus Gate, under the crenellated walls of Jerusalem's Old City, and into the warren of ancient, whitened stone lanes that are ground zero for believers from all three great faiths.

Here, the death match between reason and superstition—monitored by laughing commerce—plays out in a city that for millennia has nurtured the great religions that shape the world in which we live. Here, devout practitioners are everywhere, scurrying hither and yon in black hats and flowing robes and tightly wound headscarves, holy books in hand, trailing prayer beads and crucifixes and shawl fringe, redolent of frankincense and myrrh, observing ancient purity laws, muttering prayers beneath their breaths, adhering to codes that date back a millennium or two or three. Each belongs to a specific group clinging to its own interpretation of God's law and to a man, woman, and child, they exist on the precipice between godless modernity and submission to ancient supernatural instruction. They dare not look a different believer in the eye, for fear of meeting a challenge they cannot possibly walk away from.

Jerusalem seethes with political and theological conflicts involving Orthodox Jews, Muslims, and Christians, Israeli nationalists, Palestinian gunfighters, and atheist scientists, all existing in a framework of machine guns and guardhouse checkpoints, metal street barricades and barbed wire. It is so rich with spiritual history that newly arriving believers who do not first faint, literally kiss the ground and weep. And into this world had stepped an imp of deceit, or so the police alleged.

When I embarked on this project, I thought of it as an exotic crime story, *The Maltese Falcon* meets *Raiders of the Lost Ark* with a little bit of *The Da Vinci Code* thrown in. I had no way of knowing that the story was not only that but also much, much more, and that it would bring me to contemplate the psychological motivations of believers, hucksters, scholars, and police, and the political significance of bits of the past scraped out of limestone dust and dirt on a piece of real estate the size of Vermont—the most bitterly contested and spiritually prized turf on the planet.

<p style="text-align:center">⁜</p>

BEFORE I KNEW any of that, though, I found myself inside Moussaieff's sunset-daubed apartment on an October evening in 2006. He was not easy to reach by phone, though journalists had reported from his aerie, and I had been led to know that this was a very special occasion, engineered for me by a filmmaker friend of his who shares the old man's interest in Kabbalah—the mystical, New Age branch of Judaism to which Madonna now adheres. In requesting the interview over his cell phone in Hebrew, the filmmaker had used one word in English that I understood—"sexy"—with a broad wink and devious grin in my direction. Apparently, it worked.

The old man ushered us in cheerfully, speaking heavily accented English, frequently lapsing into Hebrew, and wearing a boyish striped polo shirt. He had lively brown eyes and a few wisps of gray hair combed over his liver-spotted pate. The apartment, atop a luxury beachfront hotel, was painted ultraminimal white, the better to display the hundreds of ancient objects scattered on the walls, floors, and built-in, museum-style vitrines. Over the course of a long evening, interrupted frequently by the arrival of men and women who were never introduced and who simply seated themselves around the long rectangular table and waited for Shlomo to take them aside

and do business, the old man told me his life story. As he spoke, his eyes sometimes rolled back, like a man in a trance, hypnotized by his own tapestried past.

The Jerusalem into which he was born, in the 1920s, was an Arab city of mosques, camels, and Bedouins, little electricity, and few cars. It was a city in which religious Jews had begun to settle in the past fifty years. The idea of Zionism—the return of the Jews to Palestine—was just gaining hold in Europe, but Shlomo was not of European stock. He was the eldest son of a rabbi descended from wealthy Bukharan traders who had been in Jerusalem for five generations. Bukhara is a very old Silk Road city in central Asia—located in what is now Uzbekistan—and Moussaieff's ancestors had grown rich on precious stones in the caravan trade. Moussaieff's father was unforgiving and rigid to his twelve children. The dyslexic eldest boy—unable to read the Torah—was a great disappointment to the conservative patriarch, and it was paternal punishment for Shlomo's inquisitive nature that first set the boy searching for God. One night, his father brought home an oil lamp with a wick that could be turned up and down by a handle. The boy was fascinated, having never seen such a modern device. When his father was not looking, he turned the wick higher and higher until the glass lamp suddenly exploded.

"I get punishment," Moussaieff recounted, eyes closed. "A beating nearly to death!" Between blows, his father threatened God's wrath as well as his own. " 'God will punish you, burn you! Like this!' And he take me to the kitchen and he put my hand in the little stove. Until now I have the sign of this burning on my hand."

That night, Shlomo ran away from home and slept in one of a series of cave tombs, called the Sanhedrin Caves. Ancient Jewish sages were supposedly buried there, and the sites are holy to Orthodox Jews of Jerusalem (who have installed fluorescent lights and prayer nooks inside them today). In the 1920s, the caves, which

still smell faintly of death, were home to hundreds of Arab urchins. Young Moussaieff joined them. In that place, he says, he began his search for both relics and God. "This [burning of his hand] was God's work! And I wanted to look for this god, I want to speak with him. I went to look for god. He burned me."

Like any real Jerusalemite, the homeless boy got a proper grounding in all three religions at a young age. Among his temporary shelters were both a synagogue and an Arab reform school—where he was sent after being arrested for looting coins and metal from tombs. He also spent time in a Christian hospital, where nuns periodically cured his worms and deloused him. At the synagogue, Moussaieff memorized the Torah. At the Arab reform school, he learned not only Arabic, but memorized the Koran. And from the nuns, he learned the New Testament. Moussaieff considers himself an "Oriental Jew" and is proud of his Arabic connections. His Arabic has obviously served him well in business, but he seems to feel a special kinship with Arabs also because of his childhood experiences. "Arab boys never went to school. European Jews regarded the Oriental Jews exactly like Arabs. They didn't send them to school or give them an education. And I couldn't learn, so I was just like the Arab boys."

Shlomo started collecting old coins from the unguarded tombs that dot the hills at the city's edge, selling the small treasures for food. He has saved one of the coins from those days— an ancient Jewish coin with a menorah on it—and he pulls it out and meditates on it sometimes because it reminds him of a period of deprivation and the beginning of his seeking God. "My motivation was always to see God. I wanted to see who punished me. I said, 'I am not going to believe until I can find God.'" He paused, took a drag off his cigarette, then continued, "God you have to find. If you don't know what he looks like, look more!"

As a seeker, not a practitioner, he has avidly collected biblical

relics for seventy years. "You won't like what I tell you," he responded when I asked him to explain why he collects. "Money buys everything. I use it only to prove the Bible is genuine. I don't practice religion. Since I got beaten for the sake of religion I don't practice at all. My religion is in the heart, in understanding the universe. It has nothing to do with these laws: Don't do this. Don't do that. But if you know the Bible well, it is a great book. Why? Because to the monotheistic people in the Bible, it never says, 'I command.' It says, 'God commands.' You see, it's not the ego motivation. It is about building a society, so life can continue."

In the course of the evening, Moussaieff frequently retreated into a corner of his apartment to have private discussions with one of the men and women who had arrived alone or in pairs. It took a few of these interruptions, and some discussion with the people who remained, for me to understand what was going on. It turned out that each of them had objects of possible interest to sell to Moussaieff. All were experts of a sort in ancient Near Eastern antiquities. They knew the difference between an ostracon and a bulla. And they could tell a real Christ-era oil lamp from a fake one at a glance. One woman, originally from Brooklyn, unwrapped an incantation bowl she said was from Iraq. The bowl would be for sale, she said, but she also had "a present" for Shlomo, an antique baby crib from the European Jewish diaspora, circa nineteenth century.

Moussaieff is a voracious collector, and he often makes deals on feel alone. For this reason he is both a shrewd operator and an easy mark. If he likes something, he'll write a check on the spot. But he's no fool. He might write a check, and *then* take the object to have it verified by a scholar. Sometimes he will postdate a check for a year, awaiting scholarly verification. But first, he trusts his own instincts about an object, relying on his photographic memory and his seventy-odd years handling bits of Holy Land archaeology. And indeed, he

can recite historical details about any of the thousands of ancient coins in his collection with barely a glance at the object. "I didn't learn this in school," he says. "I had no teacher. Like a computer, I see it in my head. I know the moment I bought it, from whom I bought it, the atmosphere, everything."

The possibility that he might buy forgeries—that his judgment calls might sometimes be off—doesn't bother him unduly. Fakes in the storeroom are a collateral cost of making a collection. "They made fakes twenty-five hundred years ago! A lot of coins were faked. I can make mistakes but I never have a contract. I buy it and—get lost! I have a million on a statue of King David right now. Why do I need a contract? I bought it! I have it! I know I am breaking the law, but I have no other way." This is not to say he is unbothered to discover someone has taken him for $100,000. He didn't become a billionaire without mastering an arsenal of psychological tools, tools that have made him not a few enemies even among the people who gather at his table and sip his cans of Diet Coke.

Moussaieff sees himself as a man heroically safeguarding biblically significant objects that might otherwise be lost, overlooked, broken, dispersed, or misinterpreted. He has an ambivalent relationship with scholars. He sometimes needs them to verify his instincts, and he has helped finance numerous digs, including, he claims, giving $200,000 to Columbia University to find Noah's Ark. But archaeologists generally deplore collectors, and Moussaieff doesn't take kindly to being second-guessed. He is suspicious of scholars who warn that his artifacts might be inauthentic. Some he accuses of a kind of secular bias against the Bible itself. "I know I am bound to make a mistake. But the biggest scholars who say these things are fake also say there was no truth in the Bible. They won't say it's real. They will say it's fake. If I were them, I would do the same, because they don't believe. And for me, the most important thing is to prove

the Bible, from the time of the First Temple. You see, here and here and here!" For emphasis he pulled out one of the numerous catalogs of his collection, and jabbed his finger at photographs of ancient scripture, carved in stone.

⟨⊹⟩

IT IS NOT A CRIME to buy, sell, or trade antiquities in Israel. Israel is almost alone among what are known in the parlance of cultural heritage experts as countries of origin in allowing the trade; it is the only Middle Eastern country to permit it. One reason for this is that holy relic collection is an integral part of the history of archaeology in Israel. Theology is a cornerstone of the field. The first archaeologists in what was then called Palestine and Syria were pastors carrying the Bible in one hand, and spade and map in the other. Even secular excavators today still get healthy infusions of cash from religious institutions and believers. A significant number of Bible archaeologists are also seminarians, that is, people schooled both in theology and the science of archaeology.

The interaction between Book with a capital *B* and shovel has a long and storied history in the Holy Land. The Byzantine emperor Constantine and his mother, Helena, back in the mists of history, were among the first Christian relic seekers. Helena is credited with locating the site of Christ's crucifixion in the fourth century CE, a site now known as the Church of the Holy Sepulchre. In the intervening years, Christian pilgrims from Chaucer's Wife of Bath onward have voyaged to the Holy Land hoping to bring back a piece of something as significant as John the Baptist's head, or simply—today—a clear plastic amulet containing Jordan River water or a crown of locally grown thorns.

Today, the field known as biblical archaeology is in a state of profound flux, disarray even. Scholars argue about whether the

Bible should be viewed as a historical document, a rough guide to the ancient world, or total fiction. Meanwhile, the number of biblical archaeological "finds" has increased dramatically in the last two or three decades. Since the Six Day War in 1967, Israel's expanded borders have meant more Western digging, motivated by theology, politics, and science. Where historians seek clues to the puzzle of the ancient world, evangelical Christians seek proof of their literal interpretation of the Bible, and nationalist Israelis want evidence of ancient Jewish inhabitation.

Archaeologists working in Israel, as elsewhere, need money. Wealthy collectors like Moussaieff do donate to digs. Archaeologists who disdain the antiquities trade are uncomfortable with this kind of funding, but they often have no choice. Digs are expensive. It costs tens of thousands of dollars to transport, house, and feed the human labor chains that painstakingly brush dirt away from ancient walls and tombs and sort through tons of sherds seeking the one scrap that holds meaning.

Moussaieff takes a dim view of the scientific pretensions of the scholars who criticize him for buying unprovenanced objects. "I know what an excavation is," Moussaieff told me sarcastically. "I financed Megiddo." (Megiddo is a major archaeological site, a pile of succeeding cities dating back millennia, much contested in ancient times between the great civilizations to the north—Babylon and the Hittites—and the Egyptians to the south. It is also the site of the biblical Armageddon, or battle at the end of the world. Tel Aviv University scholars who dug at Megiddo throughout the 1990s say the old collector did donate in the five figures over a period of years.) "Since then, they have no budget. They have students from Germany out there digging, complaining that it's too hot so they work at night. At night! That's the time to make love, not to dig! Everywhere, it's the same thing. I was there! I know! They take children—sixteen,

seventeen, eighteen—out in the sun! They want to enjoy life. They don't want to dig in the heat!"

✠

RATHER THAN RELY ON BORED, randy teenagers and their professors to haul ancient Bible evidence out of the dirt, Moussaieff and most other private collectors rely on a semi-illegal system that begins with an unauthorized digger—usually, an Arab.

Amateur, nonacademic digging, treasure hunting, or looting, is a common enterprise in the Holy Land, and even a profession for some Palestinians. These "excavators" form the bottom tier of the antiquities trade, digging up objects that increase hundredfold and thousandfold in value as they move farther away from their origins. It is not uncommon for some collectors and licensed dealers to step across a military checkpoint, go no farther than a few hundred meters into Palestinian territory, cut a deal with a digger or more likely a middleman, then bring back into Israel an object whose provenance is utterly unverifiable under Israeli law. Usually, though, collectors like Moussaieff rely on one of seventy-five licensed dealers. These dealers—most of them Israelis, a few Palestinian—are officially licensed by the government to deal in the ancient objects. They pay a fee and submit to a background check for the privilege of the license, and they agree to tell the authorities when and where they acquired their collections, and who is buying their pieces.

Palestinian dealers have shops along the narrow lanes in Jerusalem's Old City, while Israelis keep their concerns near the big hotels in Jerusalem and Tel Aviv. But each is recognizable by a glass front crammed with all the flotsam and jetsam of the Holy Land's storied past the owner can fit into display—Byzantine crosses, medieval Islamic swords, Roman glass and coins, Christ-era oil lamps. Israeli

authorities estimate that 90 percent of the stuff in the shops is fake, but that warning doesn't stop tourists or collectors from buying.

The biggest licensed dealer in Israel, an individual Moussaieff relied on much in recent years, is a man named Robert Deutsch. The Romanian-born son of Holocaust survivors who emigrated to Israel in 1963, Deutsch is a dealer with an unusual academic pedigree. He studied archaeology and dug at Megiddo—to the horror of the traditional archaeologists in the department—and eventually held an adjunct university teaching job as well. His twice-yearly antiquities auctions involve almost all the dealers in Israel.

I met Deutsch in his Jaffa shop on a summer's day in 2007. Sunlight winked off the Mediterranean a few blocks away, and sparkled blindingly on the white concrete plaza in the new visitors' park near Jaffa's Old City. Now a suburb of Tel Aviv, Jaffa has a long and rather macabre history. An ancient port town, it was the scene of ferocious historic battles as armies fought their way up and down the coast. As recently as 1800, a French massacre of Ottoman Turks left so many dead that visitors reported the stench of carnage still hung over the area three years later. In 2007, however, only a small, underground, and blissfully air-conditioned museum commemorated this grisly history. Deutsch's shop is located on one of the steep and narrow old lanes lined with pricey antiques shops and French restaurants. Farther on, vendors sell cheap collectibles at outdoor stalls in an open-air flea market.

Deutsch calls his emporium an "archaeological museum." His door is plastered with the logos of at least a dozen credit cards, and the sign hanging above it reads Licensed to Sell Ancient History. Deutsch operates as a clearinghouse of sorts, running an annual auction from a Tel Aviv hotel, mediating deals between collectors and other dealers for commission.

A tall, lumbering man with great goggles of aviator-style glasses that magnify his already large blue-green eyes, Deutsch had a hang-dog look about him when I sat down across from him at his desk in a room filled with vitrines organized by era and floor-to-ceiling shelves of books on archaeological arcana. By the summer of 2007, he had been on trial for three years already, and was a defendant in not one but two trials involving what the Israeli authorities charged were illegal business practices, fraud, and the sale of stolen objects. After three years in court defending himself against charges that he denied, he was understandably embittered at having had to keep paying expensive lawyers and live in legal limbo while his career and reputation have suffered.

The son of a dentist, born in 1951 in Romania, Deutsch has been involved in the antiquities trade since his college years. In his late thirties he decided to go back to school and earn advanced degrees in archaeology and epigraphy from Tel Aviv University. Deutsch's presence at the Archaeology Department was always controversial. When he was snared in the forgery case, the university swiftly severed its ties with him.

Deutsch fell a long ways. A confidant and friend of Moussaieff's, who had published books and articles about the old man's collection, Deutsch lost his patron's trust—and his professional and academic reputation—in one day.

Although he denied the main charge of knowingly selling fake ostraca (inscribed bits of ancient pottery) to Moussaieff, Deutsch was not inclined to explain to an outsider exactly where he got his objects, how he verified their authenticity, and how he conducted his business.

The biblical archaeology trade is clannish, a bit brutish, and very murky. Everyone knows everyone else's dirty laundry, and airs it when convenient. Literal blackmail is a job hazard—and a tool of the trade. If an Arab looter/excavator asks too much for an object,

a collector or dealer need only threaten to turn him in to the Israeli authorities to get a better bargain. Similar threats work all the way up the food chain. To move his objects in and out of the country, Moussaieff employs a Byzantine process involving diplomats, corrupt government officials, and customs officials with sticky palms.

None of the Bible archaeology dealers I interviewed ever answered a question straight, and Deutsch was no different. They are a breed of men (all the dealers I met were male) able to talk for hours about antiquities arcana, waxing on about vendettas being run against them by other dealers, greedy collectors, or the Israeli antiquities police, and the incompetence and corruption in those official ranks. But while they scrupulously avoided describing their own methods of acquiring objects in any detail, they were often happy to reveal one another's tricks of the trade.

When I met with Deutsch, I had already interviewed a number of dealers in Jerusalem. I was becoming used to their oblique, sideways method of talking, their ability to change the subject seamlessly, and cast aspersions on fellow dealers' honesty and integrity. They were never reluctant to rat one another out. Thus, in my first meeting with him, I was not surprised Deutsch was eager to tell me how he'd been betrayed by Shlomo Moussaieff, a man to whom he had sold hundreds of thousands—probably millions—of dollars' worth of objects over the years.

Deutsch now said of the billionaire collector, "I never was good friends with him because he is an impossible man. He's not normal. He's not a normal man. My wife always told me, 'Why do you have to stand this man? He's such an ugly man, ugly in his behavior.' And I said, 'I want to publish his stuff!' But he can tell you, 'You are the best,' and after you leave the apartment, he will tell someone else, 'He just stole some coins from me.' And after two days he finds the coins and then never tells people I didn't steal his coins. This kind of

stuff. For him to talk about somebody or destroy his name is nothing." Deutsch snapped his fingers angrily. "It's a play. It's a game."

Even Oded Golan—who was never a licensed dealer and who insisted that he never sold an object "outside Israel"—had problems with Moussaieff's business style. He accused him of inflating prices. "Moussaieff is the most suspicious person in the world, because he doesn't know how to behave with the dealers, and dealers are paying it back to him in the same coin. Moussaieff crushes the dealers, if he can. You see, if they ask $1,000, he offers them $100. It's not a way to make a deal, you know. And if he doesn't succeed to lower the price 50 or 60 percent, he doesn't buy the antiquity even if it's worth five times more. And of course, most of the dealers in the world know it now. They figured it out, maybe fifty years ago. So everybody offers antiquities at five times more than they are worth, knowing he will try to bring it down! So you see it's a ridiculous situation. Now he cannot understand who is really giving him the real price and who is giving him the suspicious price in order to try to bring it down. That's the world. That's Moussaieff!"

In a life as long as his, in a business as fraught with miscreants as the antiquities trade, it is not surprising that Moussaieff picked up enemies along the way. But they continued to flock to his table, and he always welcomed them even if he saw glints of envy or resentment in their eyes, so profoundly did he want first dibs on the rare piece.

⁜

BASED ON LEMAIRE'S FRESH INTERPRETATION, the James Ossuary, as it was soon to be named, had enormous meaning for Christians and the history of Christianity. The ossuary now had the potential to become at least as important as the Shroud of Turin in the pantheon of objects that provide physical proof for biblical stories, and in this case, the biggest story—the existence of Jesus Christ. Quite soon

after he saw the ossuary, Lemaire tipped off his friend, the editor of *Biblical Archaeology Review*, to the find. *BAR*, as it is known, is an American popular journal with a subscription base of a quarter of a million lay readers and amateur biblical archaeologists, many of whom are evangelical Christians interested in seeing their beliefs verified with material objects. *BAR* is not peer reviewed like an academic journal, but scholars do publish in it, partly because it gives them a wider audience than the more respected scholarly journals.

The founder and editor of *BAR* is a Washington, D.C., lawyer named Hershel Shanks, who has been publishing popular news of biblical archaeology since the mid-1970s, through his nonprofit organization, the Biblical Archaeology Society (BAS). BAS also operates scholar-guided Holy Land tours, has a Web site, offers stateside seminars, and sells books and advertising.

Shanks is an odd duck—lawyer, crank, P. T. Barnum, and Indiana Jones all rolled into one man. *New Yorker* writer David Samuels compared him to "a Saul Bellow character." He spends a good part of the year globe-trotting with major names in the world of biblical archaeology. At home, he reports to work at his own offices in upper northwest Washington in a brown leather explorer's hat and leather jacket, a somewhat incongruous kit for a septuagenarian. A curmudgeon, known for bringing lawyerly argumentativeness to scholarly gatherings, Shanks attends all the major biblical archaeology conferences, invited or not, and always times the annual conference of his own Biblical Archaeological Society to take place side by side with annual meetings of the official scholarly societies, the Society for Biblical Literature and the American Society for Oriental Research, the latter an organization of archaeologists and scholars who study the ancient Near East. Among the real scholars, the American lawyer is something of a joke, but they take him seriously insofar as he can deliver their papers to a wide audience and pay them handsome

fees—including travel expenses—to lead tours around areas of the world to which they are deeply attached.

Shanks is always on the lookout for the rare find, and he knows well how to make the most out of a potential piece of news. He was the first, for example, to publish word of the famous pomegranate two decades prior. He is deeply committed to supporting the private antiquities trade and philosophically inclined to believe that not to do so results in the loss of history. He often notes that most of the Dead Sea Scrolls, widely considered to be the most significant archaeological discovery of the twentieth century, were looted and purchased from middlemen. Yet no one suggests the scrolls are forgeries.

When Lemaire told him about the James Ossuary, Shanks was so excited that he personally arranged for two researchers at the Geological Survey of Israel to authenticate the ossuary's inscription as well. The main business of the Geological Survey, or GSI, is mapping Israeli mineral and water resources. But certain scientists employed by the GSI were known to have an interest in private collections and Shanks knew they would be happy to examine an important but unprovenanced find. The geologists examined the James Ossuary's patina— the natural coating that builds up on objects over time. After a single day of tests, the geologists said it was consistent with two-thousand-year-old stone and didn't appear to contain any modern materials.

Shanks then turned to the task of getting backup for Lemaire's epigraphic conclusion, and first on his list was Ada Yardeni. According to Ada's datebook, on September 15, 2002, Susan Singer, an associate of Hershel Shanks, called to invite her to a dinner with Hershel in Jerusalem in two weeks. Ada knew Shanks "superficially," she says, and had written occasionally for *BAR*. The invitation flattered her, and she accepted. They met at a Jerusalem restaurant, joined by a classics professor from Hebrew University.

"Hershel saw me before we went inside and he said, 'You know, Ada,

we have something very important to talk about.' I thought he meant the stone tablet. I said, 'Well yes, I think I know what you mean.' And then he said, 'Ya'akov.' And I said, 'Why Ya'akov?'" She didn't think of the ossuary, because, she says, she didn't know Jesus had a brother named James. Then Shanks told her about the ossuary, and insisted it was very important. "He tried to pressure me to go to Oded and draw the original. I said, 'I can't leave my mother. My mother is ninety-five, and I cannot leave her alone to go to Tel Aviv.' And he said, 'Look, it is important.'" Shanks offered to pay her cab fare to Tel Aviv and back.

Ada reluctantly agreed, but went home after the dinner feeling troubled. "I couldn't sleep. Somehow it bothered me. I had a bad feeling about the whole thing—I don't know why. My intuition is very, very strong. And I had a really bad feeling about the whole thing. I phoned Oded Golan Sunday morning and asked him if I can come to see this ossuary. And he said I should come the same day, in the afternoon, because he was going to put the ossuary in Shanks's magazine soon."

She left her aged mother at home, and took a taxi for the one-hour trip from Jerusalem to Tel Aviv. Shanks and Golan were waiting for her at Golan's apartment when she arrived about three in the afternoon on Sunday, September 29.

"I saw three ossuaries. He put them in the kitchen, where I could really see them under the window where the best light is, because his apartment was very dark. I don't know why, but it was dark and gray. Not nice! Beautiful piano. But I didn't like his apartment."

Oded and Shanks watched as Ada took tracings onto her paper from the ossuary. As soon as she'd finished, Shanks hurried her out the door. "I drew all this, and then Shanks immediately took me to a Xerox machine. We took a taxi to the shop. And in the taxi he asked me, 'Ada, do you like adventures?' I said, 'No, I'm not particularly fond of adventures.'" She laughed at the memory. "This was strange you know? Strange."

The Detective

Fall 2002

*For as the body without the spirit is dead, so faith
without works is dead also.*
—THE EPISTLE OF JAMES, 2–26

The first appearance of Jesus in the archaeological record!
—HERSHEL SHANKS, PRESS CONFERENCE,
WASHINGTON, D.C., OCTOBER 21, 2002

ETECTIVE AMIR GANOR was in his office at the Rock-
efeller Museum on the Arab East side of Jerusalem when
CNN called in October 2002 to ask about a limestone
bone box, which was said to have once held the bones of Jesus Christ's
brother, and was thus the first archaeological evidence of Christ's exis-
tence. The query displeased the detective for a number of reasons.
First of all, it was part of his job to know about any "new" archaeo-
logical find of any importance from Israeli soil, whether stolen or not,
and he'd never heard about this particular object. Second, the way the
news was delivered to him—CNN calling for comment, his English
not so great—was disconcerting. He told his press secretary to give
CNN a standard comment: "There are many looted places in Jerusa-
lem, many caves are opened every year, and maybe one of the caves

was looted. We have three hundred sites each year looted." Then he put in a call to the office next door to his in charge of export licensing. A colleague there confirmed that the historically significant ossuary had been licensed for shipping outside Israel with a whopping million-dollar insurance policy, a red flag that should have alerted the clerk to make some inquiries. Ganor was furious. "I asked her, 'Why did you let him [the owner] do this?' And she said, 'Because he's my friend and he helped me with my dissertation.'"

More irritating, the box apparently belonged to a prominent Tel Aviv collector whose apartment the detective had visited just two weeks before. And during that visit, the collector had not mentioned anything about owning a soon-to-be internationally famous object.

Amir Ganor is chief of the Israel Antiquities Authority's Theft-Prevention Unit (IAA). A tall, big-boned, almost ungainly man with tiny oval glasses perched on a great beak of a nose and a Glock perpetually tucked into the forty-eight-inch waistband of his Lee jeans, Ganor is an unusual kind of cop. Like all Israelis, he's served in the military, and although he's in his late thirties, he still gets called up to active duty whenever war breaks out. He's a man of the sword, but also a man of the books. He's a trained archaeologist, and his job is to protect the thirty thousand archaeological sites around Israel from looters—and limit the illicit trade in antiquities.

Operating out of an office decorated with a giant Google earth map of Jerusalem's Old City, fueled by endless cups of Nescafé he stirs up in Styrofoam cups, Ganor oversees a twelve-man unit that is supposed to guard Israel's antiquities from the hordes of tomb raiders, religious faithful, wealthy collectors, and dealers who want to get their hands on a piece of it.

As a "dirt" archaeologist in college, Ganor helped excavate the site of En Hatzeva, an ancient Judahite city. The fruits of that labor—a collection of clay Edomite idols— are displayed behind a glass case

in the Rockefeller Museum not far from his office, and he occasion-
ally visits them simply to relive one of his proudest moments. As a
college student, working in the blazing summer sun on his knees
with a brush and a bucket, he found a pile of cracked clay—which
when pieced together turned out to be a hoard of pagan idol fig-
ures. Having poured his own sweat into Israel's ancient history, he
has strong feelings about the sanctity of archaeological sites—even
though he's not a terribly religious man. "A looted site is like a dead
man," he says. "You cannot revive it."

Ganor is the son of an Egyptian Jew who emigrated to Israel in
the 1950s and who until recently ran the Israeli Arab television sta-
tion. The detective leads a special brigade from headquarters at the
Rockefeller Museum, a hulking, pale stone, Ottoman-style building
in Arab East Jerusalem, a few hundred yards from the gold-topped
Dome of the Rock and the Temple Mount.

I first met Ganor in October 2006 and he was running very late.
It was the last Friday of the Muslim holy month of Ramadan and
almost impossible to drive to his office just across the street from
the Old City because of roadblocks set up by the Israeli Army and
police to contain possible post-prayer rioting. My cabdriver had
finally given up and unloaded me in the middle of crowds of obser-
vant Muslims—men, women, and children—all hurrying to midday
Friday prayers, and all equally inconvenienced by the blocked arter-
ies into and out of East Jerusalem. The Israelis are always nervous
about what goes on inside mosques on Fridays, but during Rama-
dan, the holiest time of year for Muslims—and especially the last
Friday of Ramadan—the Palestinians are presumed to be exception-
ally volatile and the authorities are thus exceptionally vigilant.

I whiled away the time in the walled courtyard of the museum
attempting to chat with a young man at the guardhouse dangling a
machine gun from his fingertips, who spoke not a word of English,

and who had been reluctant at first to let me pass. Once we r.
the end of our mimed pleasantries, which involved sharing a stic
gum and snapping a few digital photographs, I moved farther up t.
long, walled driveway toward the entrance to the museum, which
was closed for the day. Two men were standing outside a white van
filled with television monitors. The van was connected by a cable to a
white blimp soaring high overhead, which was beaming down to us
an aerial view of the plaza outside the mosque. On the small screens
in the darkened hull of the van's interior, we could see thousands of
people milling about on the sun-splashed marble expanse around
the gold dome. The two men were eating donuts, cracking jokes, and
occasionally checking the tether holding their spy blimp in place.

No one seemed unduly concerned that a violent riot might be
imminent—the ostensible reason for the spy blimp—but I learned
to chalk that up to the pervasive local attitude about violent conflict,
which is that it's a fact of life and to be expected much as New York-
ers accept rudeness and noise. For Israelis and Palestinians, war is
the permanent background noise. All my meetings with the detective
took place under the shadow of episodes of ongoing aggression and
aggrievement. Six months later, I met with Ganar again as masked
Hamas gunmen took over Gaza a few hundred miles away. A year
later, I was in his office just after the Israeli Air Force had bombed
a Syrian building that might or might not have contained a nuclear
bomb factory, an act about which an unnamed British ministerial
source would tell a London tabloid, "If people had known how close
we came to World War III that day there'd have been mass panic."

<p align="center">⁂</p>

ACROSS ISRAEL, contradictory versions of both recent and ancient
human history provoke arguments, protests, arrests, the throwing
of rocks, the firing of tear gas and bullets, the detonation of human

bombs on buses, and even the firing of missiles from jets. Here they have taken Robert Frost's advice to heights unimagined in Vermont. If a good fence makes a good neighbor, how about a thirty-foot-high cement wall, meandering for miles across the countryside? Good checkpoints make good neighbors too. Throughout the land, they are as common as McDonald's golden arches along highways in the United States. Lissome young women with pistols strapped to their low-slung waistbands guard hotel entrances, and soldiers with M16s are a common sight. The tension is especially fierce on the narrow streets and tight, curving corners of the ancient and holy hill city of Jerusalem, which is uneasily shared by Israelis and Palestinians.

Palestinians and Israelis do physically coexist in Jerusalem, but there is rarely a moment without an undertone of conflict. In the Jewish quarter of the Old City, the stones are washed and white, in contrast to the paving stones near the Damascus Gate and the entrance to the Haram, which are usually slick with liquefied, rotting vegetable garbage. One afternoon, I was there to visit a Jewish dealer and stop in at the headquarters of an organization dedicated to restoring the Temple Mount. A pair of Palestinian workers was pushing a small stalled truck up the narrow lane, inconveniencing people on foot. "Doing what they do best," muttered an American in ultra-Orthodox dress. Meanwhile, on Fridays, imams in mosques throughout the occupied territories preach that Jews are untrustworthy and that martyrdom for the homeland is a god-sanctioned honor.

Waiting for Ganor, I had ample time to think about life in modern-day Jerusalem. Just beyond the gated walls of the Rockefeller Museum, diesel exhaust mingles with the smell of rotting garbage, human sweat, and fresh-baked bread on the Arab edge of the Old City. The religious people all seem impervious to the odor and crushing heat. Arab women drift along in the sun, serenely not making

eye contact, their headscarves wrapped ever tighter around their hair, their bodies encased in floor-length polyester coats, buttoned up to the neck, in navy, black, or brown. They clamber out of little green and white battered public minibuses that serve East Jerusalem and the dust-choked roads past the checkpoints into Ramallah or the small Arab villages. Some of them lurch off the buses and vomit curbside, a reaction to heat, carsickness, or the mere stress of being female and stepping out in public.

The *haredim*—Orthodox Jews—move among them dressed in black, trailing forelocks and scarf ends, looking distracted, profoundly unexercised, pale as hothouse orchids. The men always move a few steps ahead of their women and children. The only haredim I ever saw remove their hats in public were at the Tel Aviv airport security check, and once on a Jerusalem street at noonday. The man removed it for a second while waiting for a traffic light to change, wiped his brow, then snapped it back on, returning a pound or so of beaver fur—it was a holy day—to its traditionally mandated spot between the top of his head and the desert sun's radiation.

Not far from where I waited for the detective, on the western side of the Old City walls, was the cliff overlooking the Valley of Hinnom, a place with a dark pagan history as the site of child sacrifice to the god Moloch. From the top of the cliff, parents once tossed children into a perpetually burning rubbish fire, to satisfy a god. And here, to end the practice, the ancient Jews first imagined a more just and moral deity, one who didn't need immolated infants, just undivided faith and obedience to purity laws. As the source of this primordial discernment between good and evil, Jerusalem itself also sometimes seems to be the source of all good and evil.

On that first crisp, sunny late October day, Detective Amir Ganor finally arrived, apologizing profusely. Presumably, a wave of his official ID card had somewhat speeded his trip, but no card can

move stalled traffic. I followed him through a series of white stone arcades past curving staircases and into a warren of small offices. The building was financed in the 1920s with $2 million from John D. Rockefeller, at the suggestion of an American archaeologist from the University of Chicago's Oriental Institute, to house important regional archaeological finds. It owes its fantastic look—white walls, hexagonal tower, and graceful courtyard, conjuring up a Mameluke citadel and khedive's palace in one—to the British architect Austen S. B. Harrison, who designed it in an Orientalist-Gothic style. Until the Six Day War in 1967, when Israel took over East Jerusalem, the building was called the Palestine Archaeological Museum, and it housed Palestinian archaeologists. During that war, Israeli and Jordanian troops fought fiercely around it, and Israeli soldiers eventually used the tower as a lookout.

Ganor has the surveillance apparatus of Israeli security forces at his disposal, and he is comfortable behind a Glock (a caricature of him on the wall at this office, drawn by a fellow officer with an artistic bent, has him pointing a gun at an Arab, while the real thieves are getting away behind him). But he's also studied archaeology since he was a teen. He really knows his way around fakes. He can put his tongue on a tiny ceramic oil lamp and taste the difference between an ancient one and one fabricated for sale in the Old City tourist market.

Near his desk, Ganor keeps a small glass cupboard containing some of the forgeries his IAA teams have collected over the years. He is especially fond of a small, crusted pearlescent glass jug, supposedly an ancient Roman relic, for which a tourist paid $1,200 at a shop in the Old City. Beside it, also carefully mounted, a modern-day electric lightbulb. The shape of the belly of the small jug exactly replicates that of the lightbulb—because, in fact, beneath the pretty paint job, the supposedly ancient artifact is also a lightbulb, charm-

ingly and convincingly decorated and attached to a genuinely ancient glass handle and lip.

Ganor's antitheft unit monitors the business transactions of Israel's seventy-five registered antiquities merchants and keeps track of the thirty-some major private antiquities collectors, including Shlomo Moussaieff. The unit also regularly traverses the countryside in jeep patrols searching for gangs of tomb looters. On any given night, Ganor can be found running what he calls "an operation," which consists of taking soldiers and police officers equipped with night-vision goggles and handcuffs into the brush and olive trees around one of the tens of thousands of unsecured archaeological sites in Israel and waiting for looters. On the morning we met, three mud-caked metal detectors lay on the floor beside his desk—the previous night's haul of captured tools from a trio of looters nabbed at a dig outside Jerusalem.

But even if Ganor runs an operation every night of the year and nabs looters every time, he and his twelve theft-unit colleagues still face a Herculean task. Almost every night, an antiquities site is robbed. With thirty thousand sites to monitor, the unit's work is never done. They are like men trying to put out forest fires with teapots. *Ha'aretz*, the respected Israeli daily, estimates that over 90 percent of the antiques originating in Israel have been looted from sites all over the country, most of them open and unguarded.

The law says every piece of antiquity found after 1978 belongs to the state. But the burden of proof is on the IAA, not the dealers, and the dealers have learned to play a simple shell game with Ganor's twelve inspectors. Each piece has an ID number. But if an object with an ID number is sold, the dealers simply transfer the number to a new piece. "If they sell an oil lamp, they take the ID number from the one they sold and glue it to another oil lamp that came out of the field last night," Ganor said.

In 2002, the Israeli government tightened the rules. Now it's the

duty of the dealer to know who he is buying from and to be prepared to share the name and address with the IAA. That would seem to have solved the problem, but, says Ganor, it has simply pushed the trade beyond borders. "Now they bring all the stuff from outside because Israel is the only country where dealing antiquities is permitted. Now most of the things looted in Egypt or Lebanon or Jordan are smuggled to Israel, get a permit here, and then get sent to London, to Germany, to the big markets."

In their daily work, Ganor and his men bridge two vastly different societies. One is the world of Tel Aviv, with its beaches, hotels, and secular, cosmopolitan millionaires, some of whom indulge a taste for illicitly gotten ancient stuff. On the other side of the gulf, only forty-five miles down Israel Highway 443, they navigate Jerusalem, its conflicted, shared ownership with Palestinians, and the tension sewn into daily life by the ultrareligious men and women from all three major religions vying for the right to call the Holy City theirs.

Ganor moves easily in the half-occupied, disputed hills around Jerusalem and the Arab streets around his office, on the east side of Jerusalem. His Egyptian heritage serves him well. Like Moussaieff, Ganor speaks Arabic, and he knows Palestinians. Some of them he even considers to be friends—or at least, trusted informants.

Ganor has mixed feelings about the conflict with the Palestinians. On one hand, he is a soldier and a cop, and so concerned with security. Before I first met him, he had been impossible to reach by telephone for a month because he was in Lebanon, fighting during the summer of 2006. On the other hand, he seems to long for a different kind of society. "As a child, I lived in a village," he told me. "I would cross to the Arab village on the other hill and steal grapes. I had many friends from the Arab village. They [Arabs] used to come and go freely from their villages. Many people used to come to a

spring nearby to swim. But during the last intifada, two religious guys went swimming there, and the Arabs attacked and killed them in the pool. That was the end. They closed down everything. Now, the wall destroyed the view between the villages. But we live like this in Israel."

The detective explained that he and his men are in a pitched battle not just to protect the antiquities from site looters, but also to preserve the very evidence of Jewish heritage in Israel. "The Muslims have already destroyed the old arches under the Old City walls," he said. "They want to destroy—erase—all evidence of the Jewish people on the ground."

This was an argument I would hear more than once as I made my rounds of the archaeological community in Israel. Ganor's most pressing issues, however, are not ideological. They are commercial and criminal—therefore suprapolitical—involving the taking of precious objects out of the ground and moving them to a high-end market. It is an enterprise that involves, typically, the cooperation of Palestinian and Israeli alike.

✦

THERE WAS a crescent moon overhead when the detective picked me up outside my lodging at the Albright Institute, an American archaeological center on Salah Ed-din Street, the main strip of Arab Jerusalem. It was after ten at night, and he had invited me to accompany him on a night raid at a nearby tomb site, hoping to nab some "looters"—Palestinians, usually—who creep out onto the rocky hills around Jerusalem under the cover of darkness, using metal detectors to scour ancient tomb holes for treasure. The detective navigated his green jeep through the back streets of East Jerusalem, dodging late-night strollers in djellabas and headscarves, who walked willy-nilly in the roadway, ignoring vehicle traffic. As he steered, he explained

that the periodic surveillance operations he and his men undertake only deter—not exactly eliminate—unauthorized site digging.

He took a circuitous route out of Jerusalem, scaling steep hills from the tops of which the entire city was a blinking carpet of light below us, and then abruptly doglegged to plunge back down hills, into dark Arab villages where electricity seemed in short supply. Five minutes beyond the city proper, we drove up one especially long, steep hill, and ended up on a straight dirt road that skirted the edge of a ravine. Ganor turned off his lights and slowly drove the vehicle in the dark another half a mile, by moonlight, toward the end of the path. There, we met two of his agents, already peering at a hillside beyond the ravine below with night-vision goggles. In the distance, Jerusalem was just a glow behind a hedge of hills. Closer by, small Palestinian villages dotted the hillsides, little clusters of light. Strange, exotic screeches and rustlings wafted up the steep hill from far below. We were, Ganor informed me, just above the Jerusalem Zoo. The sound of the monkeys and peacocks and crickets blended with the call of the muezzin— a Muslim crier who calls the hour of daily prayers—from a minaret on a distant hill.

A gentle breeze ruffled the mountainy meadows, carrying the fragrance of wild lemon thyme—an herb the Arabs call *zatar*— between where we were standing and the far hill we were spying on. All three men had semiautomatic handguns tucked into their waistbands.

Ganor tried to orient me in the dark, as we took turns eyeing the white-specked hillside across the valley. We stood at the very edge of the 1948 border of Israel, he said. There was an Arab village atop the hill across from us. Bethlehem was just to one side, blocked from our view by a scrim of hills.

"There is an excavation under way on the top of the hill and because of it, the villagers think they will find treasures," Ganor said.

"Before the excavation, robbers were already here, there were ten or twelve piles. There's a Second Temple villa on top of the hill, and tombs below on the hill, lots of tombs, from the First and Second Temple and Middle Bronze Age." (The First and Second Temple periods refer to Old Testament historical eras, roughly beginning around 1000 BCE, the supposed date of David's conquest of Jerusalem, ending in 70 CE, when the Romans sacked the Herodian Temple, a method of organizing historical data that dates back to the earliest days of Holy Land archaeology when Victorian Christian pastors arrived in Palestine searching for facts to support the biblical record.)

Most of the tombs on the hill we were monitoring were prebiblical, had been untouched for as long as five millennia, and are still yielding treasure. Each tomb had held thirty or forty people, and each deceased was buried with ten to one hundred personal belongings. In each tomb a looter might find between three hundred and three thousand objects. Multiply the objects in value by $100 to $1,000 and it's easy to see why an unemployed Palestinian would chance getting arrested and sent to jail for terms that last from months to a few years. "This area is really worth their time to come and dig," Ganor says.

Tens of thousands of such sites exist all over the country and valuable things can be found in each of them. Certain caves used around the time of the Jewish Revolt against Rome in the first century CE hold coins that are worth half a million dollars. Often the tombs hold bones as well—an additional and different sort of problem for the IAA and archaeologists working in the region, because religious Jews will picket such sites if they think human remains are being disturbed.

Tomb shafts are not marked, but they tend to sink five to ten centimeters below ground level, and the practiced eye can spot them immediately. Ganor said some of the looters have taught him more

about locating troves of archaeology than he learned at the university. From them, for example, he learned that a different kind of weed grows on top of an old tomb shaft. "These are things you don't learn in school." He so admired the skill and natural knowledge of one of the men he arrested that he gave him a job with the IAA, policing sites, after his jail term ended.

The white spots visible on the dark hillside were heaps of limestone, freshly excavated by treasure hunters on previous nights. Ganor and his men were hoping to catch them red-handed this evening. As we trudged up the rocky hill, Ganor pointed to a half-covered hole in the ground nearby. In the darkness, by moonlight, we could make out a heap of shovels and metal detectors. The tools were left on the hillside by day, for use at night.

<div align="center">✢</div>

PICKING OUR WAY CAREFULLY in the dim light, avoiding the thorny scrub and the rocks and pits, the burly detective joked about his terror of snakes and that his deputies made fun of him. A third of the way up, we stopped for another peek at the village. The flashing lights of the checkpoint far below seemed incredibly tiny. I got a whiff of the sense of freedom the villagers might feel up here in the dark. Amir lowered himself inside a recently excavated tomb, one that looters had tried to cover with a heap of brush, and had a look around, while the other two men stood by.

After hiking about fifteen minutes up from the road, we were level with an Arab village about a half mile away on the hillside. We were close enough to see firelight—kerosene lamps?—winking in the windows of a lone two-story house and to make out people moving around in the courtyard of a house at the top of the hill, moving through shadows and lights. We heard their muffled voices.

A man with a flashlight stepped outside, and flicked his lamp off

and on, off and on. Ganor and his men froze. Then the flashlight was extinguished for good, and the man reentered the house. We sat. Typically, if the IAA officers wait long enough, for enough nights in a row near the tools, they are sure to make an arrest.

The Big Dipper was to our right and Orion to the left, in a cloudless sky. We watched and waited. One of the agents spoke unaccented American English and told me his family lived in Brooklyn and his uncle worked as an editor of the U.S.-based Jewish daily, the *Forward*. Sitting on the hillside with the men, we took turns surveilling the eerily green tiny village through their night-vision goggles. I could make out laundry hanging from a porch, a lone figure stepping outside for a smoke, then going back inside. The smoker couldn't possibly have known he was being watched from a hundred yards away on the dark, deserted mountainside. Or could he? Was the smoker also a tomb raider? I would never know. We sat in the dark for about an hour, then the men decided to call it a night, explaining that if the looters weren't out by midnight, they were unlikely to be going to work. Site looting is manual labor, and it takes time. The agents returned to Jerusalem, empty-handed.

⳨

ON OCTOBER 21, 2002, Shanks held a dramatic press conference in Washington, D.C., announcing the discovery of the James Ossuary. The BBC, CNN, and the major English-language newspapers and magazines all sent correspondents. "It is the first appearance of Jesus in an archaeological discovery," Shanks told the assemblage. "This is the first archaeological attestation of Jesus, plus also of Joseph and James, which is kind of mind boggling."

Shanks refused to name the owner of the box, despite repeated questions. "We asked him to attend the press conference," a senior editor at *BAR* told *Ha'aretz* later, "but he didn't want to be at the

center of the story; he's a modest man." Shanks told reporters that the owner had been shocked by the box's significance. "He threw up his hands, 'How could the Son of God have a brother?'"

At the press conference, Shanks also made short work of the question of the provenance of the box, explaining that the anonymous owner had purchased the ossuary in the 1970s for between $200 and $700. "The Arab dealer told the owner it came from Silwan," Shanks said, referring to an Arab suburb of Jerusalem.

Shanks also dispensed with questions about the statistical frequency of the names Jesus, James, and Joseph in first-century Jerusalem. An NPR correspondent, interviewing Shanks the same day as the press conference, asked, "The assumption here is that if somebody were named Ya'akov, or James, and was the son of Joseph and the brother of Jesus, that that would lead us to Jesus of Nazareth. Are the names so unusual for those days in the first century that it couldn't be another . . . Ya'akov—whose brother was Jesus and father was Joseph?"

Shanks replied, "They are common. All three of these are common names. And we figured out—André Lemaire has figured out the statistics, and we know the approximate population of Jerusalem, we know the percentage of the times that these names appear. And there are three or four other people who could be James with a brother Jesus and a father Joseph.

"But the clincher in this case is that it's on an ossuary. And it's very unusual—in fact, there's only one other case where a brother is mentioned [on an ossuary]. And when a brother is mentioned, that means either that the brother was responsible for the burial, which would not be true in this case, or that the brother was prominent and that the deceased was associated with him."

That night, the amazing find was covered in the nightly newscasts on CBS, BBC, CNN, ABC, and Canadian television. The next morn-

ing, the *New York Times* ran a lengthy front-section story reporting, "This could well be the earliest artifact ever found relating to the existence of Jesus."

Before holding the press conference, Shanks had been on the phone with the president of the Royal Ontario Museum in Canada, offering the exclusive first right to exhibit the box. He had also negotiated to sell exclusive film rights to a Canadian television producer, Simcha Jacobovici (no stranger to the subject matter, Jacobovici sometimes calls himself "The Naked Archaeologist"). Jacobovici appeared with Shanks on national Canadian television to discuss the ossuary the day after the Washington press conference, and he mentioned he had already started filming. Shanks was also cutting a book deal with a major American publisher to write about the ossuary. (His book was published in 2003.)

The press was not entirely credulous. In the first articles about the ossuary, reporters inserted comments from skeptical scholars. The *Washington Post*, for example, included this warning flag. " 'If it's looted, archaeologists would say it's useless, because we have no idea where it came from, and it has no context,' said Near Eastern studies specialist Glenn M. Schwartz, of Johns Hopkins University. 'Also, the object, if real, would be hugely valuable, so anybody interested in forging it would make it as believable as possible.' " American epigrapher Kyle McCarter similarly warned the *New York Times*, "This could be something genuinely important, but we can never know for certain. Not knowing the context of where the ossuary was found compromises anything we might say, and so doubts are going to persist."

But none of these scholars had actually seen the box. And André Lemaire, Sorbonne epigrapher, was certainly as credible a scholarly source as anyone a reporter might find on deadline. American scholars, who had not seen the box, could only second Lemaire. "Like other

biblical scholars, Dr. James C. VanderKam of the University of Notre Dame praised Dr. Lemaire as an authoritative epigrapher, or specialist in ancient inscriptions, whose research is thorough and evaluations judicious," the *New York Times* reported. "'Since the research comes from André Lemaire, I take it very seriously,' Dr. VanderKam said. 'If it is authentic, and it looks like it is, this is helpful nonbiblical confirmation of the existence of this man James.'

"Dr. Eric M. Meyers, an archaeologist and director of the graduate program in religion at Duke University, said the rarity of this configuration of names occurring, especially the inclusion of a brother's name, 'lends a sense of credibility to the claim.'"

Soon after the press conference, Christian magazine writers and bloggers began debating what the ossuary meant, not for history, but for Christians. A leader of the so-called Jerusalem Church in the years just after Christ's death, the apostle James died in 62 CE when he was thrown off the walls of the Temple. James is described as a "brother" of Jesus in Paul's Epistles and the Gospel of Matthew, but there are three different interpretations of the relationship. Protestant scholarship holds that James is a full-blood brother of Jesus, while Eastern Orthodox churches regard him as the son of Joseph by a previous marriage. Roman Catholic scholars have suggested that "brother" is an idiom, and that James was Jesus's cousin. Besides the sheer newsworthy sensationalism of finding a box that proved the materiality of Christ, the box was gasoline on a controversy between Protestants and Catholics. For Protestants, the notion that Christ had a brother is tolerable, even part of their belief system. For Catholics, who believe Mary was a lifelong actual virgin, the box represents a challenge to Church dogma.

Hershel Shanks's *BAR* audience is heavily Protestant, and his critics say he deliberately appeals to the large market of evangelical Christians, mainly in the United States, whose interest in Israeli

archaeology is motivated primarily by a literal interpretation of the Bible. Indeed, the American evangelical movement is interested in holy sites and finds, and there is big business around that interest. The relationship between Israelis and evangelicals is sometimes rather strained, though. Evangelicals tend to place Israel's very existence smack in the middle of an apocalyptic reading of the Bible, which they believe predicts an imminent Rapture (the spontaneous disappearance into heaven of a multitude of Christian believers) once Israel is finally restored to its biblical-era borders. Pat Robertson's plans to build a Christian theme park on the shores of the Galilee were dashed when he publicly attributed Ariel Sharon's devastating stroke to God's revenge for Israeli concessions regarding the return of Gaza to Arab control. Before he made his unfortunate remarks, he was close to signing a $50 million deal with the Israeli Ministry of Tourism. It was hoped that his resort would draw one million Christians a year.

Still, political relations between some American evangelicals—called Christian Zionists—and Israel have warmed in recent years. One of the most currently prominent of these men is Texas-based preacher John Hagee, who ministers to an eighteen-thousand-member flock at Cornerstone Church and has a major television ministry, founded a lobbying group called Christians United for Israel (CUFI) that was able to send three thousand people into congressional offices in one day to urge support for Israel in the 2006 war against Hezbollah in Lebanon. CUFI also actively pushes for war against Iran. Hagee has written numerous bestselling prophecy books, and in one recent tome, *Jerusalem Countdown,* he cited various unnamed Israeli intelligence sources to allege that Iran is producing nuclear "suitcase bombs." War with Iran is a CUFI policy goal. "The coming nuclear showdown with Iran is a certainty," Hagee wrote in the Pentecostal magazine *Charisma.* "Israel and America must confront Iran's

nuclear ability and willingness to destroy Israel with nuclear weap-
ons. For Israel to wait is to risk committing national suicide."

Shanks denies that he deliberately serves and profits by the
Rapture-inclined evangelicals and their fascination with the land of
Israel. In an interview over *rugelach* and black coffee at Morty's Deli
in Washington, Shanks insisted he is about respecting history, not
finding niche markets:

> First of all, I think you have to be very nuanced about evan-
> gelicals. It's like talking about Jews. They're all extremely [dif-
> ferent]. They're like night and day, and the evangelicals are
> that way too. We have many evangelicals who read our maga-
> zine. And many of them don't agree with us. You have some
> that are critical scholars, I mean some wonderful evangeli-
> cal archaeologists in Israel. The real divide is the people who
> want to dig to prove the Bible. We're all against that. The way
> I put it now is we want to illuminate life in the Bible times.
> And we're all for critical scholarship, but some statements in
> the Bible are inaccurate. We don't have to trash it. I believe
> in treating people with respect. Then the next level is, the
> scholars who scoff not only at the people who are proving the
> Bible, but who scoff at the idea of a "relic" as they call it, or a
> "curiosity." I think it's terrible. I think there's a very legitimate
> interest that people have—all people have—in their past.
> And they connect with it.

‡

IT WASN'T UNTIL CNN CALLED that Ganor and the IAA learned
that an object had been found proving the materiality of Christ.
With one phone call, Ganor also learned who it belonged to. He
was furious because just a few weeks before the call from CNN, he

had made a routine visit to Oded Golan's home in Tel Aviv. During that visit, Golan had never mentioned the ossuary that was about to shock the world, the one with the inscription "Ya'akov bar Yosef achui Yeshua."

"He hid the ossuary and showed me three thousand items, properly organized on shelves," Ganor recalled. "It's not at all realistic to expect me to be familiar with all his items."

Ganor knew about the collector by reputation, because Oded Golan's collection was one of the larger ones in Israel, but also because Golan had once himself been under scrutiny by the IAA— some years before Ganor joined the agency. In 1993, the IAA had accused the collector of illegally acquiring objects from a "bronze hoard"—the archaeological term for a heap of tomb treasure found in one place. For some reason the IAA had investigated, but then allowed the collector to keep the valuable objects. Ganor speculated that perhaps Oded Golan had agreed to provide the agency with some other information it wanted. In any case, Golan had not been in further trouble with the IAA until one day two months before the call from CNN, when one of Ganor's informants had watched the collector cross a checkpoint, walk fifty meters in Arab territory, conduct some kind of trade, and then reenter Israeli territory without reporting his new acquisition.

"One of our sources gave us information that some guy came to one of the border blocks between the West Bank and Israel. And the source told us that one of the guys was from Tel Aviv. His name is Oded, and he bought some jars and some other things from the diggers." Intrigued but not in a hurry, Ganor waited until he ran into Golan at Robert Deutsch's semiannual auction in the Dan Hotel in Tel Aviv in September. "I said, 'Shalom, Oded, I hear you have a wonderful collection!' And he asked me to come and visit his home."

A few weeks later, Ganor and a deputy had paid Golan a friendly

visit at his third-floor apartment in Tel Aviv. There, the collector proudly and without any show of nervousness, showed off his vitrines full of small objects, and the collection of larger pieces on an enclosed porch three floors up from a nondescript street near downtown Tel Aviv.

The detective noticed nothing amiss, except for the fact that he found the apartment—which smelled strongly of sweat—uncommonly dirty. "We saw his collection. We sat with him two, three hours. It was very dirty. The smell was not good. But we thought that he was a very nice guy." Golan was gracious, and he showed the authorities his pieces. "He told us about the market and his connections inside the market, and he was very nice. I asked him what about the things he had bought two weeks before at the checkpoints and he said to me, 'Ah! Those things? This is one of them.'" He was very surprised. But he didn't hide anything. He said, 'OK, OK.'"

But at no time during the visit did Golan mention anything about an ossuary that had so interested Lemaire and Shanks that the American was preparing to write a book, market the object to a Canadian museum, and sell the film rights. On the contrary, Golan downplayed his ossuary collection. Ganor recalled later that he noticed the large collection of ossuaries on the enclosed porch. "He had many beautiful ossuaries. And I asked him, 'You have something with inscriptions?'—because uninscribed ossuaries are so common in Jerusalem that people use them as planters—"and he said to me, 'No, I don't have money to buy that.'"

Back at his office after meeting the collector, Ganor wrote a short summary of the visit and filed it into his computer. "We thought that we might need to deal with him about what he bought from the looters on another day. Not on the same day. We'd prefer to do it in our own time. We often ask and they say, 'You know how it is in the market. Nobody can give us receipts.' And I need evidence to

convict. So this was the first meeting with Oded Golan. He was very charming. And I remember that when we left his apartment, on the way back to Jerusalem, I said to my deputy, 'Listen, he's an interesting guy. He knows everything. Maybe he can help us. He knows the market and all the players. And he was very cooperative.'"

Shortly after Ganor's visit, Golan had asked the IAA for a permit for the temporary export of two ossuaries in order to display them at a congress for Bible scholars in Canada. On his export document, Golan had described the object merely as an ossuary—despite insuring it for a million dollars. "There are thousands of ossuaries, it's nothing unusual," said an IAA official, explaining why no one paid it any mind at the time. In the export request, Golan didn't mention the fact that one of the ossuaries bore an unusual inscription that would almost certainly rock the Christian world. The office that handled such requests granted Golan the shipping permit without alerting Ganor or even paying much attention to the matter because Golan had asked only for a temporary permit, to send an item to a museum, and the IAA usually examines items only when there is a request for permanent export from the country.

Within hours of getting the call from CNN and ascertaining that the newsworthy ossuary belonged to Oded Golan, the detective called the collector and ordered him to show up at the police station in Jaffa, a few miles from his Tel Aviv office, for questioning. Golan "didn't seem surprised," to get the call, and arrived at the station without incident, without a lawyer. He amiably agreed to be videotaped.

"I was there with one of my guys. It was about nine or ten at night," Ganor recalled.

And we asked him about the ossuary. And he tells us, "This was just one of my ossuaries and it's been in my collection from the beginning of the 1970s." He tells us that one

of the scholars came to visit him in his home and "he told me that there is something in this ossuary I had never heard about before." He told us the story that he would tell everybody, that he never knew about the brother of Jesus and all that. And I asked him, "OK, why are you going to send it out?" He said, "I want to send it to a museum in Canada and there is no problem because I got approval." I said "OK, you got approval. There is no problem. But listen, why, when I was visiting your home two or three weeks ago and I asked you specifically if you had something with an inscription, why did you say nothing about it?" He said, "I was afraid of you because I didn't know you. I know [the woman in charge of export licenses], and it was better to speak with her, OK?"

Ganor didn't argue with the collector because he wanted to maintain the delicate balance of fear and reward that helps him police the trade. It made sense for the collector to fear the police, and it also made sense for him to be obscure about his objects. The detective thought maybe the collector was lying about when and where he had acquired the ossuary, but he couldn't prove it on the spot, and the collector seemed to be trying to stay within the law as far as sending the box abroad for exhibit. The last thing on the detective's mind was that the box might be a fake. "We thought only that maybe he bought it from looters, recently, in Jerusalem. So we decided to give him permission to send it to the museum, and while the ossuary was at the museum, we would try to find out more about whether it was stolen from the Jerusalem area, from our territory."

The videotaped interrogation session ended before midnight, and Ganor sent the collector on his way. But before he said his final goodbyes, he decided to ask him about one more object. The object was entirely unrelated to the little bone box, but if real, even more impor-

tant from Ganor's point of view, with implications for the very tenets of the Jewish faith and the claims of the Israeli nation to the city of Jerusalem itself.

⁜

AMIR GANOR'S OFFICE at the Rockefeller Museum is located within one hundred yards of one of the most politically contentious pieces of turf on earth. Nestled behind the high, white walls of the Old City of Jerusalem, its golden dome is visible from high points for miles around, accessible only by passing through a series of armed guard posts, and narrow, shadowy alleys, honeycombed around and beneath with archaeological digs legal and illegal—those who claim the site can't even agree on what it should be called. To religious Jews and Christians, the vast, serene plaza is called the Temple Mount. Muslims call it *Al-Haram al-Qudsi al-Sharif* (the Noble Sanctuary), at the center of which today sits the gold-domed Dome of the Rock, and nearby, the Al Aqsa Mosque, built in the seventh century.

The spot has spiritual significance dating back millennia. The Bible says Solomon built a temple here, its walls lined with gold, and deep inside it made a room for the Ark of the Covenant, a box containing the stone tablets on which were written the Ten Commandments, believed to be the Hebrew God's actual instructions to mankind, delivered to Moses. The Babylonians destroyed the First Temple and the fate of the ark has been a mystery ever since. The Second Temple was a holy place of worship for the ancient Jewish people until the Romans destroyed it in 63 CE. The Temple was never rebuilt. For several hundred years, there was a Byzantine Christian place of worship on the site. In 637 CE, the Muslims captured it and built the Al Aqsa Mosque. Muslims now consider the site their third-holiest place after Mecca and Medina.

Inside the dome is a rock, believed by Muslims to be the pre-

cise spot from which Muhammad ascended to heaven. Jews call the same spot the Holy of Holies, the holiest place on earth. There is an inscription in mosaic frieze on its inner walls with what is considered to be the oldest citation from the Koran. "Bless your envoy and your servant Jesus son of Mary and peace upon him on the day of birth and on the day of death and on the day he is raised up again. It is a word of truth in which they doubt. It is not for God to take a son. Glory be to him! When he decrees a thing he only says be and it is."

In 1967, when the Israelis captured East Jerusalem from the Palestinians, a great wall below the western edge of the plaza became a religious site. It had been blocked by houses, which the Israelis removed. Observant male Jews can be seen at this site day and night, praying at the base of the stone wall believed to be the last remains of the Temple. Women are cordoned off a slight distance, also praying.

Some apocalyptic Christians believe that when the Jewish people regain the Temple Mount, Christ will return to earth. To hasten this event, extremists have actively attempted to destroy the mosque. In 1969, for example, an Australian Christian tourist set fire to one end of the mosque, and later admitted he was hoping to hasten the return of the Messiah. He was hospitalized in a mental institution, found to be insane, and was later deported from Israel. In September 2000, Israeli leader Ariel Sharon sparked the second "intifada" or Palestinian uprising, by leading a phalanx of security guards onto the Temple grounds. Israeli authorities have waged a continuous low-grade defensive battle with a group of right-wing Jews called Gush Emunim Underground, who want to blow up the mosque.

The contentious site is technically under the control and care of the Waqf, a Muslim foundation that administers holy sites. Even educated Palestinians now contend there was never a temple at the site, a canard guaranteed to infuriate Israelis. In the past forty years of uneasily shared control of East Jerusalem, Palestinians have

accused Israelis of weakening the structural fortifications beneath the mosque during secret archaeological excavations. Israelis accuse the Waqf of irresponsible digging during repairs and improvements to the site that have destroyed religious artifacts important to Jews.

There is no acknowledged digging under way beneath the Temple Mount, although religious Jews and Israeli scholars alike believe that there could be evidence in the dirt that could prove aspects of biblical stories, including the existence of Solomon's—a.k.a. the First— Temple. The absence of such proof, and the eagerness of groups to get their hands on it, is a significant issue for religious extremists and Israeli nationalists, as well as Palestinians, who want to make East Jerusalem their eventual national capital.

For Amir Ganor, and the rest of the Israel Antiquities Authority, anything having to do with the archaeology of the Temple Mount is fraught with tension, and therefore handled with extreme diplomacy. The IAA works with the Waqf to make sure that repairs to the site are carried out with sensitivity to the possibility that just two feet below ground level might be found objects that are deeply important to religious Jews and Christians, but also keeping in mind the needs of the Waqf when it comes to serving millions of Muslim faithful who visit the holy site for their own religious observances. They walk a fine line in this duty. Too much cooperation with the Waqf and the IAA is accused of appeasing the Muslims, but taking a hard line with the Waqf only adds fuel to Palestinian charges of heavy-handedness.

For some months before CNN called Amir Ganor, he and his staff of twelve and their informants in the antiquities market had been picking up rumors about an extremely significant find having to do with Solomon's Temple. "There was something that we had been working on, since 2001. We had heard about a tablet, a stone with inscription that someone supposedly found in the Temple Mount was in the market." The word on the street was that someone was

asking $4 million for the tablet. The price alone would have been enough to interest the IAA, but the fact that it also had enormous potential political and theological significance—since no archaeology has ever corroborated the existence of Solomon's Temple—made the investigators extremely curious.

After questioning him about the ossuary, Ganor dismissed the collector, but he threw out a question as an afterthought. He had been rather nice to Oded Golan, and perhaps, just perhaps, the collector would be willing to trade a little information in return. It never hurt to ask. The detective decided to see what Oded Golan had heard about a First Temple tablet. "It had nothing to do with him. We had collected information on it, and his name never came up. So at the end of this interrogation, I asked him, 'Have you heard something about a tablet from the time of the Iron Age?' And he says to me, 'Yes, I heard something, but I don't know anything else.' And we sent him on his way and the ossuary was taken to Canada, and became famous."

At the Jaffa police station that night, Amir Ganor's intuition told him Golan was lying about the source of the ossuary. He opened an official investigation a few months later, in January 2003, as to whether the box had been stolen or otherwise illegally acquired. But before he could get too deeply involved in tracing the real source of the now-famous bone box, he was distracted by something more urgent.

In January 2003, an Israeli journalist named Nadav Shragai published an article in the daily *Ha'aretz*, about an extremely significant unprovenanced archaeological object, circulating on the antiquities marketplace in Israel. The object was said to have been found in a heap of debris dumped outside the Old City walls by the Waqf during some illegal excavation of the Temple Mount. The object was a sandstone tablet, which geologists had examined and dated to the Iron Age. Curiously, it was also found to be flecked with real gold

and even more amazingly, it contained sixteen lines of an inscription in ancient Phoenician script seeming to confirm a specific passage in the Old Testament describing repairs on Solomon's Temple. The sixteen lines were remarkably similar to phrases in 2 Kings 12:

> *And they gave the money, being told, into the hands of them that did the work, that had the oversight of the house of the LORD: and they laid it out to the carpenters and builders, that wrought upon the house of the LORD, And to masons, and hewers of stone, and to buy timber and hewed stone to repair the breaches of the house of the LORD, and for all that was laid out for the house to repair it. Howbeit there were not made for the house of the LORD bowls of silver, snuffers, basons, trumpets, any vessels of gold, or vessels of silver, of the money that was brought into the house of the LORD: But they gave that to the workmen, and repaired therewith the house of the LORD.*

The mystery tablet described King Jehoash's orders to "buy quarry stones and timber and copper and labor to carry out the duty with the faith" in repairing the Temple. The tablet was shrouded in secrecy, and the reporter did little to pierce it. He did not identify the tablet's owner, nor explain where it was being held. He noted that the Israel Museum had been allowed to look at it, but the museum had refused comment. The reporter also quoted an official of the Geological Survey of Israel as saying that he had seen the tablet, and that the gold flecks burned into it suggested that it may actually have been part of Solomon's Temple itself. His reasoning was that the burning of the site by the Babylonians, as described in the Bible, would have melted the gold walls and caused gold to embed in the stones of the rubble. One Israeli archaeologist who was aligned with religious excavations over the years, Gabriel Barkai, told the newspaper that it was

too early to tell, but that if real, the tablet would be "the most signifi-cant archaeological finding yet in Jerusalem and the Land of Israel."

The news article did not go unnoticed at the IAA. On the con-trary, it entirely refocused the attention of the agency. That morning, Ganor was barely into his first cup of Nescafé when he received a call that the Education Minister —the government agency under which his agency operates—wanted to speak with him. "She [Limor Livnat] called our director and she said, 'What's happened here? There is an important item to Israeli history out there. Where is it? I want it on my table! Shake every tree!'" Meanwhile, scholars around Israel were beginning to publicly opine on the subject, and right-wing religious groups eager to claim the Temple Mount for Israel were making statements. "Scholars were saying this is the most important thing ever discovered, the state must find it. Must buy it. Members of the Knesset went to the head of the police in Jerusalem, and asked for an investigation to find it. So my director, Shuka Dorfman, tells me, 'Amir, you must find the stone.' And now it's gone from a four to a ten on the level of importance."

Ganor rounded up his staff and formed a task force. They set aside the next two months to devote themselves to locating the tablet and its owner. All hands on deck, all confidential sources to be con-tacted, every dealer pressured and grilled. Ganor himself called the *Ha'aretz* reporter first. No luck. "The problem with reporters is that they do not cooperate," he said.

In the frenzy of that hour, with the minister breathing down his neck, it was easy to lay aside his suspicions about Oded Golan and put questions about the ossuary on the back burner. As he turned his attention to finding the stone tablet in January 2003, the detec-tive had no way of knowing that, in fact, he had already begun to unravel its mystery.

Pieces of God

The incorrigible pilgrims have come in with their pockets full of specimens broken from the ruins ... Heaven protect the Sepulchre when this tribe invades Jerusalem!

—MARK TWAIN, *INNOCENTS ABROAD*

HE WESTERN PILGRIMS made their way to the Garden Tomb on Nablus Road in East Jerusalem, walking past the Arab bus station. It was October 2007, Ramadan, and the road was thronged with fasting women in black headscarves and ankle-length polyester coats shopping for the evening feast. A jolly, middle-aged British tour guide with a name badge on his suit—Dave Howell—opened a high metal gate and greeted the Christians at the stone wall separating his placid domain from the teeming street.

The pilgrims were white, Christian, many over age fifty, with the time and resources to finally visit a part of the world they had been learning about every Sunday for many years. The small park known as the Garden Tomb is a pleasant oasis of peace and serenity in the heart of Arab Jerusalem. But its benches, gravel paths, and verdant foliage behind high white walls are not intended simply to give travelers respite from the grit and grime of the Oriental city. The Garden

Tomb is a religious archaeological site, "discovered" in the nine-teenth century by British Protestants trying to buttress God's word with facts on the ground. In claiming that they had found Christ's actual Crucifixion and burial place, the Victorian Protestants were challenging a much older—Roman Catholic—tradition, that still survives and attracts millions of visitors to this day. Constantine's mother, Helena, claimed she located the Crucifixion and burial site of Christ at a spot now enshrined within the Church of the Holy Sep-ulchre inside the Old City. But the Victorian explorers found a new and better candidate, based on proof.

Dave Howell is one of a team of Christian volunteers from England who cycle in and out of Jerusalem for months at a time guiding tours of this hallowed spot. He led the pilgrims along a pleasant, tree-and-flower-lined path, to a rock promontory set with benches and a per-gola roof. Seated on the benches, the pilgrims faced another cliff, about fifty meters away. Below was a cement expanse, filled with screaming kids and belching buses, a corner of the Arab bus station. A green minaret rose just within view to the east.

Howell advised us to ignore the hurly-burly scene below and focus our attention on the cliff face across from us. And indeed, he said, it *is* a face. Or, to be exact, a skull. "See there. There is a natural set of hollows and lumps that look like two eye sockets and a nose. And when the sun shines on the white rock face in midday, the eye sockets get even darker."

He was right, and once he had pointed it out, the resemblance was striking. It was also as random as passing clouds that suddenly look exactly like Elmer Fudd chasing Bugs Bunny. But the hint of a skull in the rock face was crucial evidence for nineteenth-century Bible explorers because the Bible says that Golgotha, or Calgary, where Christ perished on the cross, was marked by a dead man's head. The proximity of this cliff to the walls of Old Jerusalem was

also key evidence. "The Bible says Jesus died right outside of the Old City," Howell said. "We know he was never crucified *in* the city. Scripture says he died right outside a city gate. Well, Damascus Gate was the main entrance gate two thousand years ago." He paused for emphasis, then continued in a low, persuasive voice. "Jesus died right alongside this road. The first Christian martyr was probably stoned to death right down there at the bus station."

Howell then led us through the details of the Crucifixion itself. He was the first, but not the last, Christian tour guide I encountered in Israel who astonished his audience with gruesomely graphic specifics of how a man dies on a cross, using details gleaned from forensics and modern anatomy. Twenty-first-century science has allowed religious historians to add new color to biblical history. Dating techniques, archaeological stratification, and careful excavation, even forensic science and biology, have not, as one might suspect, *dis*-proven the Bible. On the contrary, the new information now embellishes the old stories. So, standing on the promontory before the skull cliff, Howell proceeded to give a forensic primer, pantomiming the placing of nails diagonally through his own ankles, holding out his arms for nailing at the wrist, and then showing how the crucified man is actually asphyxiated to death, as he or she loses strength to remain upright, and the weight of the twisted torso eventually closes off the windpipe.

"*My* Jesus spent three hours on the cross. He was no wimp," Howell says. "He knew what the punishment would be like, but he still went. That takes courage."

Howell led the pilgrims away from the skull-faced cliff and down a path toward another rock face. On the way we passed an ancient cistern for collecting rainwater, proof that the site once held a garden, as described in the Bible. That fact, coupled with the skull cliff and the nearby rock-cut tomb gave all sufficient evidence to believe this

was the exact spot where Christ died and rose again, Howell said. He ended his tour in front of a wooden door at the entrance to the ancient rock tomb. It is engraved with the words, "He is not here—for he is risen."

The pilgrims took turns entering the cool stone cubbyhole and Howell and I sat on a stone bench to talk. "I was a police officer in England for thirty years, and I like evidence and I found it here," he told me. He said he's not concerned about archaeological differences of opinion on what this site really was. "If we get three archaeologists, we get four different stories. It's not a science. I respect them, but it's just educated guesswork. Archaeologists base their findings on all the things they've seen before. But if you are a Christian you have to go by the Bible."

<div align="center">⁜</div>

THE GARDEN TOMB belongs to a large and growing list of Holy Land shrines that have attracted the faithful to Jerusalem and its environs for centuries. Helena is usually credited as the first Christian relic hunter. In addition to locating Christ's birthplace and Crucifixion site, she sailed back to Byzantium with bits of the true cross. For centuries after that, European pilgrims—immortalized by Chaucer with his Wife of Bath and her merry band—made the arduous overland trek from Europe to the scene of Christ's birth, life, and death, bringing back to the reliquaries of Europe enough saintly tibia, or shrunken heads of John the Baptist, or pieces of the true cross, to fill dozens of reliquaries and piece together many corpses. The Shroud of Turin, with its ghostly impression of a crucified man, is only one of the more famous objects in this long and rich tradition. Discovered in the sixteenth century, it continues to provoke reverence and debate to this day. In 1988, radiocarbon tests dated the cloth at 1260 to 1390 CE. An American scientist from Los Alamos National

Laboratory recently calculated that the shroud is thirteen hundred to three thousand years old and could easily date from Christ's era, while other experts have speculated that a medieval forger probably used glass, paint, and an old piece of linen to produce Christ's alleged burial cloth.

But the desire for physical proof of biblical stories has grown in recent years, and the number of such finds has increased as well. The pace of excavation—legal and illegal—in the region has increased exponentially since the Six Day War in 1967, when Israel annexed large amounts of previously Arab territory. The West Bank contains numerous sites identified in the Old Testament as ancient Israelite settlements. Some of the finds are debunked immediately, while others, quite real and important for the historical record, but not directly bolstering the Bible, have been ignored in all but the most arcane academic journals. One reason an object like the James Ossuary was greeted like a rock star in Canada is that believers are more hungry for material proof now than ever before. In *Christianity Today,* shortly after the James Ossuary was unveiled, Shanks's cowriter Ben Witherington wrote, "We live in a Jesus-haunted culture, yet it is also one that is largely biblically illiterate. Furthermore, we live in a culture of increasingly visual learners who nonetheless are largely skeptical about biblical faith. Their spiritual birth certificates seem to be from Missouri. They demand, 'Show me.' Well, perhaps in the fullness of time and at the cusp of a new millennium, God has seen fit to make the Word visible once more in the form of an ossuary."

✛

ARCHAEOLOGY, the scholarly science that interprets artifacts, is a relatively new field. In the eighteenth century, wealthy European antiquarians were more akin to site plunderers than scientists, collecting barely understood objects and bringing them home to put

in their curiosity cabinets. Archaeology as we understand it dates to the early nineteenth century and the discovery and decipherment of the Rosetta Stone, which unlocked the secrets of the ancient Egyptian civilization. By the mid-nineteenth century, German teams began systematically excavating and photographing ancient Greek sites in the Mediterranean islands, and other teams followed suit in other locations around the world. Only in the twentieth century did archaeology become a real academic discipline, with a defined methodology, scholarly journals, and university departments. New technology and scholarship continue to improve its capabilities to date and interpret ancient objects, but the field is still relatively imprecise, leaving openings for debate.

These debates are especially pitched when it comes to objects that resonate with the faithful. Biblical archaeology, an offshoot of the field of archaeology, was developed in the nineteenth century by Europeans digging in what is now Israel, Jordan, and the occupied territories, looking for proof of the Bible. The British Palestine Exploration Fund, founded in London in 1865, was one of the earliest organized attempts to map the archaeology of what was then Palestine, and the founders expressly acknowledged the biblical element: "So long as a square mile in Palestine remains unsurveyed, so long as a mound of ruins in any part, especially in any part consecrated by Biblical history, remains unexcavated, the call of scientific investigation, and we may add, the grand curiosity of Christendom, remains unsatisfied."

This early archaeological work in Israel set the tone for future digs. Although many archaeologists now working in Israel are not faith based, many of them are still interested in testing the Bible's account of history against the archaeological record. The debate between these two factions has over the years grown more heated. All over Israel and in other parts of the Middle East, archaeologists are at work digging up new objects—shards of pottery, ancient seals,

limestone bone boxes, and even whole cities—that can be used to prove or disprove biblical stories.

Of the great biblical archaeological finds, the public is most familiar with a major discovery in 1947, when Bedouin shepherds in what was then Jordan accidentally found manuscripts in jars in a series of high desert caves above the Dead Sea. Eventually hundreds of fragments were found, and together they are known as the Dead Sea Scrolls. As with so many important Holy Land discoveries in recent years, the story of that major find also coincided with a cataclysmic political event: an Israeli archaeologist purchased some of the scrolls literally the day before the United Nations formally recognized the state of Israel in 1948.

The scrolls, written two thousand years ago on leather and copper by a mysterious, ascetic, desert-dwelling sect, gave modernity a trove of information about the ancient Jewish world around the time of Christ, which is still being deciphered and provoking arguments. Some of the scrolls are simply handwritten copies of Old Testament books, but others relate to daily life in the sect, and offer evidence of how people practiced religion in what was then called Judea, at the dawn of the first millennium. They are the first and by far the largest modern-era discovery of texts from the biblical era. They quickly became a public sensation, known far beyond the arcane scholarly circles at the Albright Institute and the Ecole Biblique in Jerusalem, where the primary work of translation was happening. The twentieth-century American literary critic and author Edmund Wilson wrote a book about them. Public fascination with them has never really abated. Some of the scrolls are on public display in a separate and secure underground building near the Israel Museum in a monumental space called the Shrine of the Book. The climate-controlled grotto is designed to sink deeper into the ground and be locked under layers of metal in the event of war.

The scrolls also set off currents that ripple through the world of archaeology today. Because they were discovered "in the market" as opposed to in situ, dealers and scholars who work with unprovenanced ancient materials always point to the scrolls as the prime example of why scholars should not ignore ancient inscriptions that have been bought and sold, rather than found in controlled excavations.

<p style="text-align:center">✢</p>

TO THE UNTRAINED EYE, the thirty thousand Holy Land archaeological sites look like nothing more than dusty heaps of rock even if they have been excavated, and if not, mere hills—*tels* in local parlance—covered with grass or a new modern city, that if sliced open vertically would reveal layers of pottery and ruined walls indicating ancient human habitation. There is very little in this region to awe the eye like the ancient Roman, Greek, or Egyptian remains, with their soaring columns, graceful statuary, and treasure-filled tombs. The ruins in Israel, which archaeologists group together under the title Syro-Palestinian sites, attest to a relatively poor agrarian society, not as wealthy or culturally advanced as the greater powers to the north or the south that kept attacking it, but with a strong and identifiable religious practice that we recognize today as the basis of modern Judaism and Christianity. Because of that connection, every site here has the potential to move individuals to fall to their knees, weep, kiss the stones, wipe away tears of joy, sorrow, exhilaration, because their faith, the unproven story on which they stake both life and death, has been confirmed and refreshed. In extreme cases, the experience is even psychologically problematic. Whole chapters have been written in texts about a mania— called "Jerusalem syndrome"—that manifests in some pilgrims to the Holy Land and that requires its sufferers to be temporarily institutionalized.

In the past half century, jet travel has permitted easier access to

Jerusalem and its environs for Christians. Technological advances, especially in forensics and geological dating, have improved analysis and excavation. Rapid construction in Israel itself with digging for roads and homes, has turned over more soil. And Palestinians desperate to supplement their blockaded economy are turning to illegal backyard treasure hunting. All this means more spectacular discoveries have been pulled up from under the crust of earth known as Israel and the Palestinian territories.

Biblical archaeology is still just a branch of an otherwise dirty, tedious, and technical science practiced by patient people who feel rewarded by arcane, literally tiny new discoveries. But in it there is an unusual alliance between secular researchers and people of faith seeking proof. Organizations such as the Israel Exploration Society and numerous Christian evangelical groups, including the Seventh-Day Adventists, have plunged into this trove of history. Major universities also unearth what might be considered religious relics, although some Christian groups criticize the scholarly fieldwork for its secular nature—and vice versa.

Among Holy Land diggers, there is a long and proud tradition of religious "Indiana Joneses" who leave the pastoral safety of their parsonages in rural Texas or Tennessee and, with wallets bulging from targeted collections, head over to the Holy Land to do their own digging. Men regularly claim to find the Ark of the Covenant, Noah's Ark, and more obscure, biblically referenced materials such as the DNA of the blood of the red heifer supposedly sacrificed in ancient Jewish tradition. Fast on the heels of these men (who never entirely sever their ties with home, but now use the Internet instead of the old-fashioned church collection plate to finance their work) are the big-time Bible archaeology impresarios, including Hershel Shanks, whose Biblical Archaeology Society has earned millions through the magazine and related products—books, seminars, inter-

national tours guided by scholars—since the 1970s. Recently, even bigger media powerhouses have jumped in. *Titanic* producer James Cameron threw his Hollywood heft and cash behind a television documentary in 2007 that is perhaps the biggest biblical archaeology extravaganza in recent years. Cameron financed filmmaker Simcha Jacobovici, the same Canadian journalist who bought the exclusive rights to the James Ossuary from Shanks a few years prior, to make *The Lost Tomb of Jesus.* The documentary was introduced to the press with great fanfare in the secular church of New York City's Public Library. The producers claimed to have found the actual tomb of Jesus and his family, containing six ossuaries that once held the bones of his family in a cave near Jerusalem. Based on names scratched into the bone boxes, the film contends that one of the ossuaries contains the bones of Jesus and Mary Magdalene's son, Yehuda bar Yeshua, and that the James Ossuary itself was probably looted from this very tomb.

Leading archaeologists in Israel and the United States quickly debunked the claims, although a small and vocal minority continued to support the theory. Cameron's film was aired by the Discovery Channel and the accompanying book sold briskly—until a critical mass of scholars scoffed that any DNA samples found in the ossuaries most likely belonged to the archaeologists who initially excavated them, and that the names Jesus, Mary, and Joseph were so common during Christ's lifetime as to make the fact that ossuaries were found together statistically meaningless.

Israeli forensic pathologist Joe Zias could be said to be suffering from the opposite of Jerusalem syndrome. Zias, an American born in Michigan who emigrated to Israel in the 1960s, was one of the first and most persistent critics of Cameron's film. He once worked for the Israel Antiquities Authority as an enforcer. A tanned, fit, mountain-biking, self-described atheist in his midsixties with a snowy white

mustache, Zias would not deny that he is obsessed with ferreting out and exposing the myriad shady characters digging in the Holy Land, whom he calls "ark-eologists." Among his frequent targets has been Hershel Shanks (whom he accuses of "pimping off the Bible"), but he has also gone after a variety of university-affiliated American and Israeli archaeologists whose analyses of discoveries seem to him to veer a bit too far off into the land of theological wishful thinking. He is almost never without a scam to expose. A Yankee crank living in Jerusalem, fluent in Hebrew, and presentable in Arabic, Zias basically operates as a one-man Holy Land relic fraud-exposure team.

On a balmy June afternoon, Zias invited me to meet him on the steps of the Church of the Holy Sepulchre in the Old City, where he had some business to attend to. He was on a roll that day because the Associated Press had just disseminated worldwide his analysis of some bones found on the top of Masada—a massif in the Negev Desert where the Jewish Zealots famously held out against the Roman Empire until committing mass suicide. Masada is so central to the national legend of the modern state of Israel that the Israeli Army has been sworn in at its peak for decades, shouting "Masada will not fall again!" The bones found at the top, Zias wrote, are not Jewish but Roman. He titled his article "Skeletons with Multiple Personality Disorders."

When I arrived at the church steps, Zias was already waiting and eager to show me something. Navigating through the throng of hymn-singing pilgrims of all races and Christian creeds, we reached the entrance to the church. Five African women in white robes were kneeling, bent over on a stone slab said to have been used to prepare Christ's body for burial. They made for an interesting sight from the rear, with their knees under their chests and butts high in the air. They were quivering and praying and one of them was so moved that she rolled her entire body onto the slab and lay face-

down, hugging it and shaking. "Uh-oh. They're going to stop that, watch," Zias warned. As predicted, one of the gray-bearded Greek Orthodox priests who share care of the church with brothers from Egyptian, Armenian, and Ethiopian Christian sects, glided over in black robe and towering headgear and gently asked the women to get off the stone. Smiling and visibly spent but clearly ecstatic, the women meekly obliged.

Just another day in Jerusalem would be Zias's take on that scene. He pointed out that the stone itself was a nineteenth-century addition to the church, unlikely to have been quarried when Christ died.

As we pondered the scene, Zias shared another piece of local lore, involving the warring sects that care for the holy site. High on one edge of the building, a ladder connected a window to a roof deck. Zias said the ladder dated to a nineteenth-century feud between the Armenian and the Greek brothers. The Greeks controlled the first floor, and the Armenians controlled the second. The Greeks decided to lock the downstairs door, so the Armenians installed the ladder and a rope to send a bucket to ground level for food. On the roof itself, Zias claims a fight once broke out between the Egyptians and the Ethiopians, when the shadow of one sect's chair fell across the turf of the other's.

On this particular morning, Zias was in the Old City on a mission. His goal today was to prove that a cave recently verified by two prominent archaeologists as the Cave of John the Baptist (placing it firmly on the lucrative tour-bus circuit) was in fact, not John's cave at all. Graffiti in the cave shows a primitively drawn figure of a man and two animals. Some archaeologists had interpreted the animals as sheep, and the man as John the Baptist. Zias, however, had a different interpretation. He believes the animals are dogs. "See, they have tails and pointy ears!" he said, waving a Xerox of the graffiti

in front of me. He thinks the man next to them is in fact a leper with two dogs following him and licking at his seeping wounds. Zias contends the cave is not John the Baptist's at all, but perhaps a grotto holy to the sick dating to the Crusader era. He thinks the figure is Lazarus, patron saint of lepers. And he was headed into the Old City that day to test his theory on an unsuspecting audience—a nunnery on the Via Dolorosa where the Sisters of Veronica are expert in re-creating Byzantine icons for sale. If anyone would know whether there was ever an icon of dogs licking a man's wounds to represent Lazarus, the sisters would.

Zias was anxious to get his theory out, as one more bullet with which to pierce the moneymaking juggernaut of the relic finders, and those heretical scientists who he thinks ought to be shamed out of the academy for using their skills to validate the unprovable. "No one will come to see the patron saint of the leper's cave," he opined. "But you *will* get visitors to John the Baptist's cave."

A bewildered Sister of Veronica answered the door at the sixth Station of the cross and ushered us down some stairs to a minuscule, rock-walled, underground chapel dating back at least fifteen hundred years. Apparently this is the sisters' conference room. Austrian and with limited English, the nun listened politely to Zias, and then said she had never heard of an icon to the patron saint of lepers. He left her with his card, telling her that if she happened to come across one or could ask the other sisters as well, he'd be ever so grateful.

Back on the street, we walked under the Ecce Homo arch, which, said Zias, "has nothing at all to do with Jesus." We passed the shuttered shop of an Arab dealer named Mahmoud, who supposedly sold the James Ossuary to Oded Golan, before moving to an obscure village in Germany, out of reach of the press. We went back to the Austrian hospice for a coffee in the elegant, columned garden café, nestled behind a high, garbage-strewn stone wall. There, Zias talked

about the "dossier" he has been compiling of archaeologists who feed the beast of marketable religious proof.

Among his list of villains that morning were some American scholars and theologians, who he says actively conspire to find and profit by theological sites like John the Baptist's cave. He was especially critical of a University of North Carolina archaeologist named James Tabor, who authenticated the so-called Jesus Tomb and John the Baptist's alleged cave. He believes Tabor, Hershel Shanks, and Simcha Jacobovici are behind much of the current crop of biblical hype.

Zias saved his greatest scorn for some lesser-known characters who have used small-town church funding to go a-digging in Israel, with remarkable results. Ron Wyatt, who was trained as a nurse and who died in the early 1990s, claimed to have discovered the blood of Jesus and the Ark of the Covenant. He and his followers in Wyatt Archaeological Research eventually opened a museum for their finds called the Museum of God's Treasures. Its first home was a gas station in Gatlinburg, according to Zias.

In 2006, Bob Cornuke, a former SWAT team member turned biblical investigator—and now president of the Bible Archaeology Search and Exploration (BASE) Institute in Colorado—led an expedition searching for Noah's Ark. A completely credulous media announced his discovery of boat-shaped rocks at an altitude of thirteen thousand feet on Mount Suleiman in Iran's Elburz mountain range.

Vendyl Jones is a West Texas native who has been digging in Israel since the 1960s and has remade himself into a bearded Orthodox Jew. He drives around in a specially reconfigured "desert limo"— a Cadillac outfitted with four-wheel drive—and bulldozed himself a road to one dig. He is currently at work searching for the ashes of the red heifer, a substance Zias looks forward to analyzing with

great relish. He recently got his hands on an excavated substance that Jones claimed was burnt incense from the Second Temple. "It turned out to be dirt," he said. "But they used it anyway. They have blogs and they get money from Christians."

Zias doesn't have enough time in a day to describe all the outrages, schemes, and fabrications he's seen. In his view, it's a tidal wave of bullshit, and he's the only man with a lifeboat. He can't keep up. He testified in a landmark case in Australia ten years ago, when an Australian geologist sued an American Evangelical who claimed he'd found Noah's Ark. The court ruled against the geologist, apparently on the legal equivalent of caveat emptor. Zias tries, but can barely keep up with the dubious objects and discoveries pouring into the biblical archaeology market. "The Americans are the most gullible for this stuff. Noah's Ark rose again last year, found by another Texan. The same people lie low for a while, then turn up again ten years later."

A skeptic might wonder what's in it for him and why Zias doesn't just leave things be and put in some more time mountain biking in the Galilee. First, he's a physical anthropologist and when diggers loot tombs looking for holy stuff to sell or hype, Zias and his fellow scientists lose their in situ ancient human bones. "While some objects . . . may eventually make their way to the collectors and museums, in thirty-odd years of working in the profession, I and my colleagues have as of yet to see a skeleton from a looted tomb brought to our attention, in fact, not even an unimportant one," he wrote in one article bemoaning the trade in antiquities. "Not only does the history of the Holy Land become destroyed by these illegal excavations, but it is also a total loss to the world of physical anthropology."

Then there's the greed and lying. "We are talking about millions and millions of dollars." Zias said his emotional motivation comes from his boyhood on a hardscrabble farm in southern Michigan.

"They are trying to rewrite history under fraudulent means and that just sort of sends my blood pressure up sky-high. I don't tolerate that kind of stuff. All of us who went to public, state-supported universities, we have an obligation to all those people out there, those taxpayers. My colleagues say, 'Zias, why do you get involved in all that bullshit?' I get involved because I grew up on a farm near Kinderhook, Michigan. We are the people that get suckered into that stuff. My father got suckered into that. My father used to go to séances and all that stuff. It's the people who can least afford it."

Zias started on his dossier of fraudulent religious diggers some years back, after three preachers from the Midwest came to him at the IAA one day and asked him to look into the claims of Ron Wyatt, who was collecting money from their flocks to hunt for signs of biblical life in the Holy Land. "I said, 'Why are you people so upset about this kind of stuff?' And they said, 'Look, we're from small towns. When these people come to the small towns, when they give lectures, it's like the circus. And what happens is, money for the churches is now being siphoned off.' He said, 'This is money going for welfare. This is money for the homeless. This is money going to kids' summer camps.' I mean, I'm sort of antireligious, but the moment someone's taking money from kids' camps, and these small towns, and they're like people that I grew up with! . . . They told me that the money for the church basket doesn't go into the basket anymore. It goes to these redneck hillbilly preachers going around talking about how they found this and this. And I realized right then and there I'm going to start keeping a dossier."

One of the first pieces he collected for his file was after Ron Wyatt called a press conference in Oklahoma, and announced to the world that he'd found the blood of Jesus. "How does he know it's the blood of Jesus?" Zias asked. "Because you know that you have forty-six chromosomes. You've got twenty-three from your mom and twenty-

three from your dad. Well, when Ron Wyatt and his hillbilly did a DNA study, he found out the blood of Jesus only had twenty-four. Got twenty-three from the old lady Mary, and got one from the guy with the long white beard sitting up there on a cloud. Now that's the kind of stuff—you say no one's that dumb. People give these people millions of dollars. So I wrote to Ron Wyatt, said, 'Hey, I happen to work with a group of people that do DNA.' I said, 'I want to see the lab report. I want to know which lab did it, and send me some. We'll go and replicate it.' Well, naturally he didn't get in touch with me. So I then decided to go public with it, and he said, 'I'm not going to talk to Zias, because Zias is an infidel.' "

⁜

TOUR BUSES—HERMETICALLY SEALED, climate-controlled cylinders stocked with bottled water, Purell, defibrillators, and bathrooms with nice sinks—hiss and snort in the parking lot next to the archaeological site in central Israel known as Tel Megiddo. In Hebrew, a tel is technically a hill, but archaeologically the word signifies a hump of earth where ancient cities were built on top of each other, or where one once existed, now covered with centuries of dirt. A trained archaeologist can spot a tel from far off, and once the concept was explained to me, I started noticing tels frequently on my travels around Israel and the Palestinian territories.

Tel Megiddo is one of the most archaeologically rich tels in Israel because of its size and long history as a human settlement, which stretches back thousands of years into the mists of prehistory. Located in the center of a vast and fruitful plain, on a great spring, it was inhabited for millennia. Archaeologists have been excavating the site for over a hundred years. They believe there are at least twenty layers of distinct period settlements stacked atop one another there. Megiddo has historical residue that reveals how the

religion and culture of the region evolved over millennia, how invading forces fought over it, how empires and kingdoms rose and fell.

Megiddo, in ancient Hebrew, is a name that has to do with both water and the military. Located on a trade route, the Via Maris, about halfway between the great Egyptian empire to the south and the great northern empires of the Assyrians, Babylonians, and Hittites, Megiddo was an important trading post, an army base, and a prize in itself with its water source and fruited fields, one of the richest cities in Canaan (prebiblical Israel). Armies fought over it repeatedly, and the immense plain stretching for miles in all directions below the tel was watered with the blood of countless ancient warriors. Even in modern times, the site has played a role in contests for regional control. In World War I, British field marshal Edmund Allenby (after whom the famous bridge linking Jordan and Israel is named) had to rout the last defenders of the Ottoman Empire from the heights of the tel.

Besides that history, or because of it, Megiddo also resonates with religious people as something else: apocalypse, the end of everything. In the New Testament, its name is Armageddon. The "Armageddon" prophecy in the Bible's Book of Revelations describes Megiddo as the blood-soaked battlefield where the forces of good and evil will finally duke it out at the end of the world. The site is so religiously significant that it was chosen as the venue for the historic meeting between Pope Paul VI and the Israeli government leaders in 1964, the first-ever visit of a Pope to the Holy Land.

Megiddo is a standard stop on the religious tours that traverse the Holy Land—hourly, daily, weekly, year-round—hence, the hissing tour buses, massed in the parking lot, disgorging hundreds of pilgrims on a hot October morning. Most of the travelers walk the site with their guide, and on this particular morning, I tagged along with a group of white South African pilgrims—with, I would guess,

an average age of sixty-five—whose tour had already taken them through the Galilee, into Nazareth, dipped into the River Jordan, and was headed to Jerusalem later that afternoon.

There is a political/archaeological dispute about the meaning of some of the finds at Megiddo. The first archaeologists to excavate Megiddo were from the University of Chicago in the 1920s and they had focused on the prebiblical societies whose remains were at the bottom of the tel. Israeli diggers in the 1980s had worked a bit higher on the mound, and uncovered what some archaeologists believed were a type of stable gates and palatial buildings that matched gates and buildings in two large sites in other parts of Israel. The Bible states, in I Kings 9:15, that King Solomon built Megiddo, Hazor, and Gezer and that the city became the center of the so-called United Monarchy that officially brought the people of ancient Israel together as one nation. The Egyptian pharaoh Shishak then destroyed Megiddo around the ninth or tenth century BCE, an event that is corroborated in inscriptions at Karnak and on a stele (inscribed slab) at the site. The so-called Northern Kingdom rebuilt it, only to have it sacked and taken over two hundred years later by the Assyrians. Here also, according to the Bible, Josiah, the King of Judah, was slaughtered by the Egyptians. The Israeli archaeologists dated the newly excavated ruins to the time of King Solomon, and soon they were being used to support the biblical claim that Solomon had in fact managed to create a united monarchy, as described in the Bible.

In the 1990s, a prominent Israeli archaeologist named Israel Finkelstein challenged the biblical interpretation of Megiddo. Finkelstein, head of the Archaeology Department at Tel Aviv University, then cowrote a book, in English, recasting the dates of the ruins at Megiddo to a hundred years later. He also challenged the notion that palatial buildings at Megiddo were Solomon's palaces. In doing so, Finkelstein brought down upon himself the wrath of both biblically

inclined archaeologists who pegged him as having an atheist agenda, and the resentment of Israeli nationalists, who questioned his patriotism. As one Israeli archaeologist explained to me, Finkelstein "gives ammunition to our enemies" and should have restricted himself to expressing his doubts in Hebrew rather than English.

These academic conflicts spill over literally into the dirt. Shlomo Moussaieff gave money to the Megiddo excavations in the early 1990s, explicitly because he was hoping to find evidence there of King Solomon. Secular archaeologist Finkelstein was happy to accept his donations, because one season of digging costs $250,000 and the university can't afford it. Moussaieff donated about $40,000, in separate gifts over time. But the donations came to an abrupt end when the results didn't fit the biblical story.

British-born archaeologist Norma Franklin was a dig leader at the Megiddo site in the 1990s. Under Finkelstein's direction, her team reevaluated certain buildings, which archaeologists in the 1960s had thought to be Solomon's palace. At the time, the antiquities dealer Robert Deutsch was also studying archaeology at Tel Aviv University and had got himself a position on the dig. Deutsch's mere presence in the department, let alone on the site, was controversial, but he had doggedly insisted and the Archaeology Department consented. One day, just before the team was about to leave for the day, because of the heat, Franklin received two esteemed visitors.

"It was about noon, we usually finish work on the tel around one. Suddenly Moussaieff and Lemaire turn up. I think without any hats, without any water—it's July, it's baking hot! Israel is already back at the camp. And they come wandering in asking, 'Where's Israel, where's this and that?' So I said, 'Would you like to go and talk to Robert Deutsch?' I mean I'm busy. I knew Robert and Moussaieff were friendly. So I said, 'OK, I'll take you to Robert's excavation area.' I remember Moussaieff striding up the tel with Lemaire,

singing Deutschland, Deutschland, über alles . . . Because we called Robert's area Deutschland. Totally surreal. Maybe the sun had gotten to him."

Franklin recalled that Moussaieff later asked her, "'How's Solomon's palace coming along?' And very quickly we said, 'This isn't Solomon's. It's Ahab's.' Well, talk about dropping us like a red-hot stone! He just didn't want to know any more. He wanted it to be Solomon's. We said, 'It just isn't! We're not going to say it's Solomon's when it isn't.' So he got very upset with us. He had no time for us anymore, because we weren't producing the goods that he was interested in. I mean, OK, there's a lot of other people like that. For us it's faintly amusing, how people get stuck on their old ideas, or what 'we want it to be, therefore . . .'"

Soon afterward, according to Tel Aviv University sources, Moussaieff stopped donating money to the dig. Later in court testimony, he publicly explained why: He told the judge and lawyers that he went to Megiddo one day prepared to give the dig $300,000, thinking he was going to be shown the library of King Solomon. Instead of being shown the library, Moussaieff testified, Finkelstein showed him ancient stables, which the professor said were identifiable by the phosphates from ancient horse urine. Finkelstein lost the donation though, when, Moussaieff said, he overheard the professor saying Solomon never existed. "'King Solomon never lived,'" Moussaieff quoted Finkelstein. "He didn't say [the library] wasn't there, I didn't find it. . . . Now he denies it, now he says that he said he didn't find it, but I heard exactly. He said he never lived."

This little conflict was on my mind as I followed the tour guide up the tel. And while the guide seemed knowledgeable on archaeological terminology, he either didn't know about or didn't care to share the competing theories with his band of pilgrims. Instead, as we ascended the tel, he described its history entirely in terms of the Bible's

stories. He reminded us that in the New Testament, Jesus stopped at Megiddo while he was walking south on the road from Nazareth, and met a Samaritan lady by the well near Megiddo (the crowd softly mm-hmmm-ed). "The Samaritan—a pagan—doesn't like Jesus and she might have poisoned him but he assumes she won't and she doesn't." The guide then launched into the biblical history of Megiddo, starting with "the time of Solomon, when Megiddo was built up as a large royal city." As we walked, one of the pilgrims pointed to an incline and said, "That's Solomon's ramp." A sign near some ruins suggested that the style of palace remains were similar to Solomon's Palace in Jerusalem.

Eventually, the guide led his group to the peak of the tel, and a covered viewing deck. From this vantage point, the view was immense. The Jezreel Valley, Israel's breadbasket, spread out gloriously almost to the horizon, divided into neat squares of agricultural bounty. The Upper Galilee hills of northern Israel—bordering Hezbollah territory—were visible far beyond the plains. To the east, in the distant haze, was the edge of ancient Persia. The guide pointed out the direction of Iran and then shifted into a cinematic tone of voice, befitting the majesty of the view. "Friends, it happened here!" he announced. "The great fight. Would it be the land of the Philistines [sea people] or the land of Israel? Lucky for us David did battle and it became the land of Israel. Will Armageddon be physical or virtual? Who knows, it's up to the believers. But standing here, in your visionary eyes, you can see the two superpowers, on this great plain."

A member of the group opened a Bible. After prayer, one of the tourists opined to the group, while pointing in the general direction of Iran, "There is no question they are developing into the sons of darkness and the Judeo-Christians are the sons of light."

As the South Africans milled about enjoying the view over the final battlefield, another group of tourists tramped up to Megiddo's

peak and assembled on another viewing deck. One of them held aloft a Bible. "Let us pray," came an American-accented voice. "We don't know how it will end, Lord. It's in your hands. It's a spiritual battle. Jesus said keep a lamp lit. You don't want to be caught without oil in your lamps, my friends."

The Megiddo tour guide I had followed behind was nowhere near as colorful as some who lead the other tens of thousands of Christians pouring out of the buses in the parking lot daily, year-round. "Can you imagine this entire valley filled with blood?" Gary Frazier, the tour leader of Texas-based Discovery Ministries, Inc., said to his traveling flock while a reporter for *Vanity Fair* was along a few years ago. Gary Frazier was riffing off a passage in Revelations that predicts Christ will wreak bloody havoc on his enemies in the end times, so that blood flows out of "the winepress, even unto the horse bridles, by the space of a thousand and six hundred furlongs." With the reporter watching, Frazier, a colleague of the Rapture novelist Tim LaHaye, gestured to the Jezreel Valley below and calculated, "That would be a 200-mile-long river of blood, four and a half feet deep. We've done the math. That's the blood of as many as two and a half billion people."

✢

HAVING ENTERED the Bible science-and-history rabbit hole at Megiddo, and being halfway there geographically anyway, I decided to drive north to another standard stop on the religious tour, the Arabic town of Nazareth, Christ's hometown. There, I had heard of a new sort of biblical archaeology tourism project, similar to Williamsburg, Virginia, where Palestinians in period costume tend sheep and olive groves in exactly the manner of the ancient Jews in Jesus's time. On a hillside in the modern city of Nazareth, Christians from the United States and Europe had created a working replica of Christ's

town—on an actual archaeological site—that would allow pilgrims to get closer to the historical Jesus than ever before. The site was built on donated hospital land and the park opened in 2000. The University of the Holy Land, a nonaccredited institution founded and operated by an American Christian named Steve Pfann, helped create the site, and it is now on the tour bus circuit.

I drove down a steep hill into the main street of Nazareth and then up and around, to the site of Nazareth Village. The entrance fee was 50 shekels—a little more than $10. I arrived just as a group of elderly Canadian pilgrims with maple leaf name tags were following Melissa, a young Palestinian woman with long hair and an orthodontic retainer, carrying a small Bible, into a darkened room containing a life-size diorama of a first-century carpenter's house. Here, she gave a short description of Christ's life and death, replete with the same surprisingly graphic and gruesome forensic facts about how crucifixion really works that I'd heard before. (In her talk, she included the added flourish that thieves broke Christ's legs to quicken his collapse and end his suffering.)

Then we exited and were on a steep hill heading up a path in the midday sun. When my eyes grew accustomed to the glare, I saw that we were walking through an actual olive grove, with actual Palestinians dressed in first-century robes clearing brush, making pottery, operating ancient-style, stone wine presses, and leading small donkeys from place to place. A man with a donkey told me in broken English that he has twelve children and twelve grandchildren. Dressing in period costume and walking around with a donkey for busloads of Western pilgrims is solid work for a Palestinian around these economically barren parts.

Melissa led us up the hill, Bible in hand. "When we read the Bible, we have to ask ourselves what did Jesus mean?" she says. "Back then they didn't have to ask that question. They knew about paths, olives,

soil, wine presses." A semitruck's gears ground noisily in the background, struggling up one of the city's steep hills. The tour ended in a small replica of a first-century synagogue, copied from a real one, Melissa told the Canadians, discovered atop the desert massif Masada. In the synagogue, Melissa turned over the reins to the group's pastor, who pulled out his own Bible to read aloud about Jesus preaching in the synagogue. Melissa and other guides do an average of five to ten tours a day, perhaps more.

⁜

ARCHAEOLOGISTS WHO DIG IN ISRAEL or analyze the material found in its soil operate in an intellectual zone much different from that of the Bible-toting tour guides at Nazareth and Megiddo. But the fruits of their scholarly labors often do get repackaged for religious consumption, with embellishments or omissions where science doesn't precisely confirm scripture. The forensic details of crucifixion, or the claim that Solomon built palaces at Megiddo, could not have entered the guides' speeches without the initial work of scholars.

Archaeologists have different attitudes toward such use of their work. Many are bemused and simply ignore it. Others actively involve themselves in the marketing of their finds to the religious and lay public. Many respected scholars in the field are not above taking all-expenses-paid trips to Jerusalem, Tel Aviv, Cypress, or even Vegas and Fort Lauderdale, to instruct laypersons who have paid Shanks's BAS thousands for "seminars" on every aspect of biblical archaeology, from the Dead Sea Scrolls to how wine and olive oil were made in Christ's lifetime. And then there are those who resist any interaction at all between theology and archaeology.

Archaeologists who work in Israel have divided into three general camps—those who believe the Bible is factual, those who believe it has some historical accuracy, and those who deny any connection

between the facts on the ground and the Hebrew Bible. An arch-skeptical faction—known as revisionists or "minimalists" and based in England and Denmark—promotes the notion that most of the Old Testament is politically motivated fiction, and the great Hebrew kings David and Solomon are inventions. Among the latter crew are Niels Peter Lemche and Thomas Thompson of the University of Copenhagen. Their stand is unpopular, but they persevere, they say, because of growing demands for historical proof. "The public, that is, people not members of the fraternity of biblical scholars, are still mainly interested in history," Lemche has said. "Did it happen as written, or did it not happen? That is the question most often asked when talking to an audience of laypersons."

Because of the evolving science of dating methods, the difficulty in conclusively interpreting the meaning of objects and script, and the obscurity of Bible stories, scholars can theoretically argue over Bible-related discoveries for years. An extreme example is the disagreement over the biblical city of Cana in Israel, where the Gospel of John says Jesus performed his first miracle by turning water into wine. Israeli diggers have unearthed the remains of buildings, a Jewish purification bath, and pieces of large stone jars of the kind mentioned in the biblical account of the wedding feast at Cana near the modern-day Arab town of Cana. Meanwhile, a group of American archaeologists countered that they had discovered Cana several miles to the north of the Israelis' excavation. A British archaeologist then announced that his team had uncovered proof of ancient Cana in yet a different location, casting doubt on both the Israeli and American digs.

Besides the outside political and theological pressures they face, archaeologists working in Israel are also confronted with a basic problematic fact of regional ancient history: the ancients who lived in what we now think of as the Holy Land left very little in the form

of durable inscriptions. Thus, finding objects with actual writing on them is rare and can make an archaeologist's lifetime reputation. In the course of my research I met more than one archaeologist who had devoted his entire life work to analyzing and interpreting a single inscription, and its site.

<center>⊹</center>

SEEKING A REAL-LIFE INDIANA JONES, one could do worse than visit Seymour Gitin, a burly, white-haired scholar, in his book-lined office at the Albright Institute on Salah Ed-din Street in the heart of Arab East Jerusalem. Born and raised in Buffalo, New York, Gitin has devoted his adult life to digging in Israel, analyzing the finds, and over-seeing the publication of new historical information based on objects poked, prodded, and pried out of Holy Land soil, then reconstructed and examined and discussed in arcane journals for years. Now in his seventies, Gitin is married and has raised his two children in Israel. Six or seven days a week, he dons his uniform of suspenders, oxford cloth shirt, and generously cut khakis, and starts his day with a cup of tea and the *International Herald Tribune* in the courtyard of the insti-tute, a nearly hundred-year-old complex designed in Oriental style, with cypress trees and a fountain in the center. The Albright Institute is one of several institutions, sited around the Mediterranean and in the Middle East, that offer fellowships and resources to archaeolo-gists under an umbrella organization called the American Schools of Oriental Research, or ASOR, whose members include archaeologists, paleographers (scholars of ancient writing), epigraphers, and others who primarily work with ancient Near Eastern archaeology. Over the years, the vicissitudes of regional politics and anti-American senti-ment have given ASOR a few problems. They had to close their office in Baghdad in 1989 and never reopened. But the Albright remains an American institution situated in Arab East Jerusalem, employing

Palestinian cooks, cleaners, and secretaries, many of whom have an increasingly difficult time making their way into Jerusalem because of checkpoints, walls, and roadblocks.

The Albright was built in the 1920s under the direction of American pastor and archaeologist William Foxwell Albright for the American Schools for Oriental Research. Albright was one of the most accomplished scholars in the group of religious excavators who dug in Israel in the late nineteenth and early twentieth centuries, seeking proof of Bible stories. Over the years, the religious underpinning of the endeavor fell away and the Albright now serves as a headquarters and logistical support center for archaeologists working in the region. "Albrightians," as the denizens of the institute call themselves, were responsible for the publication of some of the Dead Sea Scrolls, among other groundbreaking archaeological work.

Gitin signed on as head of the institute in 1980, and his greatest work was heading fourteen "seasons" or summers, beginning in 1981, of excavation at a site thirty-five miles south of Jerusalem called Tel Miqne, the site of a biblical city called Ekron, one of five ancient Philistine cities (Gaza and Ashkelon are the modern-day remains of two of them). After ten years of digging, Gitin's patience and hard work paid off with a spectacular find of a lifetime: the first Philistine inscription ever found in Israel. In 1996, Gitin's team unearthed an inscribed rock, the dig's greatest discovery, the so-called Tel Miqne inscription. In Phoenician—a language very similar to ancient Hebrew—the five lines on the rock refer to a king named Akish, who was building a temple to a god. A so-called building inscription, the rock was similar to others found in the ruins of temples around the region. Akish is mentioned in the Bible and in Syrian inscriptions from the same period. So Gitin's find corroborated biblical history.

On a bright October morning in 2006, I sat down with Gitin in his office at the Albright to talk about the basics of archaeology

in Israel, including the desire among the faithful that secular diggers find physical proof that corroborates text from the Bible. Gitin acknowledged that the Albright Institute has accepted funding and resources from theological organizations and individuals, but he was adamant that such interaction did not tilt the focus of the projects toward proving a literal interpretation of the Bible.

"I think in terms of financing [digs], you will find schools in the United States that are religious, like maybe a Jewish seminary or a Baptist school. But joint projects with the Albright can in no way be called theologically based in terms of project research, design, and funding. It did have from time to time supporters that were theological."

"There are people who come who are students of the seminary, but it's not like in the twenties or thirties, when money was raised, sometimes in America, with [the mandate], 'Let's get at the facts of the Bible.' I don't think that's the case now. In just about every age of excavation, I'm sure there's some theological seminary that supports them, but to a minor degree. These are basically secular excavations in terms of their approach."

Gitin acknowledged that the public desire for proof was a powerful incentive for forgers or simply extravagant, wishful interpretations by scholars. "If I were a dealer or a thief I would say, 'My God, this is a wonderful opportunity!' I'm sure there are people, fundamentalists out there or people in general, collectors in general, who would buy all these materials. I know that whenever we find something, even though we know it's in a sealed context and there can be absolutely no question about it, we talk to a paleographer, and the first question asked is, 'Are you absolutely sure this is in a sealed context, etcetera?' I mean, we've been burned so many times, with inscriptions."

To protect his excavation from looters or people who might have

wanted to put a forgery in the ground, Gitin made sure that the Tel Miqne excavation was always guarded. On the day the team found the inscription, Gitin cleared the entire excavation and sealed the area where the rock was discovered, to ensure that no looters removed any surrounding objects that might muddy the historical record. No speck of dirt was too insignificant to be analyzed and recorded. Even with such care, Gitin had to fend off early charges that the inscription was fake, because one of the fundamental signs of a fake in ancient Near Eastern archaeology (in fact, in all art) is something that seems "too perfect." For Gitin to have discovered an inscribed object that perfectly aligned with biblical and other ancient sources, and to have protected the record that proves its authenticity is something unique in the business, and constitutes a lifetime achievement.

⁜

AFTER TALKING TO SY GITIN, I decided I needed to see an actual excavation in progress. In June 2007, one of the Albrightians, an American archaeologist doing research in Israel, kindly let me tag along with him to meet with an archaeologist working in the Galilee. We drove up one of the highways that links Jerusalem with Tel Aviv, passing red-roofed communities of Israeli settlements on the West Bank, and following the curve of the recently constructed great gray wall meant to separate Israeli and Palestinian. After several hours, we reached a pine-scented forest, and then climbed into the hills above the Sea of Galilee and met with archaeologist Rami Arav, who has been excavating at the ancient city of Beth Saida. Beth Saida was the hometown of the apostle Peter, and a city that Christ visited often, according to the Bible. The site is located in the annexed land of the Golan Heights, controlled by Israel only since 1967. A quasi-governmental agency, the Jewish National Fund, maintains the site, and heavily Christian teams have been excavating it since the early

1990s. They have uncovered roads, the remains of a temple, a town square, and houses that may or may not have belonged to fishermen like Christ's first apostles. To the untrained eye, all these years of work still do not reveal anything but several lines of rock in the dirt and a few holes also lined with rock. However, for archaeologists, the place is a trove of information. It is also deeply important to Christians, which is why numerous theological universities and religion professors, pastors, and religion students have put time and money into the dig.

Arav, an Israeli affiliated with the University of Nebraska, oversees the excavation. A tanned, jocular man, he greeted us in the standard uniform of the dirt archaeologist—Indiana Jones hat, sweat-stained T-shirt, shorts, and sandals. His crew of about forty students and adults were uniformly filthy and sweating too, squatting in the dust, diligently picking at soil with spades and brushes, filling black plastic buckets with dirt intended for a sifter. They tossed larger objects—dun-colored broken pottery bits called sherds—into a "find bucket." Sherds are meaningless to the untrained eye, but a professional can take one look at one and date it to 100 BCE or 100 CE, know whether it came from a cup, dish, or the lip of a bowl or pitcher, and by scrutinizing its shape and substance, can even make a good guess at whether it was made locally or imported from a more distant village.

The Beth Saida dig was marked off by rope into sections, each with an alphabetical name—Area A, Area B, and so on—and then subdivided into numbered areas. On this morning, the find bucket was filled with sherds, and as Rami walked by, a volunteer proudly held up something pretty, a bit of a sherd with green or blue paint on it. "That's a curse," Rami joked, because the coloring meant the sherd was actually far newer than what they seek, probably Arab stuff from after the seventh century, far beyond the historical scope of what they were assaying.

Beth Saida is a large dig, and many volunteer workers hail from the United States. There was a team of kids from Nebraska, a minister from Virginia and his wife, and another team from Creighton University, a Jesuit institution based in Omaha. A large sign near the section of the town that had already been excavated listed the dig's many previous sponsors.

As we walked, Arav joked about the peril from scorpions and snakes. He pointed out the remains of the ancient road, a line of gray rock poking out of the soil, and two large rocks, which have been interpreted as the ceremonial entrance. His greatest find so far was an engraved slab of rock, or stele. A horned bull-like creature carved into the stone was apparently a pagan moon god. Arav said visitors to the city probably took a handful of fresh water from a basin near the stele and sprinkled it on the symbol ritualistically before entering.

Many of the workers who toiled on the site that year proudly wore sweat-stained T-shirts printed with the symbol on the rock as badges of their participation in one of the most important digging seasons.

The Beth Saida dig's history has not been without its share of contention. One year, Arav found ancient human skeletons at the site, and the news attracted busloads of ultra-Orthodox religious conservatives in black hats at five in the morning to protest and, Arav says, "to vandalize" the site. Traditional Jewish law forbids the disturbance of buried human bones, and the ultra-Orthodox in Israel are adamant that archaeologists respect it. Arav took pictures of the violence and the protestors, and called the police. He angrily claims the protestors did thousands of dollars' worth of damage to his work and were never punished. "They are absolutely nuts. And all the police did was tell them, 'Please leave.'"

As we walked past his team of diggers, Arav reached down into a bucket to share something interesting. He held up a handful of

what looked like black soil. The substance was actually burnt ancient grain, blackened from a conflagration that had destroyed the city. By testing it, Arav had been able to date the destructive fire that consumed the city to 732 BCE. He also pointed out the ruins of a column between two walls, which indicated to him that we were standing on what had once been a Roman imperial cult temple that postdated the pagan cult.

I left Arav behind with his diggers and walked down a well-maintained gravel path to a section of the site already excavated, interpreted, and prepared for public viewing. Here, I realized the site's true significance—and why so many Christian institutions were involved in the digging. It wasn't about the moon-god cult or the Roman temple. It was about the fishermen. All along the path, neat metal signs were engraved with New Testament passages. One small excavated rock foundation was labeled Fisherman House, and a sign posted nearby proclaimed the following: "Jesus was walking by the Sea of Galilee when he saw Simon and his brother Andrew at work with casting-nets in the lake. For they were fishermen. Jesus said to them, Come follow me and I will make you fishers of men. At once they left their nets and followed him. Mark 1:16–18."

At the end of this lane, I found a welcome spot of shade provided by a tarp attached to poles, and beneath it I met a tall, affable American in khakis and oxford cloth. Pink-faced from the heat, the Reverend Emmitt Wilson, a Methodist preacher who hails from Bristol, Virginia, was taking a Popsicle break. Every summer for twenty years, he and his wife have come to the Holy Land, either to work on excavations or to lead religious tours. Wilson told me his digging wasn't for proof seeking, exactly, but to provide context for his faith.

"I do this basically to learn, to grow, to understand the context of the Bible, the context of how they lived, which throws light. When you are bringing the Bible to people, you can put Jesus in his con-

text! In his land! The whole context, from David, Absalom, Christ, to the fishermen, the sea. Plus, just the land. We call it 'fifth gospel' sometimes. The land is a gospel. But proof—it's faith. For people who believe, you don't need to prove."

Another sweating gentleman wandered over to join us under the shade of the tarp, a short, jolly, rotund fellow wearing the bull-headed T-shirt that marked him as a dig veteran. Nicolae Roddy, a professor of religion at Creighton, and his student team get bragging rights for finding the bull stele. He has the moment locked in memory. "On July 11, 1997, my student turned over a rock and he had a bull staring at him. He turned white. It was a moment, we might say, *mysterium tremendum et fascinans*. He came to me so excited. Eventually we found the three other pieces of the stele and learned it had been destroyed in 732 BCE."

As a professional archaeologist with a theological underpinning to his work, Roddy seemed like a good person to ask about the interplay between science, proof, and faith in the archaeology of the Holy Land. What happens when a religious man digs in the ground of the biblical prophets, of the Messiah himself?

"It's not a simple question of starting from a platform of science, or starting from a platform of the Bible." Roddy mopped at the dirty rivulets running off his temple.

The reality on the ground is that these are extremes and there's really a broad diversity across the spectrum. You have people of great faith who are willing to lay aside their faith to the best extent that they can, in the interest of science. And on the other hand, I'm sure there are people, you know, who come from just a scientific perspective—maybe a different discipline—who, once they integrate themselves with the processes of archaeology and start thinking about what it might

mean to ultimately be human, they might find themselves in a sphere of some sort of faith that they didn't have when they started, perhaps.

I think it's a universal human phenomenon that when the world seems to be subject to chance and disorder and chaos and things like that—to want proof. You know, they want to hold on to something. The problem is if you hold on to something and then it's proven to be a hoax, or it's disproven or something, you either don't suspend your belief—you either continue to believe in the absurd—or perhaps you have a lapse of faith, which I have seen happen too. But I would hope they wouldn't have a lapse of faith, but would rethink the nature of their faith. Is it really something so external as to tie it to a rock or a place? You know, is it really that external, or is it more internal?

[CHAPTER 4]

The Collector

*Child observation shows us that the infant may look
to alternative solutions for dealing with the antici-
pation of vulnerability, of aloneness and anxiety,
and often will be looking for a tangible object like a
comforter, a cushiony doll, or the proverbial security
blanket to provide solace which is not, or rather was
not, forthcoming. Thus, the collector, not unlike the
religious believer, assigns power and value to these
objects because their presence and possession seem
to have a modifying—usually pleasure-giving—
function in the owner's mental state.*

—WERNER MUENSTERBERGER,
*COLLECTING: AN UNRULY PASSION,
PSYCHOLOGICAL PERSPECTIVES,* 1994

N THE BREEZY STREETS around Oded Golan's third-
floor apartment in a residential neighborhood of angular,
cement, 1960s-modern buildings not far from downtown
Tel Aviv, hip young men and women in stylish sports gear with iPods
plugged into their ears jog past long-haired women pushing strollers,
wearing hip-huggers exposing pierced belly buttons. Tel Aviv is the
anti-Jerusalem. There is barely a black hat or prayer shawl to be seen,
and almost certainly no head-covered Muslim women. Nearly every-
one and everything is secular. The cityscape is dotted with billboards
of alluring sylphs hawking jewelry and soft drinks and cars, amidst

soaring glass-and-steel structures. The clean sidewalks and simple cement apartment buildings could be in any medium-size European city. As in Europe, the streets are clogged with honking, small, gas-conserving vehicles. There's an Italian espresso vendor on almost every block.

If Jerusalem is haunted by the ancient history of the Holy Land and its Arab past, Tel Aviv is haunted by modern Europe and its fascism—and the Holocaust. The city's soaring skyline and bustling inhabitants are a living rebuke to that dark, terribly recent passage. Here live the children and grandchildren of men and women who left Europe in the early twentieth century, narrowly escaping extermination, simply for their ethnicity and religion—a religion that many of their descendants in this city barely practice. Here is what they built, from almost nothing, from a tel. It looks and feels like Europe.

In October 2006, and again a half a year later, Oded Golan graciously invited me into his modest Tel Aviv apartment on Feival Street, a few miles but a world away from Moussaieff's beachfront penthouse. By the fall of 2006, for more than two years, Golan had been under indictment for what Israeli officials had called "the fraud of the century." He was on trial, accused of forging or overseeing the forgery of more than a dozen items of biblical antiquity, and selling them for hundreds of thousands—perhaps millions—of dollars, over a period of at least a decade, in a scheme designed to fool scholars, collectors, and the public. During the period of his indictment and trial, Golan had vociferously protested his innocence. He had been jailed once for attempting to tamper with a witness, and he had been forbidden to travel outside of Israel. He had not shown the slightest inclination to confess to anything, and he was always happy to talk to the media.

Two tall glasses of water were set on a black Japanese tray beside a laptop. We sat in black steel-and-leather chairs. The interior walls

in his residence, like Moussaieff's, are white and lined with glass-covered shelves, lit from within, displaying bits and pieces of his collection—pottery, small Canaanite figurines, Roman glass. Unlike the billionaire collector's messy but maid-serviced apartment, Golan's habitat smells faintly of unwashed male, of sweat. A layer of grit in the bathroom belies the elegance of the illuminated, glassed-in shelves and the white mini grand piano set in the center of the main room. The dirty rivulets in the bathroom sink and stained towel hanging on the wall suggest an occupant who works with his hands.

Oded Golan is spry and bright-eyed, and his impish aura is increased by his mop of brown hair. Now in his late fifties, he is an accomplished amateur pianist, an entrepreneur who's tried his hand at various businesses and more often than not, not made money. His main avocation, besides playing the piano, is collecting ancient arti-facts plucked from the soil of Israel and its environs. He has been doing it since he was ten years old, when he first poked through the parched earth and found something real—a clay seal that proved important to the history of the land.

In the sixty-year-old state of Israel, Oded Golan has a pedigree not unlike that of an American whose ancestors arrived on the May-flower. His family tree is populated with prominent socialists and Zionists who helped build the nation from nothing. All his grandpar-ents, born in Europe—in Poland and the Ukraine, came to Palestine around the turn of the twentieth century. His maternal grandfather was the youngest rabbi in all Europe, nominated at the age of eigh-teen, and a committed Socialist. Oded says the old man left Russia because he realized that Socialism and religion would not be allowed to coexist in postrevolutionary Russia. A Zionist, he gathered forty or fifty secular young Jews on the force of his personality alone, who then followed him into Palestine. Among them was Oded's grand-mother, a completely unreligious woman, who was motivated by

Zionist Socialism. The couple lived first on a kibbutz, one of the collective farms that preceded the building of the state of Israel. Eventually, Oded's grandfather played a role in the creation of the state of Israel, helping found the national political labor party, serving as a lawyer, and amassing a hefty fortune, which the family has since invested in real estate. Oded is proud of the fact that although the old man became rich, he never lost his youthful set of values. "I want to tell you something very unique about him. He remained Socialist until his last day. And he remained religious. And he's the only person in the world that I know who succeeded to live in harmony with all these contradictory things."

His grandparents' status as national founders was commemorated in their ID numbers with the nascent national health insurance system. They were numbers ninety-nine and one hundred. "In her nineties, when she used to come to doctors with the ID number ninety-nine, nobody believed that someone could be old enough to have that low an ID number," Oded recalled of his grandmother, laughing. "Because there are now like three million people in Israel, and the doctors would look at her number and say, 'This is a mistake! No! No! What is your ID number? Not your age!'"

While his grandfather retained his religion to his deathbed, his grandmother remained staunchly secular all her life. But both were deeply radical in their own ways. "She didn't believe in God," Oded told me. "And when I was twenty-five years old, I came to her and asked her, 'Tell me when did you get married with my grandfather? How did you know each other?' And she told me, 'Oded, we never got married. We lived all the years together. You know, it's a philosophy of life!' She said they never felt the need to get married, and only obtained a fake marriage certificate from Turkey when asked for one."

His paternal grandfather emigrated alone to Palestine from Poland as a young teen. "He came here to high school. He lived by

himself. I don't know how he managed to live, because he studied in high school. Maybe he worked, but he went to the only Hebrew school in Tel Aviv. He got married later on to a wonderful woman who passed away very young, when my father was thirteen years old. And her family were also prominent in the founding of the state." Golan was the younger of the two sons born to Rifka Golan-Barkai, an expert in plant disease at the Volcani Institute, which is Israel's leading agricultural research institute. She is also a world traveler, having represented Israel at international agricultural science conferences. His father is an industrialist. Both parents, in their late eighties, are still living in an apartment down the street from their son, whom they call "Dedi." His older brother, Yaron, was a self-made publisher who died in 2007, during the trial. Oded was the more scientific of the two siblings. The brothers went to high school in Tel Aviv with the sons and daughters of other prominent Israelis. Among his classmates was Rabin's daughter and a son of Israeli president Ezer Weizman.

Golan dwells in a world about which average Americans, however religious they may be, know very little. Every morning he wakes up surrounded by myriad bits of the ancient world, some worth hundreds of thousands of dollars. Every day he looks at them, dusts them, moves them around on the shelves. Sometimes, if the police are to be believed, he actually sleeps with them. And sometimes he notices a detail he missed before, a letter or a phrase usually, that links the object to stories the faithful have heard for centuries, stories that his objects might prove to be fact.

Interestingly, the owner of this multitude of antiquities from the land and time of the Bible, is not a religious man at all. "I go once a year on Yom Kippur to synagogue, not because I believe in God. It's a gesture to the Jewish culture, because I have a very strong emotion about the culture of the Jewish people, and to the history of Israel."

Born in 1951, three years after the founding of the state of Israel, Oded Golan grew up during a period of great lay interest in the archaeology of the new nation. In the decades just before and after the founding of Israel, the Jewish Palestine Exploration Society had been encouraging Zionist settlers to help carve out a specifically Jewish archaeology, different from that being pursued by the Christians who were combing the soil with a Bible in one hand. To the end of creating a national identity, the society started encouraging *yedi'at ha-Aretz*, roughly translated as "knowledge of the homeland." Among the ways of obtaining that knowledge were hiking trips organized for youth groups and others into nature, an organized way to bring the inhabitants of the newly formed nation into familiarity with the land. For the groups of hikers, these jaunts, called *tiyulim*, had a number of goals, among them an element of history finding and treasure hunting.

Treasure hunting is a common boyhood pursuit, indulged in throughout the fictional ages from Tom Sawyer and Huck Finn to the Hardy Boys. But for Oded Golan, growing up in the newborn nation, sifting through the dirt for ancient things was also to participate in a national pastime. As Magen Broshi, an archaeologist and former curator of the Shrine of the Book at the Israel Museum, put it in a 1996 discussion, "The Israeli phenomenon, a nation returning to its old-new land, is without parallel. It is a nation in the process of renewing its acquaintance with its own land and here archaeology plays an important role . . . The European immigrants found a country to which they felt, paradoxically, both kinship and strangeness. Archaeology in Israel . . . served as a means to dispel the alienation of its new citizens."

Golan's parents participated in the national effort, and brought their young sons on trips to the countryside, including the one where Oded found his first bit of history. And in a rather fantastic sequence of

events that could only occur in a new and intimate country, he became intimately involved with national archaeology. "I remember when Dedi was ten years old. It was 1961. We took him and his brother for a trip up to the north, to the Galilee," said his mother, Rifka, a short, stout woman with a dyed Fringe of reddish brown hair who strongly resembles her younger son. "We were walking through the country-side and he saw a piece of pottery on the ground. He picked it up and put it in his pocket. 'I think it's something important. I think I'll tell Yigael Yadin about it,' he said. He had never even met Yadin."

In the 1950s and 1960s, Yigael Yadin was one of Israel's most prominent archaeologists. He was also a national war hero, who had served in the Haganah, the Jewish shock troops that paved the way for Israeli statehood. Yadin had archaeology in his blood. His own father was a Hebrew University archaeologist who had acquired parts of the Dead Sea Scrolls for Israel. Besides excavating what he identified as Solomon's gates at Megiddo, Yadin famously excavated the desert fortress Masada in the 1960s, and launched it into being one of the most emotionally resonant archaeological sites, second only perhaps to the Temple Mount, in all of Israel.

In spite of his prominence, Yadin wasn't above communicating with a small boy. Oded "wrote a postcard—that's how we commu-nicated back then—to Professor Yadin, describing the pottery, and Yadin wrote back," Rifka recalled. "He clearly had no idea he was addressing a ten-year-old boy. He wrote that the pottery did indeed sound interesting, and he would drop by to see Mr. Golan when he was next in Tel Aviv. One afternoon a few weeks later, there was a knock at the door. I opened it, and Professor Yadin was standing there. 'I am Yigael Yadin,' he said. 'Is Mr. Oded Golan at home?' I explained that Oded wasn't quite a 'Mister' yet, but that he was at home. Yadin came in and I called Dedi. The two of them went off to the room Oded shared with his brother and talked there for

some time. Yadin said he would like to borrow the pottery to have it checked by an expert and invited Dedi to visit him in Jerusalem."

Years later, Oded recounted his version of the same story. The object came from Tel Hazor, which he visited during a family outing near the Sea of Galilee. And what his mother called "pottery" was in fact a piece of cuneiform—that rarest of objects in Israeli archaeology, something covered with ancient script.

"Hazor was the biggest city in Israel during the mid-second millennium BCE. I found a small clay fragment, which I could immediately identify as written in cuneiform." When he returned to Tel Aviv, Golan said, he contacted Yadin, and told him about the fragment. "He came to my parents' apartment," Golan said, "and he found that the fragment was part of a dictionary written in two languages, both in cuneiform. One is Akkadian. The other is Sumerian—from the seventeenth century BCE, if I'm not wrong. It's interesting how a dictionary was developed, because it was very functional. It was purely a commercial dictionary for traders, and the words are actually like 'good price,' 'bad price,' 'high price,' 'low price,' things like that. But the more fascinating story behind it is that Yadin brought several aerial photographs of the mound, and he asked me, 'Oded, tell me where did you find it? Because this dictionary probably belonged to the palace at Hazor, which I am looking for.' He even mentioned Yavin, the king of Hazor, who is mentioned in the Bible."

Unable to remember where, exactly, he had found the sherd, the boy tried to imagine the site. "I said to myself, 'If I was the king of Hazor, where would I put my own palace?'" Golan recalled. "So I told Yadin that I thought it was probably very close to the place where I found it, and I pointed to a specific place."

From that formative experience, the child enthusiast grew into the adult collector. Today, Oded's attachment to his ancient artifacts and his own deeply personal relationship with ancient history

cannot be overstated. "Obsession" does not fully describe it. "Love" comes closer. His find at Hazor and his childhood brush with the great archaeologist Yadin took on a kind of mystical importance in his life. He told the *New Yorker* a few years ago that even his dream of a buried palace has turned out to be eerily accurate. "You know, several years ago I went to Hazor, and I found that the Hebrew University had been working there for years, at the place where I pointed with my finger," Oded said. "And I spoke to some people, and they said that Yadin, in his so-called will, his scholarly testament, had mentioned that he believed that the palace of Hazor should be at that place. And the most incredible part of the story is that the palace is there. They found the biggest palace in the world at exactly the spot where I pointed, where I would have put my own palace as a boy, if I were the king of Hazor."

<center>⁂</center>

AS ALL ABLE-BODIED ISRAELIS MUST, Oded served his time in the military, but he was lucky enough to avoid actual combat. Even though he took part in the 1973 war, in the Golan Heights, his job was to assess daily equipment needs. "I was an officer and I was sent to the front to evaluate the casualties, not in people, but in vehicles, in weapons. The head of the army, which is in Tel Aviv, had to decide every night who will get the matériel, and America used to send a lot of aid to Israel, but it came in batches." Oded's job was to determine which unit most badly needed the limited matériel. He brought a camera with him to the front and took pictures. "I participated in the war for four, five hours a day, and I took the car back to Tel Aviv. I came home to my parents, to sleep. And at five o'clock the next morning, I went to the war again. If you think about it, it's a crazy story."

Oded studied industrial engineering at Technion University in

the 1970s, but he never worked in the field and apparently never earned a degree. He describes his family as "wealthy in Israeli terminology, not in American terminology." Afterward, he bounced around in the family business but disliked the work. In fact, he says he detested business, even though he believes he might have made a success of one, with his family wealth and the connections he now has made around the world.

His primary job for many years was managing an international architectural travel tour company called "Architect-Tour." He organized tours for architects from various countries to visit architecturally significant buildings in various nations, and also for those tours to meet with prominent architects in those countries. "We took them to unique projects that no one can go inside. We went to private houses and got them lectures. Fantastic program. Lovely, historic architecture, modern architecture. Different countries like Thailand, everyplace, that was more cultural, with the exception of Singapore. But again we put emphasis on more than architecture. Japan, Australia, and almost everyplace that you can imagine. In Italy the program was aimed at people interested in stones, mostly interior design stone. Italy was the most successful program. We had 850 participants."

Oded's travel schedule then was extremely hectic. For more than a decade his work sometimes took him outside Israel every two weeks, for five days at a time. "I love to travel. It's not easy, but very interesting. Not very easy because traveling all the time, you're always suffering from the jetlag. It was wonderful, and very instructive for many points of view, really. You meet with the most creative people in the world."

Oded's world travel also put him in contact with the kinds of people who collect beautiful things. He found common ground because he'd been growing his collection of Bible-era, Holy Land

artifacts since childhood. "I went everywhere for more than twenty-five years, and of course I visited most of the museums around the world in archaeology." However, museums never thrilled him, because, he said, "I don't see a personal touch in it. You have to love it. You have to understand it. You have to know what is there, what pieces are common or not." As a collector of artifacts from the soil of his home country, Oded was at his happiest seeking the rare find in the private biblical-antiquities market. "I never know who will call me tomorrow, and who will show up tomorrow, which period he will represent, which area, which culture. And from time to time, I have seen—but didn't buy—pieces that are really a big part of the history of this country. And there are very few people around the world who experience something like this."

Besides collecting antiquities, his other great avocation always remained the piano. In his mind, he linked the two. "Of course I studied Beethoven and Mozart and Bach," he says. "But I play any songs, Israeli and foreign songs. You can express—I never thought about it, but once I talk to you about it now, about collecting coins and collecting antiquities, when I play Beethoven, it's a fix."

I ask him if by "fix" he meant, perhaps, an obsession, and he nodded. His English is fairly good, but I was not sure he understood that word, exactly. Did he mean "fixation" or "fix," as in a necessary drug? "When I'm making improvisation on a song, it may be something completely different tomorrow as from today. From any day. I make improvisations on Beethoven, but it's not better than Beethoven. It's different."

✢

I MET THE AMERICAN SCHOLAR MORAG KERSEL in Washington, D.C., at the annual meeting of the American Society of Oriental Researchers (ASOR) in the fall of 2005. A tall, lean woman with long

brown hair, Kersel was a PhD candidate in archaeology at Cambridge and just coming off a long period of research in the Middle East. Her specialty is the illicit ancient Near East antiquities market.

Kersel belongs to a group of people who are natural enemies of men like Oded Golan and Shlomo Moussaieff. She and other professional archaeologists believe collectors de facto promote site looting, and deprive historians of information and nations of cultural heritage. The scholars see the overwhelming desire collectors harbor for the objects as a sort of perverse lust.

For her dissertation, Kersel spent several years in Jordan and Jerusalem, investigating how the antiquities trade operates "from the ground to the buyer," as she put it in the title of a paper she eventually published on the subject. "Every day in shops, on the Internet, and in auction houses, people purchase archaeological artifacts," she wrote. "Archaeological material is readily available in the marketplace, but how does it get there?"

To answer that question, Kersel trolled the streets of the Old City in Jerusalem, talking to dealers, some of whom came to trust her and described how the trade works. Eventually, Kersel wrote about an intricate system by which illegally excavated or "looted" objects are "laundered," through a series of markets and middlemen, gaining legitimacy and value at each step of the way. Objects dug out of the ground in the dark by Arab peasants are worth a mere fraction of what they will be worth after moving up the chain, from the dirtiest digger's calloused hands to the whitest, softest museum curator's or collector's hands.

What she discovered highlights the dilemma that Amir Ganor and his men at the theft division of the IAA grapple with on a daily basis. The crimes they investigate are actually only half crimes under Israeli law—and clever dealers and collectors know well how to game the system through a combination of speedy purchasing

action, handshake deals without paper trails (sometimes involving millions of dollars), and a code of silence. "Trafficking in antiquities blurs the lines between illegal and legal markets and between criminal and legitimate participants," Kersel found. "Whereas the traffic in drugs is always illegal—meaning that the buyer is as culpable as the seller—in sharp contrast, the ultimate buyer of illegally excavated antiquities can often purchase them openly and legally, seemingly without engaging in illegal activity."

The trade in antiquities is a global game, involving artifacts from culturally rich countries on both hemispheres, and rich collectors and museums all over the planet (although mainly in the West). It has a long and storied history, going back to at least the eighteenth century, as "antiquarians" like Lord Elgin filled their mansions with precious and beautiful ancient things like the collection of Greek statues known as the Elgin marbles.

In the twentieth century, a global trend toward cultural sensitivity and respect for national heritage developed, and while it didn't trim the ambitions of museums or collectors for old and beautiful things, it did provoke the United Nations Educational, Scientific and Cultural Organization (UNESCO) to pass, in 1972, a Convention Concerning the Protection of the World Cultural and National Heritage intended to protect sites from looting. A majority of nations have signed it.

Israel has its own national patrimony law that allows dealers and collectors to buy and sell artifacts, but only if they were collected before 1978. Anything excavated after 1978 is deemed property of the state. The Palestinian Authority is currently drafting its own national patrimony law, but cultural heritage in the West Bank is governed by the Jordanian Law of Antiquities of 1966, and in Gaza, by an ordinance dating to 1929—both of which are holdovers from the British Mandate period when the trade in antiquities was allowed.

Kersel believes that some if not most of the material in legally

sanctioned shops in Israel comes from looted Palestinian sites. The illicit antiquities business thrives in the murk of war and distrust, and the political, geographical, and cultural conflict between the Palestinian Authority and Israel offers an ideal breeding ground for smugglers and looters to do business. "The geographically advantaged states are those through which traders and smugglers must also inevitably pass, if only briefly, because of their physical proximity to the archaeologically rich country or their role as a regional hub," Kersel found. "Israel is an excellent example of a geographically advantaged state due to its proximity to the Palestinian Authority (PA) where most of the looting in this region occurs."

Kersel found an unlikely research guide in the person of a Palestinian shoe-shine man. "I walked by Mohammed and his shoe-shine operation in Jerusalem every day for months, never suspecting that he also dealt in ancient coins," she wrote. An archaeologist who collected coins told her about Mohammed's side job. Old coins for sale in Jerusalem attract the usual collectors, but also religious tourists, who want to believe the allegedly first-century-CE coin they are paying for might have passed through the very temple from which Jesus cast out the money changers.

By following Mohammed, Kersel learned that his coins were coming from village women in the Hebron area (a town in the West Bank where movement has been severely restricted by the Israeli response to the intifada) who grow mint and other herbs in their yards for sale on the streets of East Jerusalem. Anyone strolling the streets near the Old City walls has seen these country women, sitting cross-legged on the sidewalk, draped in billowing cotton, their faces and hands brown, chapped, and raw from outdoor work, heaps of aromatic mint, thyme, and rosemary laid out on newspapers next to their knees. "Often while gathering produce for the market, the women unearth ancient coins," Kersel wrote, adding that men and

children in Palestinian villages also dig for such treasure. The village women arrived in Jerusalem and sold the coins to Mohammed. Mohammed spoke good English, and he set up his shoe-shine operation in an area of high tourist traffic. While shining shoes, he mentioned his coins, and "on a good day" he made up to $300 selling two or three coins. Kersel also found that the shoe-shine man was expert in the value of his coins, knew the rarer ones by sight, and sold those only to licensed dealers, who also knew their real market value (unlike the truck farmer). The licensed dealer cleaned the coin, gave it a fake IAA registry number and put it up for sale. "At this point the coin has passed into the legitimate sales market for unsuspecting tourists or collectors to buy," Kersel found. "When the tourist asks where the coin comes from, he is told that it was part of an old family collection from the Hebron area." No self-preserving Christian tourist is likely to venture back across the guarded checkpoints into Hebron to confirm that story. He or she sails merrily back to Christendom with a bit of the Holy Land to pass around over coffee on Sunday morning.

Kersel concluded that Jerusalem is an ideal "transit" market through which to launder ancient artifacts, precisely because it is a location where people who habitually do not communicate with each other (Israelis and Palestinians, Christians and Muslims) interact and do business. "Unfortunately, given the dire situation in the area, the illegal trade in antiquities is a low priority for both sides."

✠

IN FACT, the men who succeed in Israel's antiquities market must know how to communicate effectively with all the participants. They must be able to at least project a certain amount of knowledge and respect for all cultural customs and traditions, from the Old Testament Hebrew Bible, to the Koran, and back to the New Testa-

ment. Moussaieff's fluency in Arabic and Oded Golan's world travel and long experience traversing Israel in the army have served them well in finding and bargaining for artifacts that come or are said to come from the West Bank. Successful Israeli antiquities dealers have a comfort level with both Arabs and Westerners. One of the best licensed dealers in the country is Lenny Wolfe, a short, bullet-shaped, black-haired, black-eyed Glaswegian who emigrated to Israel from Scotland in the late 1960s, and is among the proud and few who can speak Hebrew with a brogue. His Robert Burns dinner, replete with kosher haggis, is a single-malt-soaked annual bacchanal renowned among the expatriate Anglophones of Jerusalem.

Wolfe invited me to meet him in his home and office, in part of a fantastic three-story, nineteenth-century Oriental house, tucked away on a quiet Jerusalem lane just to the west of the old green line separating Arab East Jerusalem from Israeli territory. Strains of cello and piano wafted from the windows of a music conservatory across the street when I approached his front door. Inside, his office was crammed with antiquities worth millions, and walls of books. Young men in Orthodox costume—knickers, prayer shawls, and caps—scurried around, helping move and restore items. If not for the constantly buzzing cell phone and laptop on the desk nearby, I might have been sitting in the office of a Renaissance apothecary or alchemist.

While we talked, Wolfe sifted through three heaps of ancient coins he had laid out on his coffee table, making small piles and then lining them up into neat rectangles. One heap was greenish, the other, shined up and bronze colored. Altogether, the small hoard was worth tens of thousands of dollars.

I met with Wolfe on several occasions in Jerusalem, and in New York. He was always highly entertaining—sly, salacious, raunchy, and suggestive— but it was also clear he knew what he was talking

about. And unlike Oded Golan, whose explanations of his business were always obscure, Wolfe was happy—proud—to describe exactly how the Israeli antiquities market works. "I'm a real motherfucker," he told me the first day we met. "But I won't sell a fake." To back up the first part of his claim, he told me he had recently bought something from an Arab for about $300 that he knew to have a market value of $50,000 to $100,000. He was eager to help me with my project and wanted me to know that he was appalled at the forgeries on the market. He had a long list of enemies among the Israeli collector and dealer community, and he wasn't shy about naming them and warning me of their penchant for cheating and dishonesty.

In a paper linking the Israel museum's famous ivory pomegranate with other forged objects, he theorized about a forgery ring that had been operating since the 1980s. He called it "the lame bet workshop," after an anomaly he noticed in the Hebrew letter "bet" in all of the objects. He would eventually testify for the prosecution in the trial of Oded Golan.

As blunt as he was, Wolfe had his own form of discretion. In our conversations, he frequently dropped tantalizing hints about knowledge that would blow the lid off the forgery story, get extremely important people arrested, and so on, but then he refused to give specifics. I came to recognize this allusive, obscure way of communicating as a tic common to antiquities dealers in Israel—both Palestinian and Israeli. In their years of doing business, they have developed a habit of communicating that maximizes anticipation, while withholding for as long as possible the actual delivery of factual information and dollar figures. The delicate dance of tantalization, veiled truth, tangent, and deception is, of course, utterly Oriental, in the *Thousand and One Nights* sense of the word.

Wolfe really wanted to help, though. He decided to share some things he had written about his business methods. Eventually, he

e-mailed me an unpublished paper he had titled "On Haggling." Below is an excerpt, which effectively displays the flavor of the Israeli dealer's world, where an intimate knowledge of the most arcane aspects of history and art flows seamlessly through a species of commercial wiliness that an American used-car salesman would have to admire.

A couple of years ago we had as a dinner guest, an Anglo-American scholar, in Jerusalem for a year on Sabbatical. The gentleman was very left wing, a Palestinian sympathizer. Discussing the antiquities business in general he criticized the practice of haggling, saying these poor Palestinians needed that money for bare sustenance. I steadfastly claim the opposite: that an Arab prefers a good fight rather than someone paying immediately the ticketed price. This Anglo-American academic could be perceived as the classic case of someone coming from the liberal west and totally misunderstanding the dynamics of the Middle East . . . The essence of dealing with Arabs as with most people is to respect them. The Arabic expression is *sharraf,* which conjures up a civilised scene of mutual respect where each person is accorded his dignity. In Hebrew, it could be succinctly stated as: respect him and suspect him.

And now to haggling. Some years ago I was invited to Friday night dinner at the home of a well-known Munich collector of Judaica and antiquities. At one point of the evening the conversation turned to characters in the dealing fraternity. One of the most colorful characters in the antiquities market in Europe is a leading Turkish dealer based in Munich. [The dealer] has always been blessed with many girlfriends. The collector said that the only time when one could buy reasonably from [the dealer] was when he needed money to pay for an

abortion. He went on to relate how he had invited a sizable group of collectors and dealers to one of Munich's premier night clubs. At the end of the evening he asked for the bill which came to some 5,000 marks, around $3,000. The waiter told him that the bill had been already paid by [the dealer]. Somewhat slighted, he turned to [the dealer] and asked him what was the meaning of this, after all when buying an object from him, they haggled over every last cent. [The dealer] nonchalantly replied, "That is the Arab way."

Later in the same paper, Wolfe described how he set his own price for a necklace his wife wanted to buy from a Bedouin at the Jordanian site known as Petra.

At this point I noticed a Bedouin peddler some fifty yards away. He was seated on the ground with a rug stretched out in front of him covered with a variety of tourist goods. Lo and behold he also had a big group of the necklaces I was looking for. I told my wife to enjoy contemplating Aaron, while I spent the time with my Semitic cousin, had a fix of coffee and acquired necklaces for all. I greeted the son of the desert, sat down, introduced myself and asked after his health, his welfare, that of his immediate family, his distant family, and his livestock. I then went on to say how I was taken aback by Petra, and that it was surely the most beautiful spot on God's earth, and that he was very lucky to live here.

By this time I was on my second cup of coffee, and we were already like lifelong friends. Like satisfying foreplay I worked my way around the main issue. Finally I brought up, by the way, the possibility of purchasing a necklace. I exercised all the Arabic I knew, words, colorful phrases, proverbs

and finally we consummated the deal, buying what I wanted at the price I wanted. Since he would not drop a cent below the price I had paid for the first necklace, I suspected he was part of traditional society's version of the cartel. The entertainment made the whole exercise worthwhile. And then he said to me, "By Allah, you are like a Bedouin," typical Middle Eastern flattery I daresay.

Wolfe then shared another example of his experience dealing with a Palestinian dealer, and his unsuccessful pursuit of a rare coin.

Because the Arabic of the Islamic Levant has been spoken continuously for more than thirteen centuries it has a richness that modern Hebrew lacks. One of the expressions used to describe a Hebronite is *moocho nashef* (his brain is dry) a reflection of the inflexible nature of these fine people. Yaqub from Halhul one of the satellite villages of Hebron is no exception. He was a savvy dealer who was able to buy coins from source, if they were not actually unearthed by one of his workers with a metal-detecting machine.

The Second Jewish war against Rome, also known as the Bar Kochba revolt from 132–135 CE was sparked off by Hadrian founding the Roman colony of Aelia Capitolina on the site of Jerusalem . . . This war produced the finest Jewish coins from antiquity, tetradrachms or *selaim* depicting the . . . façade of the temple on [one] side. Silver denarii or *zuzim* depicted a myriad of symbols evoking both the Temple ritual, and the agricultural life of the land of Israel, trumpets, lyres, ewers, bunches of grapes, and palm branches. In addition there was a somewhat rarer series of very large bronze coins depicting a beautiful amphora.

After Bar Kochba lost Jerusalem, soon after the start of the revolt they moved south to a region including Hebron and its environs. This was Yaqub's catchment area, which enabled him to be such a powerful figure in the market-place . . . One of the coins that Yaqub had acquired was a *sela* probably emanating from [Bar Kochba's] mobile mint . . . Fully aware of the rarity of the piece, Yaqub, without flinch-ing, asked me sixty thousand dollars for the coin. This was around twice the price of the much rarer Year One *sela*, not-withstanding the importance of this singular variety. When one sits in the premises of a dealer who has his finger on the pulse of the market and has access to the finest merchandise, one has to decide quickly. One has to buy from him in order to be offered more merchandise in the future. However, one of the oldest tricks in the bazaar is to entrap a customer in a situation like this by asking an unrealistically high price and hoping that the client makes a counteroffer which is con-siderably less than the price asked but nevertheless much more than the market value. Falling into the trap, I in turn offered $40,000. Yaqub retorted, "What do you think, we eat cattle feed?"

I was disappointed at losing the coin, finished my coffee, made the customary pleasantries on leaving the house of a host, and made my way back to Jerusalem. Only in the car did it dawn on me how lucky I had been. In Yaqub's house I reck-oned I would have been able to sell the coin for a quick profit of ten percent. In the car I thought that the downside risk would have been far greater and that I would have lost my shirt. A few years later a second identical specimen turned up and the value of the coin today would be about $8,000. Yaqub could probably have sold the coin in the early nineties for

thirty-thousand dollars, but his greed got the better of him and at the same time let me off the hook.

Wolfe concluded, "Thus a Hebronite dealer learnt about the importance of timing and cash flow."

<center>⊹</center>

THE ELUSIVE, ILLITERATE ARAB who cannot be traced because he merely scratches an *X* under the all-purpose name "Abu Mohammed" played a significant role in all the antiquities deals described by Wolfe, Moussaieff, Oded Golan, and the other Israeli dealers and collectors I met. Without his involvement, the Israeli antiquities trade would have far fewer provenance problems and the IAA would have a more manageable mandate. Trying to learn more about these anonymous Arab excavators, I hailed a cab on Salah Ed-din Street in Jerusalem, and headed for the Palestinian-controlled city of Ramallah.

It was the twenty-seventh day of Ramadan, the day Muhammad accepted the Koran from the angel Gabriel, almost the end of the grueling fasting month, and an evening of great merriment was ahead. People were out on the streets of East Jerusalem buying new dresses and Dora the Explorer balloons for the evening's festivities. Serendipitously, the Palestinian driver of the cab I hailed had spent seventeen years in San Francisco before returning to Jerusalem because his wife was homesick. He spoke American English, and as we drove toward the checkpoint, his radio was blasting the 1978 anthem to unrequited adolescent love, "Fool (If You Think It's Over)," by Chris Rea.

At the Kalandia checkpoint between Israeli and Palestinian territory, three men with machine guns were checking a battered vehicle with a lone female driver in her polyester floor- length coat and headscarf wrapped tight as a tourniquet around her pale, moon-shaped face. We pulled up next to a gray cement slab of the new wall and

waited our turn. Past the guard tower I saw the words "Girls School" painted on one building, and next to it, sides of skinned cow hanging from hooks behind a butcher's plate glass.

Ramallah is built on hilltops, like Jerusalem, a sister city in some ways, but surprisingly it was more verdant. I had expected wreckage and poverty, but I saw new high-rises and neatly paved roads. Near Yasser Arafat's old compound there are bunches of olive trees "from Roman times," the driver claimed. He was giving me his special cabbie tour, steering his Toyota up vertiginous loops of street that skirted cliff edges. There were forests of satellite dishes on rooftops as far as the eye could see. Cars with "UN" painted on the doors were parked in front of newly built Ottoman-style buildings. The shopping district was dotted with signs in English: the Sinatra Restaurant and Café, Baghdad supermarket, Sangria's Restaurant, and an inexplicable billboard with the words "Big Chance" and a woman in a red ball gown.

Finally we pulled up at our destination—a small, three-story brick rectangle with outdoor steps, graceful green ironwork, and Moorish arched windows—the headquarters of the Palestine Department of Antiquities and the office of its director general, Hamdan Taha.

Taha is solidly built, in his early fifties, strained, and terse— perhaps made more severe by the fact that he'd been fasting for a month. He spoke fair English, but with a caricature of bureaucratic exactitude, with much focus on "protocols" and "frameworks"—a communication style I had come to recognize as common to officials in many Arab countries, at least when speaking to Western journalists. Taha was born in Hebron, got his degree from Beir Zeit University in archaeology and sociology, earned a PhD in Jordan, and joined the Palestinian Authority to participate in the 1994 negotiations with Israel, specifically to deal with archaeology. The agreement hammered out separated the West Bank and Gaza into "areas"

identified by letters—A, B, or C. Only in Areas A and B does the PA
have any authority at all, he explained, and the C areas are officially
under Israeli occupation. Throughout our interview, Taha repeatedly
referred to these areas by letter, only rarely by place name.

There are an estimated ten thousand archaeological sites in the
occupied territories, he said. Only a tiny fraction are formally exca-
vated and fewer still are guarded. Taha methodically recounted how
the Palestinians had gradually lost control over Holy Land archae-
ology. The story tracks with the larger story of Palestinian defeat
over the last sixty years. Before 1948, the Palestine Department of
Antiquities was headquartered in the Rockefeller Museum. "It has
been occupied illegally since 1967," Taha reminded me. Before 1967,
archaeological sites in Israel proper were managed by the Israeli
military (eventually to be replaced by the IAA), Jordan managed the
West Bank, and Egypt managed Gaza. After 1967, the Israeli military
began policing sites in formerly Arab territory. "People who worked
in antiquities left the country after 1967," Taha told me. However,
in the 1970s, a "new awareness" of archaeology spread through the
occupied territories and Palestinians began studying archaeology
abroad, then coming home to practice, as Taha did.

In 1994, a small group of volunteers re-formed the Palestine
Department of Antiquities, which developed into an actual PA gov-
ernment department with a staff of around one hundred and differ-
ent sections, technical units, and regional offices, working under the
preexisting Jordanian law because the PA—distracted as it is with
matters of survival and civil war— hasn't gotten around to formally
writing and passing its own antiquities law.

For now, the Palestinian archaeology department "limited to
Areas A and B," Taha reminded me, is focused on what he called
"salvage" or "rescue archaeology." The department is involved in hun-
dreds of operations, primarily dealing with sites scheduled for exca-

[UNHOLY BUSINESS]

vation by housing and road developers. Between 1995 and 2000—a period of relative peace in the region—there was a Palestinian building boom, and archaeologists were required to examine sites and record important historical finds before the bulldozers rolled in. (The IAA also does plenty of this kind of work in Israel.) In addition, Palestinian archaeologists are attempting to safeguard the numerous abandoned sites under their control, and have developed their own cultural heritage sites.

I asked Taha about the quintessential character at the center of the biblical archaeology trade—the Arab site looter. "It is true, unquestionably," he replied. "The phenomenon of illegal digging has been accelerated very much in the last few decades. But it existed before that. The IAA's own estimate is that in the end of the 1980s when the West Bank was still under classical occupation, the objects which were looted amounted to a hundred twenty thousand a year. And according to these statistics, 85 percent was going out to the international market."

Taha blamed the Israelis, not surprisingly, for site looting. He was ten in 1967, when his village became occupied territory. "I remember how people, following the war, were involved in digging around the village. Because for the first time a new market opened, a demanding market for antiquities. Before that, there was no market."

Looting boomed after 1967, he said, to feed demand. "They are not 'excavators,' because that has a scientific basis. Lots of different people are involved. They can be a worker, a student. Even educated people do it. It is not a career for many. It is seasonal work. And people are more involved during economic crises. Because of the situation initiated after the intifada, many people have lost their jobs. And some of them tried to find their livings from archaeological sites, from looting and digging. After the closure of the West Bank [in 2001 and 2002], there was a general panic among tens of thou-

sands of workers. We have noticed that people are more involved now. When things are normal, it begins to stop, I would say."

Before 1994, and the handover of some power to the PA, the Israeli military controlled the entire West Bank and Gaza, and attempted to institute a protection system. But the severely limited staff could not oversee ten thousand sites. Palestinians were not cooperative. "People viewed archaeology as part of the occupation system." Taha said Palestinians distrust any form of organized archaeology now because they associate it with laying the groundwork for Israeli landgrabs.

"Archaeology has been used as a means to justify settlements and to establish a sort of extra link with the area. And I believe that archaeology of the West Bank and generally the archaeology of Palestine—Israel—is an example of how archaeology is used as an ideological instrument in the political debate on that end."

Taha conceded that Palestinian site looting is a real problem for professional archaeology, but he denied that Palestinians are guilty of trying to erase Jewish cultural history from the face of the land. "We don't believe that through archaeology one can justify or solve a modern political issue. Archaeology is a discipline. Its main task is to reconstruct the culture and the history of the past. We know that there is a very controversial issue here concerning the Jewish element in the cultural history of the land. We believe—and I believe myself—that the Jewish element in the cultural history of Palestine is an integral part of Palestinian history. So I do not have any problem with that, including the Bible itself."

✛

HAVING THE GREAT ARCHAEOLOGIST Yigael Yadin authenticate and write about his first find when he was ten years old shaped his life, Oded Golan said, but actual dirt archaeology never inspired him. He likes the artifacts, not the hunt. "The last time I did that myself

was the age of twelve or thirteen. I used to then because that's how I could get antiquities. I couldn't buy anything. Later on I became lucky, especially fifteen years ago, when two of the major collectors of Israel went out of the market."

Golan collects mainly pottery from the Israeli-Philistine period (in Israeli archaeology, the First and Second Temple periods, coinciding with the biblical settlement of ancient Israel), and most of his pieces are sorted and organized in cupboards with glass doors, in the guest room. All the things on the shelves are very old. Of that he is quite certain. Some of it may or may not be biblically significant— something, for instance, that King Solomon actually touched, or that a relative of Jesus used. For that determination, the collector relies on his instincts, but only to a point. For confirmation, he turns to scholars, people whose business it is to know the difference between third and fifth century CE Aramaic slang, and the lexicon of the ancient Judaic bureaucracy.

Oded did not build his collection from personal digs or even visits to the dusty shops. More often than not, his objects have a highly personal provenance. He has purchased them from friends, or friends of friends, other high-stakes collectors who don't bother with shops or tourists, but who buy and sell directly to each other and to some of the richest institutions in the world—the museums, the Franciscans, perhaps even the Vatican.

Among these were Moshe Dayan and Teddy Kollek, two of Israel's foremost politicians and antiquities collectors. Kollek was the mayor of Jerusalem for many years. Dayan was a famous war hero and Israeli defense minister, remembered for his eye patch, but also as a notorious site looter who amassed a huge collection of high-end artifacts (often relic-hunting with Moussaieff) while overseeing various military campaigns in the 1950s and 1960s. Golan also said he bought pieces from the collection of the late Reuben Hecht, a Belgian

immigrant to Israel and major collector and philanthropist, many of whose artifacts are now displayed at Haifa University. "Now when they were alive, I couldn't afford to buy many pieces," he said. But when they died, he swiftly moved in and bid on objects before others with more money could do so.

In explaining the history of his unprovenanced artifacts this way, Oded Golan is firmly in the tradition of collectors and museums worldwide. Both tend to use other collectors to validate the pieces they acquire. A piece that comes straight from the ground is more likely to have been looted than a piece that can be said to have belonged to someone else before.

Palestinian unrest has also enlarged Golan's collection. "The second thing which happened was the intifada," he said. "Since the late eighties, they have been digging and bringing things in like crazy. Not only from Israel, also from Jordan, also from other places because they looked for new sources of income."

Oded Golan said he believes that as a collector, he is preserving the history of Israel, within Israel. By this logic, the authorities who try to police the trade and punish people for buying looted antiquities are helping to destroy the national history. "They killed the history of Israel," Oded said. "The authorities of Israel killed the history of Israel."

He insisted that he has never sold an object outside the nation (which is forbidden by the IAA). "If it's authentic, it should be in Israel. It's a part of the history of the nation. Look, I don't need somebody to prove that there was a First Temple in Jerusalem. I'm sure there was a First Temple in Jerusalem. The Bible of course is a very interesting historical document. I can relate items to the stories of the Bible. I can. It doesn't mean that it's exactly the same, exactly where it's mentioned in the Bible. I think a lot of historical stories just went into the Bible because a father told his child and his child,

his grandchild, etcetera, and then something in the way was lost. So the Bible, in my opinion, is an echo of all these stories. Which means it doesn't represent exactly what happened, especially in the earlier periods. And maybe I go to its future. I don't know."

Oded sees himself as a living, breathing participant in the history of Israel, not just rescuing it, but commingling with it. He feels a personal link with its historical figures and with the makers of the objects in his collection.

"The history of Israel. The history of Israel itself, and the Bible, of course, has a lot to say about it. You can touch it. You can feel it," he told me, leaning in, eyes wide. "It's something they cannot explain to you. But, you see, when I'm looking at an item, in many cases—and I'll show you some examples later—*I know the person who made it.*"

I raised an eyebrow. He revised himself.

"I'm joking now, but I know definitely the period and the area just by looking at the item."

[CHAPTER 5]

Doubt

Fall 2002

Manuscript discoveries bring out the worst instincts in otherwise normal scholars.

—Professor James B. Robinson,
translator of the *Gnostic Gospels*

DED GOLAN PASSED the three months after Amir Ganor interrogated him in a frenzy of press attention, scholarly inquiries, documentary filmmaking, and international travel. Hershel Shanks had refused to identify him by name at the Washington press conference, but by the time the ossuary was unveiled at the Royal Canadian Museum in Ontario in November, Oded was happy to step up and share the limelight with his box.

In the United States, the unveiling of the James Ossuary in the fall of 2002 was the beginning of a three-ring media circus, with Hershel Shanks as ringmaster. Shanks sold the exclusive rights to make a documentary about the ossuary and the Discovery Channel agreed to air it. He and a biblical scholar from the Asbury Theological Seminary in Kentucky named Ben Witherington III were hard at work on their book, *The Brother of Jesus*, with a foreword to be written by André Lemaire. In the book, Shanks was only going to refer

to Golan as "Joe," but most members of the scholarly community and certainly the dealers, already knew that Oded Golan was the real owner.

For his part, Oded was basking in the moment, on his way to a quiet sort of stardom. The Emmy-winning filmmaker from Toronto, Simcha Jacobovici paid Shanks for the exclusive rights to the ossuary story, and then wasted no time flying over to Tel Aviv to meet the mystery owner. "It was like a James Bond thing," Jacobovici later told the *New Yorker*, recalling the secrecy surrounding the meeting. "I didn't know where I was going until I was in the van, and then I was given a phone number of the owner and he led us through the streets. I was expecting some kind of villa with artifacts all over, like in the movies." Instead, he found himself inside Oded's relatively modest, albeit antiquities-filled, apartment. Oded serenaded the filmmaker on the piano and talked about his collection while the Canadian filmed. The ossuary was on a little table on wheels in the middle of the room. "I looked in the box, there were still some bone fragments," Jacobovici recalled. "I thought, Oh, my gosh, if this is real, then Jesus's DNA is there!" (Jacobovici later signed on with Hollywood producer Cameron to make a film that hinged on Christ's entire family's alleged DNA being found in "Jesus's Tomb.")

Jacobovici described an episode of rapturous documentary filmmaking as the collector provided a musical backdrop for the spiritual moment. "I was alone with Oded Golan, and he was at the baby grand, playing, in another world. I've got in my hands two beta cassettes, I'm watching this guy playing Bach to the bone box of the brother of Jesus of Nazareth. I said, 'Thank you very much,' and, with the music wafting, I went back to normal intifada-land and I walked on the beach in Tel Aviv. It was just unbelievable."

While Jacobovici was filming Oded in Israel, Shanks worked the phones back in Washington, arranging for the box to be unveiled

at the Royal Ontario Museum (ROM) in Toronto. On October 10, 2002, he called the ROM, and pressed the director to accept exclusive rights to exhibit the famous box. Shanks demanded a mid-November exhibit opening, to coincide with three major and nearly simultaneous conferences in Toronto, including his own Biblical Archaeology Society, but also ASOR and the Society for Biblical Literature, which would bring nine thousand archaeologists, Bible scholars, and enthusiasts to town. "I thought he was a crank," Ed Keall, the museum's chief curator of Ancient Near Eastern and Asian Civilizations, told the Canadian press. But Shanks was relentless, taking his plea upstairs to the museum's executive. A deal was reached within two weeks. "There was something of a fire-sale element," Keall recalled, noting that Shanks threatened to take the box to the Smithsonian or New York's Metropolitan Museum if the Canadians balked at his terms.

The ossuary arrived at the Canadian Museum on a Brinks truck on Halloween, October 31, 2002, ten days after Shanks first announced its existence to the world. When the curators opened the crate, they were horrified to discover that the object purported to be the first archaeological evidence of the materiality of Christ was packed "like a discount toaster oven," as one Canadian journalist put it, in a simple cardboard box. Normally, precious art objects insured for a million dollars are packed in layers of foam-lined wooden or metal boxes. "I looked at it and said, Oh fuck!" curator Dan Rahimi told a Canadian journalist. "It was just so bizarre."

The worst was yet to come. On November 1, in a climate-controlled museum room, Rahimi and others gingerly opened the box to reveal the ossuary, wrapped in bubble wrap, but cracked. One break ran right through the groundbreaking inscription itself. In hindsight, Rahimi said, the box had been shipped in an "extremely unprofessional" manner so that it was "almost guaranteed to break." With the

box due to be on display in less than a month, and the world media panting for a look, a conservator recommended emergency repairs, and insurer Lloyds of London and Oded Golan quickly agreed. The poor packing job has never been explained, although police suspected an insurance scam, according to Ganor.

The repaired ossuary went on display on November 15. On the first day, ten thousand people filed past, some in silent prayer. While the Canadian lay public lined up to see the ossuary in its clear Plexiglas box, behind the scenes, nothing was clear. In fact, scholars were publicly questioning the ossuary's very authenticity. In late October 2002, an Israel-based historian of writing named Rochelle Altman raised the first serious questions about the James Ossuary on an Internet list read by ancient-Near East scholars. She ultimately pulled her questions together into a formal critique. On November 14, 2002, the day before the unveiling in Canada, Altman posted a devastating analysis of the James Ossuary on the peer-reviewed Web site Bible and Interpretation, which is hosted by a consortium of American universities. Altman, an expert in writing systems with a PhD in medieval writing, had written hundreds of journal articles in the obscure field in which she practices, and had recently published *Absent Voices: The Story of Writing Systems in the West*. She wasn't associated with any specific university, but she had the scholarly chops to be taken seriously. Her paper, "Official Report on the James Ossuary," took the object apart on the basis of specific words and handwriting style. She charged that the first half of the inscription was written by a different hand than the second, and also, more devastatingly, that the word "of" in "brother of" on the ossuary was actually a ninth-century-CE usage, not consistent with Aramaic writing from 70 BCE. Her conclusion in short was: "The inscription on the James Ossuary is anomalous. First, it was written by two different people. Second, the scripts are from two different social strata. Third, the first script is a formal

inscriptional cursive with added wedges; the second script is partly a commercial cursive and partly archaic cursive. Fourth, it has been gone over by two different carvers of two different levels of competence . . . If the entire inscription is genuine, then somebody has to explain why there are two hands, two different scripts, two different social strata, two different levels of execution, two different levels of literacy and two different carvers."

The American author and Dead Sea Scrolls scholar Robert Eisenman was also warning journalists about the possibility of forgery. Just after Shanks unveiled the ossuary in October, Eisenman, the author of a 1997 book called *James the Brother of Jesus*, published an article in the *Los Angeles Times* calling the ossuary "too pat."

On his own Web site, Hershel Shanks responded quickly with vehement attacks on the scholarly bona fides of Altman and Eisenman (neither of whom are mainstream biblical archaeologists or epigraphers). Eventually, Shanks would call almost all the scholars who questioned the James Ossuary "Lying Scholars" in a cover story in his magazine. For one cover, he chose to print the face of one of the ossuary's academic questioners, covered with images of large fleas.

Altman, in an interview later, criticized Shanks for failing to reevaluate the ossuary after initial questions were raised, instead going on to attack her and Eisenman. She accused Shanks of baldly exploiting the public's desire for proof. "Never underestimate the will to believe. Remember the old saying? 'My mind is made up, don't confuse me with the facts.' Mr. Shanks is depending on just that will to believe. What he has not understood on his way is that he is catering to the extremists, fanatics, among his readers. If one can break through the thrall and awaken the mental facilities of fanatics, they can, and do, turn on their deceiver. I am glad I'm not in his shoes."

Altman told me the first part of the inscription was written in

"priestly unified script," quite rare, and probably referenced a very wealthy person. The forger, therefore, destroyed an extremely valuable artifact. "If the ossuary had been untouched, the idiot could have gotten much more money for it," she said. "It was a once in a lifetime find. He did not know what he had."

Apparently unbothered by the questions now swirling around his world-famous possession, Oded Golan flew to Toronto in November 2002 to attend the annual meeting of the Society for Biblical Literature. Meanwhile, the press was having a field day. Besides the informational articles being published, mostly reprinting Shanks's assertion that the box was the first archaeological evidence of Jesus Christ's existence, there were other sorts of responses. Canada's *National Post* ran a cartoon of bath time in the "Bar Yosef" family home circa the dawn of the First Millennium. James is in the tub with his rubber ducky, Jesus is walking on the surface of the water, and James is yelling, "Mom!"

The Society for Biblical Literature arranged for a special five-member panel to discuss the ossuary. On November 24, a Saturday afternoon, Shanks, Lemaire, former ASOR president and Duke University Professor of Judaic Studies and Archaeology Eric Meyers, and two other scholars, convened on a hotel conference room stage before an audience of hundreds—including Oded Golan himself—for a discussion headlined "No Ordinary Box of Bones: The James Ossuary."

Lemaire spoke first. He didn't address any of the objections to his interpretation. He presented slides of the ossuary, explaining the letters and his interpretation. He noted that Oded Golan and Ada Yardeni had read it before he did. He went on to say that the features of the letters "are well-known and appear from time to time in the inscriptions from this period, especially about the middle of the first century AD" He noted that three books had been written about James in the preceding years.

Lemaire stated that in a Jerusalemite population of forty thousand males in circa 70 CE, the probability of there being a family group with a "Joseph" father, and two brothers "Jesus" and "James," might occur in twenty families. He added that he knew of only a single other ossuary where both a brother and a father were mentioned. Most ossuaries mentioned only fathers. "In light of the fact that we have only one parallel expression [of brothers on an ossuary], . . . would mean also that we probably have here the first epigraphic mention, about 63 AD, of Jesus of Nazareth," he concluded.

The audience politely applauded.

The next speaker gave a talk on the Jewish historian Josephus's account of the life and death of James the Just, without commenting on the box itself.

Then it was Eric Meyers's turn. Meyers has been a field archaeologist for more than three decades, excavating in northern Israel and elsewhere in the Middle East. He shared with many of his fellow archaeologists a distaste for dealers and collectors of antiquities, and a distrust of unprovenanced finds.

Meyers began by saying that since Lemaire's article in *BAR*, scholars had brought up "serious questions about [the ossuary's] authenticity." He pointed out that the IAA was investigating Golan's purchase and export of the ossuary. "Here we sit now, with the owner of the artifact present in the audience, for which he paid two hundred dollars some years ago, an object now valued between one and two million dollars if its authenticity holds up under further scrutiny. To say the least, I have a very bad feeling about the whole matter."

Meyers complained that although the press had been calling him for comment, he'd never yet seen adequate slides of the object to make a judgment. A *reporter* had had to fax his first copy to him, he said. When he finally saw the box the previous week in the museum, he had noted that one section of the inscription looked scrubbed

clean. "The question, who cleaned the right side of the inscription so well? I suspect—I don't know. I'll take that back. I don't know who cleaned it so well."

Meyers conceded that the ossuary was from Jerusalem, and from the period of time around James's death. But he said the inscription was "suspect in extreme" because of the modern construction of a pronoun in the second half of the inscription, uncommon in 63 CE when James died. "The point about the dialectical rarity of the form . . . is that it raises doubts about the accuracy of the date of the entire inscription." He stopped short of declaring it a fake, but urged "great caution" in reading it. "I am not saying definitely that I believe [it] is a forgery. However, in view of the circumstances of its discovery in the hands of a known Israeli collector, its unknown context, we must bring a measure of healthy skepticism into the debate once and for all."

During a question-and-answer period, Meyers said he was speaking for both ASOR and the Archaeological Institute of America in observing that it was a bad idea to even discuss the unprovenanced box at such a gathering. "We feel that advertisements and promoting discussion of these [objects], in certain fora, encourage, not discourage, looting."

Shanks, furious and red-faced, retrieved the microphone and bellowed, "I would ask Eric, would you rather *not* have the Dead Sea Scrolls? Would you rather *not* have the inscribed pomegranate, possibly the only relic from Solomon's temple?" He then accused Meyers of hypocritically showing up to discuss the object in the first place. Meyers demurred.

It was a mildly shocking scene that the hundreds of assembled scholars, men and women used to confining their disagreements to academic prose, talked about for years to come.

A few minutes later, an audience member took the microphone

and asked the owner of the ossuary himself to stand up and speak. "I believe we would like to hear the owner say when this came into his possession and was the inscription as we have seen it today, at this time."

"Are you prepared?" the moderator started to say. Before the hushed room, Golan rose to his feet with a sheepish grin and approached the front of the room. He took the microphone, looking simultaneously small, nervous, and genial, and spoke with a strong Israeli accent.

"My name is Oded. As you probably know. I've tried to remain anonymous for several weeks, but if I'm here it means that I was not successful." He grinned. The audience tittered. "I probably have also some remark to Professor Meyers. I am collecting antiquities from the age of eight, in Israel . . . The collection is now more than three thousand items. Some of them are among the most important archaeological findings ever found in Israel. By the way, one of the first ones was found, also by chance, when I was ten years old and it was published by Professor Yigael Yadin . . . He was not worried about publishing something that was not found on strata of an official scientific excavation. This item, by the way, is the oldest dictionary ever found in the world."

He then explained that he had purchased the James Ossuary "in the early seventies." He said he thought the three names on the ossuary were father, son, and grandfather, and only noticed the word "achui"—"brother of"—later. He pointed out that the Geological Survey of Israel had examined the patina and found it "all of the same construction, composition." He concluded, "Well, that's all I can say for that." The audience applauded.

After his star turn on the panel, Oded melted back into the crowd of biblical scholars, back into the streets of Toronto. After a few Canadian dinners with Shanks and Lemaire, he boarded a plane back to Israel.

It's not clear whether the collector was actually back in Tel Aviv on November 28, 2002. That's the date on which a man named Uri Ovnat, at the time head of an enterprise called International Marketing Development Enterprises Ltd., approached the International Christian Embassy in Jerusalem, offering the James Ossuary for sale for $2 million. The embassy's executive director declined. Questioned later, Golan denied asking Ovnat to try to sell the ossuary. Ovnat said he was merely trying to help out—in a strictly volunteer sort of way, without having been asked.

If the International Christian Embassy had had the money, it might not have wanted the ossuary anyway. For Christian believers, the ossuary highlighted a theological disagreement between Catholics, who believe Mary was a perpetual, lifelong virgin, and Protestants, who accept that Mary might have had other children. This controversy is just one of the many that have divided Catholics and Protestants for years, and that are manifested in Jerusalem and its environs in the form of competing interpretations on the ground— for example, the Garden Tomb on Nablus Road, versus the Church of the Holy Sepulchre on the Via Dolorosa, as the real site of Christ's death and resurrection.

For the American Catholic writer and theologian Ian Ransom, the James Ossuary was nothing less than an assault on one of the tenets of his faith. Ransom spoke for many of his fellow believers when he criticized Shanks and his evangelical audience in a book, *Mary and the Ossuary*. He called *BAR* magazine a "glossy, non-peer-reviewed magazine that would eventually garner a circulation of around 250,000 readers, many of them being apocalyptically-minded evangelical Christians obsessed with pottery shards and other looted bric-a-brac. Mr. Shanks would over the years demonstrate a truly ecumenical talent for satisfying the needs of this evangelical community."

As Ransom was gathering material for his attack on the ossuary, other Christian writers were airing their thoughts on the meaning of the ossuary for Christianity. A Web site called Catholic Answers tried to reassure believers that the ossuary didn't challenge Church dogma, and proposed that James was most likely a cousin or a stepbrother of Jesus, by a different mother.

"Burial Box of Saint James Found?" read the headline:

Some non-Catholics were quick to tout the box as evidence against the perpetual virginity of Mary, however this does not follow. The ossuary . . . does not identify [James] as the son—much less the biological son—of Mary. The only point that Catholic doctrine has defined regarding the "brethren of the Lord" is that they are not biological children of Mary. What relationship they did have with her is a matter of speculation. They may have been Jesus' adoptive brothers, stepbrothers through Joseph, or—according to one popular theory—cousins. As has often been pointed out, Aramaic had no word for "cousin," so the word for brother was used in its place. . . . While the inscription does not establish the brethren of the Lord as biological children of Mary, it does have an impact on which theory may best explain the relationship of the brethren to Jesus.

If James "the brother of the Lord" were Jesus's cousin then it would be unlikely for him also to have a father named Joseph. This would diminish the probability of the cousin theory in favor of the idea that this James was a stepbrother or an adoptive brother of Jesus . . . According to the Protoevangelium, Joseph was an elderly widower at the time he was betrothed to Mary. He already had a family and thus was willing to become the guardian of a virgin consecrated to God.

Bottom line: If the ossuary of James bar-Joseph is that of James the brother of the Lord, it sheds light on which of the theories Catholics are permitted to hold is most likely the correct one, but it does nothing to refute Catholic doctrine.

For Protestants, the ossuary not only proved the materiality of Christ and his family, but reinforced the notion of a pre-Roman and thus perhaps more authentic, Christian church in Jerusalem. As Shanks's cowriter, the seminary professor Ben Witherington III, wrote, the ossuary represents something closer to Jesus Christ than the "Church of Peter and Paul," worked out by the Romans, and the basis of Roman Catholicism. "The ossuary brings back to the fore the importance of the church of Jerusalem which was centered around James and the family of Jesus and was much more traditionally Jewish than the other Christian communities emerging in Rome and elsewhere in the empire," Witherington wrote, in the book he coauthored with Shanks. "Unfortunately the Jerusalem church faded in importance with the violent suppression of the Jewish revolt in the latter half of the first century and beyond. The ossuary thus opens the door on a story and an authentic form of earliest Christianity that has been largely lost to us but may well be most closely linked to the person and religious way of Jesus."

For Eric Meyers, the theological arguments took a backseat to his concerns about unprovenanced objects coming through the market and influencing scholarship. In an interview he noted, "Men like Moussaieff are part of the problem. He is willing to pay $300,000 in cash for unprovenanced objects. In the world of biblical antiquities, the pedigree is everything. It might be the crummiest little seal, but if it has a biblical name it's worth money."

But Meyers said the example of Moussaieff and a few other deep-pocket collectors aside, the biggest investors in the unprovenanced

biblical archaeology market are not individuals, but groups of believers, who he says have tended in the past to be predominantly French and Spanish—people from Catholic countries with big appetites for relics. Historically, the biggest single group of Christian travelers to Israel are Roman Catholics. But American Evangelicals now increasingly finance digs, edging out the Ottoman-era tradition of having Franciscans oversee sites important to Christians.

Meyers said the number of Holy Land digs and consequently, the artifact industry itself, exploded after 1967 and the annexation of territories, and the Israeli excavation of the Western Wall. When Jerusalem came under Israeli control, he said, "The trade imploded exponentially over the years and produced a lot of this material. What seems to be hitting the market is stuff that has been forged epigraphically. The inscriptions have been added to genuine antiquities."

From his vantage point as a scholar and archaeologist who has worked in Israel for decades, Meyers believes we are in the midst of a periodic explosion of interest in biblical history, and increased production of forgeries to take advantage of that interest. "At the end of the nineteenth century, which was probably the apex, we had the Shapira frauds. [German-born Moses Shapira copied genuine Moabite idols and statues and ultimately forged an entire copy of Deuteronomy, one of the books of the Bible, before he was found out.] The nineteenth century was a period of great pilgrimages to the Holy Land, which created an enormous, insatiable appetite in Christians for artifacts and raised prices. Even P. T. Barnum had a diorama of Holy Land artifacts."

The people behind today's forgeries—and Meyers believes there are many— are "underworld crime figures" who are "all up-to-date, all computer savvy. They know real artifacts and know how to add them to materials with state of the art equipment. This is a sleaze

industry, these dealers in Israel. When you deal with these guys you have to have your dukes up and your pocketbooks buttoned or you will have your pants taken off. It is a big-item industry. I have seen guys show up with basalt menorahs from an ancient synagogue, obviously smuggled out via Lebanon, that [get] a million and a half dollars in L.A. It has been going on for a long time, but was mostly accelerated when the West Bank and Golan Heights were occupied."

Meyers didn't accuse Lemaire of being a financial beneficiary when he identified the ossuary as belonging to Jesus's actual brother. "Lemaire is an armchair archaeologist. Since the letters looked good he said OK. I am not saying he was innocent. I am saying he was having an ego trip. He was not making the six figures other guys are getting."

Meyers applauded Shanks for making the dusty field of biblical archaeology look sexy and exciting. "Outside of *Archaeology* magazine and the magazine of biblical archaeologists, which changed its name to *Near East Archaeology*, the journals are just not as colorful. To go four colors in archaeology is quite rare. Only Hershel does it with the gusto and expenditure. A lot of [scholars] want to have these reprints and have their finds made public. By publishing in Hershel's magazine, they pick up a couple hundred thousand readers. But it is kind of self-serving. I used to publish in there until it got too nasty."

⁜

BACK IN ISRAEL as 2003 came to a close, Oded Golan and his famous ossuary were in the newspapers as well. One who noticed the unfolding story was Orna Cohen, a Hebrew University archaeologist, chemist, and conservator. What she knew about Oded Golan would have been very useful to Eric Meyers in his argument with Hershel Shanks halfway around the world.

A genial, middle-aged woman with a cap of short black hair, a

jovial face, and a bemused manner, Orna Cohen has been interested in archaeology since she was a girl in a small town in northern Israel. Trained as an archaeological conservator, she specialized in rescuing old things. Her greatest work, and one for which she gained a kind of accidental fame among Christian evangelicals, was to have disinterred and restored a two-thousand-year-old wooden fishing boat from deep mud on the edge of the Sea of Galilee. The "Jesus Boat," it has been suggested, might not just have plied the waters during Christ's lifetime, but might actually have carried the Savior himself. Cohen spent eighteen years working to encase the boat in buoyant plastic and free it from its muddy tomb, finally floating it to a dryland site for public exhibition. For Christians, Cohen is now linked permanently with the miracle of the boat, a sanctified object on the religious tourist route, and the fact amuses her greatly.

In about 1993, Cohen reckons, she received a call from Oded Golan in her office at Hebrew University. He told her he was a real estate developer, interested in restoring historical buildings and that he needed some information on how to fabricate old patina—the naturally occurring coating on old stones—to make his buildings look more authentic and uniform.

"You know, it was an honest question," Cohen recalled. "I do get this kind of question sometimes. He sounded like an honest person. He told me about some buildings he was interested in, I did some research into the literature, and I gave him all the information about the chemical process, how it can be done." With a minimum of research, Cohen was able to suggest some ways to make stone look old in a laboratory. "You see fresh stone and old stone looks different. It's not just pollution. It's actually a chemical process, on the surface of the stone. It's done by bacteria and bleaches that attack and you can do it. You can fake it in a laboratory. It's possible. So I gave him that information. I said, 'Do you want to bring some samples of

the stone you're working with? We can do that.' He said, 'No that's enough for me.' And that was it."

Some time afterward, she learned that Oded Golan was in fact a major antiquities collector. An alarm bell went off. "I contacted the antiquity authority and told them [about Golan's inquiry]. I felt it was my obligation. I only work with clean stuff. I never deal with fakes and stuff like that. Sometimes people come to ask me about an object, if it's a fake or real, and that's my expertise. But I don't fake anything. I do replicas, but not fakes."

When she read about Oded Golan's world-famous box, it had been many years since she'd seen him and alerted the *Reshut* (Hebrew for authority, and the scholars' nickname for the IAA, short for Reshut ha'Atiqot or "Antiques Authority") about his interest in faking patina. She never knew whether the authorities followed up on her tip, but she read the articles about the newly famous old stone box with much interest.

The Tablet

Fall 2002

So it was, whenever they saw that there was much money in the chest, that the king's scribe and the high priest came up and put it in bags, and counted the money that was found in the house of the Lord. Then they gave the money . . . into the hands of those who did the work, who had the oversight of the house of the Lord; and they paid it out to carpenters and builders who worked on the house of the Lord.

2 KINGS 12–10, 11

IKING TO THE TOP of Masada, the ancient desert fortress, is best attempted before sunrise in summer because of the withering heat. On a morning in June 2007, I set off in the darkness at 5:00 AM to participate in what has become a ritual for Israelis and tourists. The palest hint of the pink scallop shell of dawn illuminated the oily surface of the Dead Sea a half mile away as I contemplated the course ahead of me—thirteen hundred vertical feet to the top of a stark, gold-colored desert massif. Since I was starting from the lowest point on earth, it would be like climbing out of a volcano. Armed with a bottle of water, I began trudging up a single-file, gravelly trail called the Snake Path that twists hairpin-

style to the top, and the spectacular, excavated, and restored first-century ruins of a palace compound built by kings of Judea, chiefly Herod the Great.

The ruins themselves, however, are not the reason why Masada is such a popular tourist destination. The site is invested with national importance for Zionists, who believe Masada (from the ancient Hebrew word *metzada* or "fortress") was the site of the ancient Jewish people's last stand in the land of Israel after the Roman invasion that destroyed Jerusalem and the Second Temple in 63 CE. The story of what happened at the top of the forbidding cliff two millennia ago is as grisly and horrific as the story of what happened to David Koresh's band of followers in Waco, Texas, in the 1990s. As the Jewish historian Flavius Josephus told it, a band of Jewish believers known as the Zealots took refuge at the top of the hill. The Zealots were a revolutionary sect who violently opposed Roman rule and appeasement during the years just before the Great Jewish Revolt that ended with Rome sacking Jerusalem. When the Romans besieged Masada, the Zealots decided that rather than be captured, they would commit mass suicide, leaving a store of grain and water in the center of the compound so that when the Romans entered they would know that the Zealots had not been starved but had chosen to die rather than live under Roman rule.

In the early 1960s, Yigael Yadin, Israeli archaeologist and former chief of staff of the Israel Defense Forces (IDF), excavated Masada in a massive project involving amateur diggers who came from all over the world to participate in what was seen as an effort to uncover proof of ancient Jewish martyrdom. After the excavation, newly minted soldiers would march at night to the top of the mountain to be sworn in, shouting, "Masada shall not fall again." Some IDF units still make the ritual climb, but in the last ten years or so, Israeli and other scholars have begun to question Yadin's interpretation of what

he found at the top of the hill, and whether it actually confirms the story of the Zealots' mass suicide. Yadin himself later conceded that his interpretation might have been influenced by the needs of the nascent Israeli state to craft a national history. In 2002, the author Nachman Ben-Yehuda wrote in *Sacrificing Truth: Archaeology and the Myth of Masada* that Yadin conducted "a scheme of distortion which was aimed at providing Israelis with a spurious historical narrative of heroism." On the day I made my own climb, the Associated Press had just disseminated a new paper by Joe Zias, in which he claimed that his own analysis suggested the skeletons Yadin found atop the mountain were Roman and not Jewish.

The arguments over the interpretation of Masada's remarkable archaeological record had not, however, filtered into the consciousness of the tourists with whom I hiked up the mountain. To my astonishment I was not alone, nor was I the oldest person attempting the grueling trek. After five minutes of climbing, I realized I was underprepared for what should have been marked as an expert-level hike. The heat was pulsating and pressing downward. Struggling to keep going, I thought about the Ein Gedi oasis just twenty barren desert miles away, where I'd spent the previous night surrounded by palm fronds, bougainvillea, and fresh water pools, and how in the context of this arid void, that place must have seemed to the ancients like the source and beginning of all life. In fact, some biblical historians suggest the biblical writers were thinking of Ein Gedi when they wrote about the Garden of Eden.

I had already consumed my small bottle of water and sweated it into my drenched shirt before the sun burst fully over the cloudless horizon and became a searing orb, bleaching the gravel under my feet bone white. Halfway up, I encountered an American grandfather and his eight-year-old grandson, calmly taking a rest on the side of the path. The old man informed me he'd made the trek several times

before. Half an hour later, panting like a dog, I stepped around a puddle of fresh vomit. Scrabbling at last over the top I found a middle-aged woman passed out and being attended to by several of her companions, who were pouring bottled water on her waxy face. Young and old alike were catching their breath in squares of shade, and I joined a Croc-wearing husband and wife from suburban Philadelphia, who were on a summer pilgrimage with their teen children and their synagogue. As I contemplated my blistered feet, we chatted about what we were all doing in the Middle East. Having traveled to Holocaust memorial sites in Eastern Europe, they were now on the second leg of their pilgrimage in Israel. They had survived the climb to the fortress better than most, having started in the pitch darkness at 4:00 AM. I told them about my project, and when I mentioned forged antiquities, the husband confessed that he had just purchased three ancient coins for $20 each in the Old City. He smiled sheepishly as his wife chided him for telling her they had cost him only $9 each.

Masada, like most religious archaeological sites and biblical-era objects in Israel, has different meanings depending upon the audience. There is the popular, marketed interpretation, and the academic—and often, disputed—one. Academic disputes can be notoriously petty, but disagreements in Israeli archaeology are colored by the politics of the greater Israeli-Palestinian turf conflict.

The battles are not confined to Israeli soil. In the summer of 2007, a nasty fight about the politics of Israeli archaeology made the pages of the *New York Times*, involving an Arab American academic named Nadia Abu El-Haj and her bid for tenure at Barnard University. In her dissertation, published as a book called *Facts on the Ground: Archaeological Practice and Territorial Self-Fashioning in Israeli Society*, in 2001. In it she charged that interpretations in Israeli archaeology are distorted by the nonscientific need for a national mythology. She used the example of Masada in her opening page. "During the early

decades of statehood," she wrote, Israeli archaeology "transcended its purview as an academic discipline . . . Science and the popular imagination were deeply enmeshed." She charged that excavations like Yadin's at Masada "emerged as idioms through which contemporary political commitments and visions were articulated and disputed."

A hemisphere away from the archaeological site of Masada, Abu El-Haj's premise so angered pro-Israeli commentators in the United States that they petitioned Barnard not to grant her tenure. Typical of the response was American-born Israeli Paula Stern, who started an online petition to deny Abu El-Haj tenure. Abu El-Haj's "scorn for evidence-based scholarship is explicit," Stern wrote. Alexander H. Joffe—a former lecturer in archaeology at Purchase College–State University of New York—who dug for several seasons at Megiddo and, as of 2008, directed a pro-Israeli American organization called Campus Watch—also weighed in to discourage tenure. "Abu El-Haj has written a flimsy and supercilious book, which does no justice to either her putative subject or the political agenda she wishes to advance. It should be avoided." Barnard tenured her anyway.

Abu El-Haj's book was ham-handed and political, to be sure, but within Israel archaeologists argue about the same issues. Something as simple as changing the estimated dating of certain biblical-era excavations by a hundred years—as Israel Finkelstein, chair of Tel Aviv University's Archaeology Department has done with the so-called Solomon's gates at Megiddo—is cause for resentment, criticism, even accusations of anti-Zionism. Finkelstein is the author, with the American archaeologist Neil Asher Silberman, of *The Bible Unearthed: Archaeology's New Vision of Ancient Israel and the Origin of its Ancient Texts.* By reinterpreting the dating of sites like Megiddo and other ancient biblical cities to a hundred years later, Finkelstein and Silberman revised fundamentalist, literalist interpretations of biblical archaeology. Their new dates, coupled with evidence

unearthed at the sites that indicates a far less unified and wealthy ancient Israel than the nation presented in the Bible, led them to theorize that Old Testament stories reflect conditions at the time of the writing of the Bible—not historical events in ancient times. They argue that stories about the Exodus and David and Solomon's vast biblical empire might be just that, stories, without archaeological corroboration. Their interpretation offended those with more literal views of the Bible. It also had larger, political implications for Israeli nationhood, at least from the point of view of those who would base nationhood on ancient land claims. As one archaeologist told me, "When they have these arguments in English, it gives ammunition to our enemies." And in fact, that is true. Yasser Arafat often used to contend that there was no proof of Jewish inhabitation on the Temple Mount, pointing to the absence of artifacts.

⁂

I MET ISRAEL FINKELSTEIN in the fall of 2007 at his office on the sprawling, ultramodern campus of Tel Aviv University. A tall, rangy man with a bushy, graying beard, born in the north of Israel in 1951, Finkelstein heads a decidedly secular Archaeology Department in Israel's most secular city. He came of age with the baby boomers, and he has an informality and iconoclastic sense of humor that places him firmly within his generation. He doesn't deny that he belongs to a revisionist movement. He thinks it's his generation's job to set archaeology "back on course" and "eradicate an extremely destructive course of thought"—fundamentalist biblical archaeology.

"There have been ups and downs in this debate. And in my opinion, the direction is very clear. The process has taken two centuries and will probably take two more centuries, but we are [moving] from the notion that you can read the Bible as you read the *Boston Globe*."

Finkelstein sees himself and like-minded members of his genera-

tion facing the same kind of faith-based opposition that confronted their Enlightenment predecessors two hundred years ago. "As this critical approach to the Bible developed, the more reactions there were. I would call it revolution and counterrevolution. And the major counterrevolution is the one that is still kicking and biting and today is the highly conservative biblical archaeology." Interestingly, Finkelstein blamed the American William Foxwell Albright, one of the pre-eminent early biblical archaeologists working in what became Israel, for the modern resurgence of fundamentalist biblical archaeology. "He was the one who invented it," Finkelstein said." Albright was the one who came in with the idea that you could fight off high criticism of the Bible with the magic tool, with the doomsday weapon, which is archaeology."

Another of the men Shlomo Moussaieff referred to when he decried people "who want to disprove the Bible," Finkelstein thinks collectors like Moussaieff and alleged forgers are both symptoms of Bible-driven archaeology. "Once in a while, you hear of something which comes from the field, not from the market, that is as crazy and as unbelievable as the surfacing of the Shishak bowl from Megiddo. [One of Golan's alleged fakes, the Shishak bowl is a genuinely old alabaster bowl, with hieroglyphic script carved around the rim translated as a dedication from the Egyptian pharoah Shishak to his general, congratulating him on sacking Megiddo in the eighth century BCE. The bowl seemed to answer a question that scholars had argued over for years: Who destroyed Megiddo?] They want to stop the moderating trend, to desperately prove the Bible is per-fectly historical from A to Z. It's almost a cult, you know. So once a year, always in the summer, at the end of the summer, after the dig season, I wait for the eruption. I call them Messianic eruptions in biblical archaeology. The journalists start calling me. 'Did you hear about this amazing find?'"

As an example, Finkelstein pointed to a 2005 discovery by Israeli archaeologist Eilat Mazar, who excavated what she identified as being King David's actual palace on the outskirts of the Old City in Jerusalem. If the hillside site is in fact the remains of David's palace, then it is not only the first archaeological evidence of David's residence in Jerusalem, but only the second archaeological remnant of David's monarchy ever discovered. (The first and only one so far unearthed is the so-called Tel Dan inscription, a ninth-century tablet that refers to the House of David.) Mazar's site quickly found its way onto the tourist map, and is part of a well-maintained park with state-of-the-art, multimedia, air-conditioned indoor exhibits called "City of David."

Finkelstein is not convinced. "The finding of the palace of King David in Jerusalem is a messianic eruption in biblical archaeology. Why? The dig is OK. The excavation is good. The method is OK. The interpretation is Messianic," Finkelstein says. "I mean, if you look at the finds, you see that there are several big boulders there. Maybe they belong to one building. Maybe other ones are from the same period. Maybe not. There's no context for the dating. The dating can be sometime in the Iron age. It can also be Hellenistic. So how to get from this to King David? You must have some sort of ignition in your brain. There is this idea that you can stop the nightmare called biblical criticism. You can stop the nightmare by a single amazing find, which will revolutionize biblical archaeology and bring everything back. This idea is not only naive, it goes against scholarship. Science does not go on a single find. Science works by a slow accumulation of either legwork, be it in medicine, or library work in literature or whatever. And you're not going to revolutionize a field with one single find."

On trips to Jerusalem, Finkelstein has anonymously visited the City of David Park. "I like to stand there quietly on the side, without anyone noticing me and look at the industry that's going on. Groups

are coming. School kids. Soldiers. Some of them are praying. Some of them put yarmulkes on their heads. But why? It's not a sacred place. And then you hear one guy saying, 'Look, this is where Abraham came from. And then after this he went there. And this was the headquarters of King David, the great United Monarchy which stretched from here to . . .' And so on and so forth. It's an industry."

⊹

DRIVING FROM THE TEL AVIV AIRPORT to Jerusalem on a sunny Sunday morning in Fall 2007, I assumed a quiet day was ahead. In Jerusalem, three weekly Sabbaths are observed in a row. The Muslims' Friday, the Jews' Saturday, and the Christians' Sunday are each respected with various sectors of the city shut down in observance, and the cramped city streets can be somewhat less chaotic on all those days. Traffic was indeed light on the highway, but as soon as I veered off into Jerusalem's winding, hilly streets, I was trapped in one of the worst cases of gridlock I've ever seen. Inching toward the center of the city, I noticed a large series of lighted number 40s perched atop lampposts, celebrating the fact that 2007 marked the fortieth anniversary of Israeli control over Jerusalem. I soon realized that police roadblocks were inexplicably diverting traffic away from the eastern—Arab—edge of the Old City, precisely where the Albright Institute, my temporary home for the next few weeks, was located. Idling with thousands of others in the noonday haze, I had ample time to consider the accuracy of what one of the Albrightians had told me when we drove near Gaza one night a few months before— that being in Israel is like watching a Fellini movie. Everyone else seems to know what's going on, but you don't have the faintest idea.

Hours later, addled with jet lag, I finally got to my room, flicked on the laptop, and surfed the Web to find some news item that could explain what was happening on Jerusalem's streets. It turned out

I had unwittingly timed my arrival in Israel to coincide with an occasional march by Christians and Jews who want to reclaim the Temple Mount from the Muslims. A Web site called Temple Mount Faithful announced that "the faithful will make their pilgrimage . . . and demonstrate against the evil ungodly plans of the weak prime minister and the pressure coming from President Bush and Condoleezza Rice on Israel to divide the land of Israel, to found a 'Palestinian' terror state." The group had planned to attempt "the liberation of the Temple Mount from Arab (Islamic) occupation 18 Tishrei 5768." On the English calendar, that was September 30, 2007—the precise date of my arrival.

Later I learned that this day was also the first day of the Jewish holiday of Hol Hamoed Succot, when crowds of pilgrims from all over Israel visit the Old City. It was also the seventh anniversary of the outbreak of the intifada. As usual, the Israeli police were in the unenviable position of serving as the thin blue line between what passes for Palestinian-Israeli coexistence in Jerusalem, and its opposite—all-out rioting. In order to keep the peace, the police often set up roadblocks willy-nilly that divert traffic from the main routes connecting West and East Jerusalem. Such had been their tactic on that Sunday afternoon.

The focus on ownership of the site of the ancient First and Second Temples is a relatively new phenomenon in Israeli politics. As recently as 1969, former Israeli defense minister Moshe Dayan had exclaimed of the Temple Mount, "Who needs a Jewish Vatican?" The French journalist Sylvain Cypel, in his book *Walled: Israeli Society at an Impasse*, writes that the early Zionist settlers were secular, not motivated by theology, and did not see the colonization of Palestine as a primarily religious endeavor. "The relation to the Bible was marginal at first, since belief and faith were alien to the founding fathers of Israel," Cypel writes. "However, given time and the need,

once Israel was created, . . . the Bible came to play an increasingly crucial role in Israeli nationalism." By the time of the Camp David accords in 1978, the issue of control over the Temple Mount was crucial enough to derail any agreement with the Palestinians regarding the division or sharing of Jerusalem.

Forty years after Dayan's Vatican comment, national aspirations have shifted entirely toward what the former defense minister once jokingly derided. Foreign minister and rising political star Tzipi Livni, forty-eight and a relative moderate, explained to the *New York Times* in 2007, "[M]y existence here comes out of the connection between me and Temple Mount. This is the umbilical cord. It comes from Jerusalem."

Palestinian control over what Muslims call the Haram means that any Israeli archaeological investigation into what lies beneath the plaza and behind the Western Wall is impossible. Recently, Israeli scholars, including Finkelstein, have petitioned the Israeli government to stop the Waqf from digging on top of the site. The Committee for the Prevention of the Destruction of Antiquities on the Temple Mount was founded in 2000 and claims that fifteen thousand square meters in the eastern Temple Mount now "appears like a gigantic construction site." Hershel Shanks, writing in the *Wall Street Journal* in summer 2007, charged that the Palestinians are practicing "Temple denial." Since 1996, Shanks wrote, the Waqf has converted "Solomon's stables" into a large mosque, and bulldozed parts of "the Mount" to make "open mosques." Shanks and others believe the Palestinians, under the guise of making improvements, have deliberately destroyed ancient cisterns, damaged ancient walls, and removed thousands of tons of debris, dumping it all unsifted into the Kidron Valley—a desolate rubble field just beyond the Old City walls.

Yusuf Natsheh is the Palestinian archaeologist employed by the Muslim Waqf to oversee the Haram. We met at his office, on the Old City's Bab al-Hadid Street, in what was once the grand sheik's

headquarters in a warren of low, arched-ceiling rooms that for eight hundred years was a Sufi complex. The metal doors along the quiet alley that lead to his office are all sprayed with dots of multicolored, Day-Glo paint—symbolizing the fact that the occupants have made the Hajj, the pilgrimage to Mecca required of all observant Muslims. Israeli soldiers guard the nearby entrance to the mosque.

Natsheh, a London-trained archaeologist who has written a book cataloguing Ottoman architecture in Jerusalem, strongly resembled Mel Brooks, with the same potato-shaped head and blob of a nose. He brushed aside charges that he and the Waqf are practicing "Temple denial" and destroying ancient history. "We appreciate the mixed heritage and we take care of the site," he said. He insisted that any digging on the Haram is needed to properly maintain the site. "As with any house, any historic site, it needs restoration, maintenance, and this is what we do. No excavation whatsoever. It's not our interest. It's not our thing. It's not our duty. It is not an archaeological site. It is a religious site. And we maintain it according to the needs of the believers and the people who would like to come here to seek a quiet place, to be united with God, and to concentrate." The Israeli police advised the Waqf, he said, to make a bigger entrance gate, for safety purposes. "Three weeks ago we had an electrical failure, so we are putting in a new electricity cable. We moved building stones. The dirt below was added after the expulsion of the Crusaders, it is Muslim fill!"

Natsheh contends that Israeli archaeology is "a mixture of folklore and science." Even the nomenclature of ancient sites is a matter of dispute. "Whenever they mention the mosque, most, not all Israeli archaeologists, they call it the Temple Mount!" Natsheh said. "It's like calling Mohammed 'Jack.' It is the eradication of the name by which it has been known for almost fourteen hundred years, to be replaced by an older name, and that is forgery."

The ongoing fight over ownership shrouds the entire site. The fog

of war obscures not just the visible parts of the site—which are often closed to tourists and even academics—but makes ever more tempting the invisible, buried, and unexcavated areas deep underground. It is easy to understand why, in the climate of deep suspicion and conflict, people can imagine a hidden mountain of historical debris containing secret ancient treasures just waiting for the knowledgeable scholar to identify and interpret them.

In fact, one of those Temple treasure rumors had Israel riveted in the winter of 2003.

⁎

BY EARLY JANUARY 2003, Detective Ganor had made a bit of headway in tracking the mysterious stone tablet. He'd confirmed that an otherwise anonymous character calling himself Tzuriel had attempted to sell to the Israeli Museum, for $4 million, an object of potentially huge theological and political significance: a seventh-century-BCE black sandstone tablet, flecked with gold, bearing an inscription referring to Jehoash, King of Judea, and the First Temple.

The man who had shown the item to the museum had claimed it was found in the rubble of an illegal work site opened on the Temple Mount by the Waqf. The museum had jumped on the object—even reportedly wiring half a million dollars into a numbered Swiss account as down payment—partly because it had been authenticated by the Geological Survey of Israel. GSI scientists had performed fairly rigorous chemical and mineralogical tests on the stone and its patina. They found the letters had microscopic defects along their edges, suggesting weathering over time. The geologists also found that the patina seemed free of any adhesives that might have been used to apply a fake coating of age.

The GSI's most startling discovery, though, was that the patina

contained tiny globules of pure gold. The researchers speculated that when the First Temple was set ablaze by the Babylonians in 587 BCE, as the biblical account holds, the gilding on the walls melted and settled on the ground as tiny particles, which later became embedded in the tablet.

"We started with the GSI," Ganor recalled. "They told us that the same guy had brought the stone to them, several times." The first time, the mystery man showed up with photographs only, then he returned with the tablet in a briefcase, handcuffed to his hand. "It was something . . . something amazing like in films," Ganor said. "And he stayed while they examined it for an hour, two hours, that's it."

Besides providing a description of the man, the geologists told Ganor that the epigrapher Ada Yardeni had also seen the tablet. Ganor paid her a visit, tripping over the passel of cats on the doorstep. Inside, he found a few crumbs on the trail. From Yardeni, Ganor learned that her mentor, Joseph Naveh, had also seen the stone. From the two epigraphers, Ganor collected a business card and a letter with a logo and a phone number.

"We know how to check a phone number. We know how to check an address—but nothing was OK. Nothing! It was a place that never existed! The phone number belonged to an army camp in Ramat Gan [suburban Tel Aviv]. The mailbox belonged to an old woman. The phone numbers were not connected. And we checked the state computer. No one had the same name. There were many, but no one the same age or the same description as this guy. Nothing!"

The man with the Temple-proving tablet handcuffed to his wrist was turning out to be a ghost.

⁜

WHILE THE DETECTIVE was chasing his leads down to a cipher and dead ends, a Tel Aviv University professor and archaeologist named

Yuval Goren was conducting a different kind of investigation on his own. Goren, a married father of two who lived in the suburbs of Tel Aviv, is a geo-archaeologist who specializes in petrography—a highly technical way of examining clay and rock that can determine the geographical origins of ancient artifacts. In his twenty-year career, Goren had worked at the IAA and examined major objects from all over the Middle East, including the historically significant, inscribed Amarna tablets from a tel in Egypt.

A boyish, rather shy man then in his late forties with short black hair, Goren read the *Ha'aretz* article about the tablet with much interest. He was well aware of the politically charged conflict in biblical archaeology between his department chairman, Finkelstein, and archaeologists like Eilat Mazar at the City of David. Personally, he came down on the side of the secular, but he had never expressed his views or entered into the fray at all. He'd never had any reason to.

As a boy growing up in a small settlement in the Negev Desert, Goren knew when he was about ten years old that he wanted to be an archaeologist. "Everybody in Israel lives near some dig," he told me when we first met at the courtyard of the American Colony Hotel in Jerusalem. "I found some coins and started collecting them." Unlike Moussaieff, though, Goren relinquished the habit as a young man. "When I finished high school, I had a nice collection of coins," he said. "When I started studying archaeology, I felt it was a conflict of interest, so I dropped everything I had. I haven't had anything at home ever since, except for things that come and go through the laboratory."

Goren was unaware of the mystery behind the Jehoash Tablet when he first read the article about the amazing object in the Israeli daily *Ha'aretz* in January 2003. However, as an archaeologist for more than twenty years, Goren knew that no archaeological evidence had yet been unearthed supporting stories of Solomon's Temple. As he

read the article, Goren felt unease growing into anger. "It made me angry because I had a feeling that this is too important to be examined secretly by only two people." He was especially curious about the gold supposedly found in the patina of the tablet, attributed by the two GSI researchers to the burning of the gold walls in Solomon's Temple. This notion struck him as bunk. "I think, first of all, the Babylonians were not stupid. They would protect the gold, not burn it. And secondly, if you are an archaeologist, this is far-fetched. You don't find such things. It's too good to be true."

Goren fired off a letter to the GSI, asking a series of questions about how they had examined and verified the stone. He waited a few weeks, but the state geologists never replied. Now he was irritated at the lack of professional courtesy. "I had a feeling somebody was abusing my specialty, which is geo-archaeology in the broadest sense, and using it for things that are— that one needs to be very cautious with." So he sent his letter with its questions to the reporter at *Ha'aretz* who had written the article. He also published his questions on an archaeological Web site. Eventually, the reporter shared photographs of the object with Goren, and a copy of the GSI report. Reading that, Goren could see the geologists had done an adequate job of inspecting the stone. "The examinations they did were perfectly all right," he said. "But the interpretation was not the only interpretation I could think of."

Still acting on impulse, he says, he published his own analysis on the Bible and Interpretation Web site, which is read by archaeologists and Bible scholars worldwide (the same Web site where Rochelle Altman, historian of writing systems, had published her critique of the James Ossuary). "And then, you know, it drew a lot of attention," he says, visibly pained. "Much more than I expected. I knew it was a national controversy, but I didn't know that it was just the tip of the iceberg."

Soon, he found himself in the thick of a controversy unlike any-

thing he had seen in his years as a quiet inspector of ancient rocks in laboratories. "Had I known the dimensions this would take, I don't think I would have sent the letter," he told me in 2007. "I didn't have the slightest idea what I was stepping into."

⁜

IN THE FIRST FEW WEEKS after the *Ha'aretz* article appeared, Detective Ganor and his men worked feverishly to try to track down the tablet and its mysterious owner. Unbeknownst to them, members of the Israeli Knesset had gone to the head of the police in Jerusalem, and asked for a police investigation. Ganor was eating dinner at a restaurant with his wife in January 2003 when he noticed he was being eavesdropped upon by police officers. "My wife and I were in this restaurant and it was entirely empty. I remember I went to the car to get my case file because I was nervous about it, and I had put it in my wife's bag. Then this couple comes in and takes a table right beside us. The restaurant is empty. Why do they sit next to us? It was a man and a woman. And I knew they were police. I realized the police were sending people to follow us, to find out what we have."

A day or two later, Ganor called a meeting with the head of the Jerusalem police. "We asked them to help us, because we couldn't find the stone and we were under a lot of pressure from the Ministry. And the head of the police in Jerusalem says to me, 'If you hadn't come to us, we were coming to you, this week.' So we decided to work together. And that guy next to me in the restaurant turned out to be part of the staff."

The man selected to run the case from the police side, Major Jonathan Pagis, happened to be a personal friend of Ganor's. Pagis, then in his early thirties, and the married father of three (his marriage would fall apart before the case was solved) was physically and temperamentally Ganor's opposite. Where Ganor is lumbering

and dark, Pagis is fair haired, with delicate features, gray eyes, and a heart-shaped, pale, pockmarked face. Ganor is outgoing and—if his colleagues' jokes are to be believed—potentially trigger happy. Pagis is soft spoken, nervous, and restrained. But they have a few things in common, including their training in and respect for history and the fact that they are both highly educated men for cops, with highly educated, well-known fathers. Pagis is the son of the late Israeli poet Dan Pagis, a Polish-born internationally known linguist who survived a notorious Nazi death camp at the River Bug in Romania where forty thousand Jews are believed to have been killed in just four days. One of Dan Pagis's best-known poems is a spare piece that manages to encompass the catastrophe endured by twentieth-century European Jewry in just six lines, called "Written in Pencil in the Sealed Railway-Car" (*"Katuv b'iparon bakaron hehatum"*):

> *here in this carload*
> *i am eve*
> *with abel my son*
> *if you see my other son*
> *cain son of man*
> *tell him that i*

Jonathan Pagis—"Yoni" to Ganor and his friends—grew up in Jerusalem and studied archaeology and languages. His father taught Hebrew literature at Harvard and Chicago, among other places, before he died in 1986, when Pagis was just twenty-one. Pagis studied archaeology in Israel, but went abroad before finishing the course, and "fell in love with Spain." He became fluent in Spanish, and also in Arabic. In the 1980s, Pagis worked as a translator of Arabic in Yitzhak Rabin's administration, making his way through thousands of nineteenth-century Ottoman documents relating to Palestine, includ-

ing early censuses of Palestine, "which told a lot about the country in the early years as a sociological document," he said. He later worked inside the Israeli National Archive and translated documents captured during the various skirmishes and wars with the Arabs over the years.

In the 1990s, he took a job in police intelligence, then moved to investigations, working undercover before becoming deputy head of the fraud division. Pagis and Ganor first met while investigating a case of Russian relics fraud involving the Russian mafia and became fast friends. "It was love at first sight," Pagis joked. Because of Pagis's position in the Fraud Division, he was able to head the police investigation into the tablet mystery.

I met Major Pagis twice in Jerusalem, where he now serves as advisor on Arab Affairs to the head of the district police. We convened at a coffee shop near police headquarters, and both times he was clad in a gray, short-sleeved T-shirt, sneakers, and jeans, armed not with a gun but a cell phone. Unlike his more gregarious counterpart at the IAA, Pagis was extremely reluctant to talk, fearing that anything he said might jeopardize the case he'd spent two years meticulously building. He agreed to be interviewed only with the tape recorder turned off.

✣

PULLING TOGETHER THE RESOURCES of the Jerusalem police and the IAA's network of informants among the site looters, dealers, and collectors, Ganor and Pagis buckled down to find the tablet and its owner. They got a break when they learned that the mysterious Tzuriel had made a phone call to one of the IAA's informants. "He made a mistake, and we got a real name. And we checked his name and we found that he was ex–Shin Bet. A spy."

With a little more digging, Pagis and Ganor learned that the man

they thought they wanted, a lifetime spy now working for a private detective agency, was traveling outside Israel, in Bangkok. There was nothing they could do but put out an alert to detain him at the airport and wait.

It was mid-January 2002 when Ganor finally got a call that his man had been arrested at the airport in Tel Aviv. He immediately drove over and commandeered an interrogation room. "I said to him, 'Listen, I know who you are, and I know your business. This is the picture of the stone. Tell me everything about it, and who owns it.'"

The man denied all knowledge. "He said, 'I don't know anything about it. It's a mistake,'" Ganor recalled. "I had waited three weeks for him to come back to the country. He's the only key to my investigation. I know he's involved."

Ganor knew he was dealing with a man trained in interrogation techniques himself. "There was something very wrong with him," Pagis said. "His suitcase was full of eavesdropping equipment." Ganor snapped a picture of the man, tossed him into jail, and took the picture to Ada Yardeni, who said she *thought* he was the man who'd brought her the tablet in fall 2001—but she couldn't be sure. Then Ganor got a warrant to search the man's house. Scouring the premises, the police didn't find any antiquities. They did, though, find "many other things," the detective recalled with a sly grin. "Things that were . . . good for us to know."

The Mysterious Tzuriel

Winter 2003

Do not remove the ancient landmark
Which your fathers have set.
—PROVERBS 22:28

IN THE HIGH-END BIBLICAL ARTIFACT MARKET, it's not unusual to have several layers of middlemen between the excavator and the buyer. It was Amir Ganor's job to know the names and the networks, and in many cases he did. Some were among his confidential informants. But in his years on the job, he had never encountered the mystery man calling himself Tzuriel, who'd been going around Israel with a First Temple–era, history-making inscribed tablet handcuffed to his wrist.

The fact that Tzuriel seemed to have connections to the Israeli Secret Service didn't unduly trouble the detectives. They were both part of the Israeli national security apparatus, after all, and investigating a legitimate case. Still, it gave the case an extra frisson, adding to the pressure coming down from high in the government. They knew that the man sitting in the airport holding cell was not going to be easily cracked. A professional spook, he knew all their tricks and more.

Sometimes, though, investigations advance thanks to luck and unrelated information. Ganor's search of the man's house had yielded neither the stone nor any links to it, but the detective had found something significant—something rather embarrassing, actually. It was something Ganor could use as leverage. "It's not nice what I did to him," Ganor said sheepishly, without being more explicit.

Pagis filled in the details.

"It was Friday noon. I'm with my kids at home in Jerusalem. The guy is in Tel Aviv, and he still says he has nothing to do with the stone. Amir is sure he is lying. His suitcase is full of eavesdropping equipment. They then find something very embarrassing for him, which is that he was cheating on his wife. So Amir tells him and the guy begs them, 'Please don't tell my wife!' He is terrified."

Apparently domestic tranquillity was worth more than whatever the tablet's owner had paid. After four days in a cell, the previously unbreakable spy quickly confessed that although he was not "Tzuriel," he knew who Tzuriel was and where he could be found. He provided an address. Satisfied that the man had cooperated, Ganor released him on the spot—a mistake, in Pagis's opinion, but Pagis was in Jerusalem babysitting and not consulted. As it turned out, the man wasted no time warning his colleagues to cover their tracks.

That afternoon, Ganor dispatched an undercover IAA deputy to the address, which turned out to be the office of a small private detective agency in Ramat Gan, a high-rise suburb of Tel Aviv with a large diamond exchange and, at the time, a thriving prostitution and gambling scene. The IAA operative went to the office and pretended to be seeking to hire a private eye. Waiting inside, he noticed a document with an IAA logo come over the fax machine behind the receptionist, along with a scribbled warning note. It was a document Ganor had given his suspect at the airport. The secretary took the fax into an inner office, and minutes later emerged and started feed-

ing paper into the office shredder. That's when the agent stepped out and excitedly called Ganor, who was cooling his heels in a car on the street downstairs.

The burly detective wasted no time. Leaving his car illegally parked midstreet, he burst through the office doors—a six-foot-six man with holstered semi-automatic pistol on full display—and demanded to see the boss. "I got inside and I saw the secretary was putting paper in the shredder," Ganor recalled. "I said, 'Who is the head of the office? Where is he?' She said, 'In his room.' I said to her, 'I am going to his room.' She said, 'No! No, you can't come inside!' I walked into his room and said, 'I know who you are. I know what you're doing. I want Mr. Tzuriel here in the office, now! If you don't bring him now, I will close your office.'" Pagis described the scene in a bit more detail. "Amir told him to hand over the tablet, or he would turn the office upside down. They believed him. Amir is good at that."

The detective recalled that "I was very upset and I shouted at him. He was petrified. I don't know why. He was also an ex–Shin Bet guy. Very famous, actually. Maybe he was afraid that we had found something on him in the search."

The former spy turned private detective immediately became cooperative. "The guy that you're looking for will be here in two minutes," he told Ganor. "He knew exactly who and what we were talking about," Ganor said.

After ten minutes, a nondescript, middle-aged man walked through the office door, shook Ganor's hand, and invited him to come to his house for a quick chat. "I said to him, 'You are Mr. Tzuriel?'" Ganor recalled. "He said, 'I'm not Mr. Tzuriel, but I present myself as Mr. Tzuriel. And I have a problem.' He said, 'I have a flight to Paris an hour from now.' And I said to him, 'You won't fly anywhere, until I hear the whole story.' And I set up the video camera right there, and said, 'Let's start.'"

Perhaps thinking about a fine bottle of Château Margaux wait-ing a few hours northwest by jet, Tzuriel—according to Ganor—got straight to the point. "I'm the guy that you're looking for," he said into the camera, Ganor recalled. "My name is Tzur. I present myself as Tzuriel. I met Professor Yardeni. I met Professor Naveh. And I met with the GSI. And the guy that trained me to do everything was Oded Golan."

THIS BOMBSHELL REVELATION did not exactly stun the IAA detective. Two weeks prior, an informant had linked the Tel Aviv collector to the stone. Based on that tip, Ganor had begun surrepti-tiously trailing Golan between an office, a storage warehouse, and his Feival Street apartment in Tel Aviv. Ganor had also applied for and been granted a search warrant for his properties. But IAA chief Shuka Dorfman, the detective's boss, was worried that a confidential informant's tip was not enough to base a search on in such a high profile case. "He said, 'It's not enough evidence. Please wait,'" Ganor recalled.

Now, Ganor had something more. Tzuriel himself was on video-tape, naming Oded Golan as the owner of the precious stone. He called his boss and again insisted on a search of Oded Golan's prop-erty. Again, Dorfman urged caution. "He was worried if I missed once, I would never find the stone. There was great pressure on his back. So he said to me—this was two in the afternoon—'Wait.' And I said, 'I have the evidence. He is involved. I want to do it now!'"

Dorfman ordered his impatient detective to hold a meeting first, to assemble his team in Tel Aviv at five that evening, before starting to search. At the meeting, Dorfman gave Ganor the go-ahead, and by seven that night, agents from the IAA and police were in place out-side the collector's Tel Aviv apartment, outside his office, and outside

his storage warehouse, waiting for orders to enter. The plan was to search all three locations simultaneously. Ganor himself was waiting outside the collector's apartment and was about to pull the trigger for the search, when his cell phone rang. It was his boss.

"Then the real drama started!" Ganor recalled. "Ten minutes before the search, Shuka calls and tells me, 'Amir, listen. I got a phone call from the Ministry of Education. And they told me that the owner of the stone wants to negotiate with us, to present us the stone.'"

Ganor was furious. "I said to him, 'Listen Shuka. I have worked on this for three months. For three months, I didn't sleep! My team's been working around the clock to find this stone. Now I want to go inside. Now I want to find it. That's it.' And he said to me, 'OK.'"

Ganor and four agents rang Oded Golan's doorbell. The collector ushered them in. The detective didn't beat around the bush. "I said to him, 'Hello Oded, you know me. I'm Amir, and this is my team. We have a search warrant to search your house. Please give me the stone.'"

The collector denied any connection to the stone. He was, Ganor recalled, upset, shaking and nervous, but he stood his ground. "And I said to him, 'Oded, we know everything. Please! Do it!'"

Oded wouldn't back down. Ganor and his men commenced their search. They went through the collector's house from top to bottom, focusing on papers in his desk and files. After hours of painstaking search, they came up with everything but the stone itself. They found a contract for the stone, written out to the Israel Museum, but unsigned. They found receipts from Isaac Tzur's detective agency. They found a collated set of pictures of the stone, which had been presented to the GSI. "Everything! We found everything. But he said, 'It's not in my possession. I know nothing about it.'"

It was dawn when Ganor packed his evidence in boxes and did

the only thing he could think to do. He arrested Golan on suspicion of holding stolen property and trying to sell antiquities without a license. It was a standard charge—something he could have brought up against any number of collectors or dealers, at any time. He took the collector to a Tel Aviv police station for a formal videotaped interrogation.

That morning's session was fruitless. Oded turned out to be tougher than he looked. He refused to admit that he had any knowledge of the stone, even faced with the paper evidence that seemed to link him to it. Ganor had no choice but to send the collector on his way, with instructions to come back the next morning for more talks. "We told him to come back to our office every morning after that," the detective recalled. "And we talked about all of the things that we found in his home, about the documents and the draft agreements that he made with the Israel Museum and with collectors and other people all over the world."

Ganor had not forgotten about Oded Golan's connection to the James Ossuary. It was February 2003, and the relic that had rocked Christian interpretations of the Virgin Mary's virginity and supposedly proved Christ's materiality was still on display in the Royal Ontario Museum in Canada. The box was out of sight and out of mind in Israel, which was in a state of panic and turmoil. It appeared an American assault on Iraq was inevitable. Israelis well remembered the Scud attacks of the 1991 Gulf War and fully expected Saddam Hussein to propel his weapons their way again. Furthermore, there was the tablet itself, a piece of proof that would help cement historic Jewish claims to the Temple Mount, tantalizingly within reach, yet mysterious and unattainable.

"It was funny because during our search [of Golan's apartment], we saw albums of pictures of the ossuary but we didn't take them," Ganor recalled. "We were very focused on the stone, the Jehoash Stone."

From late February into mid-March, Ganor and Pagis grilled Oded Golan in Tel Aviv on a daily basis. There were thirty interrogations over a month's time, during which the collector never cracked. Ganor and Pagis first developed the working routine that would characterize their lives for nearly two more years. They spent the days interviewing people—starting with the collector, with whom they were now involved in an open game of cat and mouse—and ended them surveilling. "We started tailing him, like hunters after prey," Pagis said. "We were full of adrenaline. We wanted the stone. And at that point, we didn't suspect Oded Golan of doing anything wrong [other than lying]."

At night, after a morning of interviews and an evening of tailing the collector, the two investigators would rendezvous in one of their two offices, mix heaping double spoonfuls of Nescafé into boiling water in Styrofoam cups, and discuss the case, mapping questions, theories, and strategy for the next day. "We would come back to my office and first of all calm down," Pagis said. "Then we started talking about what we did today and about what to do tomorrow. All these decisions had to be thought out carefully and thoroughly. There was no easy way to confront a person like Golan."

The daily cycle of interviews and surveillance continued for four weeks with the collector conceding and revealing nothing, but the detectives and their teams were making small headway. They were gathering bits and pieces about Oded's modus operandi by surveilling him day and night and culling information from anonymous sources in his circle.

Throughout their videotaped interrogation sessions, Oded was usually pleasant, if evasive. It was only toward the end, Pagis recalled, that he stopped cooperating. "We would come in and say, 'Good morning.' And he would say, 'On the advice of my lawyer, I can't speak to you.' And then he'd say nothing."

Thanks to heavy surveillance, in mid-March, the detectives got a break. They learned that the collector had another storage warehouse in suburban Ramat Gan that he had not previously revealed. "He had told us that he had one storage down in his office, and another empty one in Tel Aviv, and that was it," Ganor recalled. "Then we discovered that he had a huge storage warehouse at Ramat Gan. So we arranged another search warrant. But before the search, we brought him to the police station, and we asked him about it." The collector again denied having any connection to either the stone or any storage space in Ramat Gan.

"So we arrested him," Ganor recalled. "And we took him with us in our car to Ramat Gan."

It was early evening on the night of March 13 when they pulled up in front of the warehouse. Ganor had already arranged for his staff to assemble there, with trucks and packing boxes. He made sure Oded saw the trucks and understood that whatever was inside could be removed. "We pulled up and we asked him one more time. 'You have something to say to us now?' And he saw the IAA truck and all the people that were there to take things, and he said, 'Oh yeah, I forgot. I had another storage here in this building.' I said, 'Ahhh, OK.' And I asked him if there was a chance we were going to find the tablet inside. And he said again, 'I don't have any connection to the tablet.'"

When the authorities asked him why he had secreted so many valuable objects in this one spot, Oded Golan told them that he was worried about imminent Iraqi bombing. The detective found that argument ridiculous and told him so. "This was the one bombed area in the first Gulf War! The only area in Israel that was bombed! Why hide things here?"

The handcuffed collector stood by in silence as the police and IAA broke open the warehouse door, and faced the mother lode: literally hundreds of antiquities, on shelves and in boxes, crammed to

the ceiling. "These were unique things, very special things," Ganor recalled. "Worth hundreds of thousands of dollars."

Still, the detective was inclined to give the collector the benefit of the doubt. "I thought that maybe he tried to hide the things here because in the first search warrant, we didn't take any archaeology from his home, only documents and pictures. And maybe he thought we were planning to take his collection. And so he tried to hide it. I don't know. That was my assumption."

The agents commenced their search. Half the storage space belonged to Oded's publisher brother, so some of the shelves were crowded with books. The searchers also found a massive collection of pornographic videos and DVDs, which they cataloged and seized. Still, they found no tablet and nothing obviously illegal.

Late in the night, though, Ganor's men made a curious discovery. They found a large number of boxes filled with tools—diamond cutters and grinders mostly—and other materials including wax, clay, industrial chemicals, and baggies of soil, labeled by origin, as they would be in the university Archaeology Department where Amir Ganor got his training. Furthermore, there were boxes of half-made antiquities—seals, seal impressions, and statues. It was three o'clock in the morning, and suddenly the detective had a revelation.

"It was amazing! I said to him, 'What is going on here? Why *do* you have all this laboratory equipment?' There were little nylon bags with the charcoal from dated archaeology sites, stolen from the university. Why did he need it? I knew why he needed it! The moment I saw it, it clicked and I understood. I asked him, 'Tell me, Oded. Are you preparing antiquities? Have you got a laboratory to fake antiquities?'" The collector, who had been standing by in handcuffs all night, was visibly shaking. "It was not nice for him to be in handcuffs," Ganor recalled. "It was a lot of pressure. It was our wish that he feel the pressure."

"He said, 'No!' He was shocked. He said, 'No, don't say that!' And I asked him why he needed all the tools and why he had half-prepared statues? There was box after box. It was amazing!"

<p style="text-align:center">⊹</p>

FOR GANOR, THE tools and ziplocked baggies of charcoal and the half-made figurines and ostracon were deeply suspicious, and something to file away for future reference. But he hadn't accomplished his primary objective, the one for which the whole state of Israel was waiting, the Jehoash Tablet. He felt, though, that between the handcuffs and the incriminating discoveries, the collector was ready to crack. He needed only to press one more button. He was loath to do it, but he felt Oded had left him with no choice. As dawn broke, and the IAA trucks loaded with his collection drove away from the warehouse, Ganor rounded up some police officers and a few of his agents, and, with the collector still handcuffed, they headed off to Golan's aging parents' apartment in Tel Aviv.

Even as they were driving there, the detective hoped he could avoid what was coming. "I said to him, 'Don't do this to your old parents. Just bring me the stone. Tell me where it is. That's it. We know everything. Why are you playing with us? Bring me the stone and I will take it and check it for ninety days. I have the right to do that under the law, and you know it. And after ninety days, I will give it back to you. What is the problem?' He said, 'No, I don't have any connection to the stone.'" Ganor pleaded with him. ' "But Oded, we have found everything. Why are you doing this to yourself?' So we took him to his parents' house."

The detective grimaces at the memory. "It was not very nice for us because he was in handcuffs and we woke his old parents up and they came to the door straight out of their bed. I felt sorry about his parents. This was not a nice picture to see."

The detective asked Golan's parents to sit in a separate part of the apartment while the agents began their search. He felt, he said, that the Golans were "not surprised" to be thus disturbed. "They knew exactly what we were looking for."

As IAA and police agents poked in drawers and desks and under couch cushions and beds, Ganor chided the collector. "See what you are doing to your parents? Aren't you ashamed?"

The breaking point came as agents entered the bedroom. "He didn't want us to check their bedroom," Ganor recalled. "I still don't know why, what he had hidden in there, but he didn't want us to see it."

The handcuffed collector suddenly approached a police officer and asked for a private conversation. He said he did not want to speak with Ganor. He told the police officer that if they didn't search his parents' bedroom, he would bring them the stone.

"The police officer comes to me and says. 'Amir, here is the deal.'" Ganor glanced at Oded and saw that the man was broken, sweating and panicked. "He was destroyed at this time." For his part, Ganor was furious that the investigation had reached this point. "I didn't enjoy the suffering of his parents. I wanted to hit him, for what he was doing to his parents. I saw my own grandfather and grandmother in the same situation. I don't like to do that. Even when we search actual criminal guys, to see their children, to see their wives, it's always very difficult for me. It's my trauma. I don't like it. I never have."

Ganor restrained his fury and considered the offer. He quickly decided that as curious as he was to know what Oded had hidden in that bedroom, having a bird in the hand was better than searching for one in the bush. He agreed to Golan's offer. The search party retreated from the apartment.

Oded agreed to turn over the Jehoash Tablet in a few days, with his lawyer present. "He said to us that he needed to bring it from the

hiding place, and he asked us to give him two or three days to bring it." The detective agreed not to tail him.

The next day, the collector's lawyer met with the Jerusalem district attorney to work out a deal. Golan would turn over the stone for inspection, if the authorities would agree not to charge him for lying about it.

⁘

TWO DAYS AFTER the climactic search at his parents' apartment, Oded delivered the stone to his lawyer's office in Jerusalem, and Pagis and Ganor went to collect it. Both men recall a shiver of excitement at seeing the notorious object. "The lawyer took the stone out of a box and it was really something for both of us," Pagis recalled. "It's like you are holding part of the First Temple in your own hands."

After admiring it, the cops carefully put the stone back into its case and delivered it to the police station, where they then assembled their entire team, the head of the Jerusalem police, and the director of the IAA. They decided to milk the moment for all it was worth and to publicly present the stone to the minister of education. "In a few hours we arranged a journalist party," Ganor recalled, translating the Hebrew for *press conference* literally.

Then a new drama ensued. Half an hour before the press conference, the team gathered to celebrate and gaze upon the precious, elusive Jehoash Tablet. One of the police officers, a member of the investigative team, reached in and pulled the tablet out of the box. The object slid out of his hand, fell onto the table, and cracked in half.

Every face in the room, Ganor recalled, "went white." The officer himself looked like he was going to have a coronary. A moment of shocked, horrified silence ensued, then Ganor burst out laughing. "They said, 'Why are you laughing?' And I said to them, 'At least now it's possible to examine it from the inside.'"

Ganor and the Jerusalem police were remarkably undeterred by an accident that, in the United States anyway, would have left them at the least liable to be sued by the tablet's owner. They proceeded to present the broken tablet to the education minister, who then displayed it to a room packed with local and international journalists. It was March 17, 2003. At the press conference, the minister asked Ganor if he would read the tablet. He started to translate it, and then Pagis interrupted. "Yoni said to the minister, 'I would like to translate it,'" Ganor recalled. "He said, 'It says, two months of no sleep, around the clock.'" It was a funny moment, and the assembled team and the journalists burst into laughter. For the investigators, the laughter was part relief, fueled by a sense of a job well done. "We had found the stone and we were happy," Pagis recalled. "We thought it was all we were looking for. We hoped it was genuine and that we had proof of the First Temple."

Neither Ganor nor Pagis nor anyone else in the room that spring afternoon knew that the investigation had actually just begun.

[CHAPTER 8]

Scholars

Spring 2003

Everybody wants to find the Holy Grail.
Especially scholars.

—TEL AVIV UNIVERSITY GEO-ARCHAEOLOGIST
YUVAL GOREN

URING THE FIRST THREE MONTHS of 2003, while the detectives and Oded Golan were playing cat and mouse in police stations and IAA offices and on the streets of Tel Aviv, the James Ossuary was on display behind Plexiglas at the Royal Ontario Museum. Throughout the Toronto winter, thousands of people bought tickets to see the pristine, simple white box, many in silent prayer, mostly oblivious to the questions about its origins and meaning, and all certainly ignorant of the daily police interrogations the ossuary's owner was submitting to on the other side of the planet.

In fall 2002, the IAA had given Oded Golan a license to ship the ossuary out of Israel for three months. At the beginning of March, with the collector ever more implausibly denying any connection to the Jehoash Tablet, Amir Ganor asked him to bring the ossuary back to Israel, as specified by the temporary export license. "We asked

him to give it to us for checking, which is one of our rights under the law," Ganor recalled. The collector balked and tried pulling official strings to get around the IAA. "He tried the minister of tourism, and lawyers, to help him so he could send the ossuary to the United States and Europe first. But we told him he must bring it back." When the ossuary arrived at the Tel Aviv airport, Golan was still insisting that the IAA couldn't have it, but Ganor seized it anyway.

By the middle of March, the IAA had both the Jehoash Tablet and the James Ossuary in its possession, both a little the worse for wear after their long odysseys.

At the same time, international scholarly contention about the James Ossuary's validity had grown to such a pitch that the Israeli authorities felt it was incumbent on them to investigate. Ganor didn't suspect anything was wrong with the ossuary itself. What he did suspect was theft or fraud in the way the object had made its way onto the market. After three months of Oded Golan's lies about the tablet and his warehouse, the IAA couldn't simply ignore the concerns about another world-famous object in his collection.

Uzi Dahari, deputy director of the IAA, was put in charge of the committees. In a final report, he later explained that the IAA was forced to investigate by the national and theological furor over the objects themselves. "Word of the almost simultaneous discovery of the bone box known as the 'James Ossuary' and the Yehoash inscription, from an unknown source (not from a methodical excavation), together with the emotions raised by the finds and extensive public interest amongst Jews and Christians, obliged the IAA to take action . . . If the pieces are authentic (particularly the Yehoash inscription) then they are of great scientific value. The IAA was bound to do everything possible to arrive at the truth and present its conclusions."

The IAA established two committees of scholars to examine the two objects. The committees were organized by area of expertise.

A Materials and Patina Committee consisted of chemists and geol-ogists who could examine the fabric of the ossuary and tablet. A Writing and Content Committee consisted of epigraphers and philol-ogists who would examine the words, context, and form of the script on the artifacts. The writing committee was further subdivided into First Temple and Second Temple period experts.

IAA director and former Israeli general Shuka Dorfman made a point of announcing that the members had been selected objectively and with extreme care, and that they had been chosen on the basis of their expertise, not on the basis of previous opinions they had voiced about the objects. (The decision to ignore scholars' previous statements and perceived biases became problematic right away.) Dorfman instructed the scholars to "arrive at the truth based on pure research only—without taking into account any other related factors regarding the collector, current gossip, rumors, or prejudices."

Among those selected for the materials committee was Yuval Goren. While Ganor and Pagis had spent the winter trying to find the tablet, Goren—without having seen the tablet itself—had inde-pendently posted a paper on the Internet proposing a method by which a person could have faked the tablet. Goren actually created his own fake patina in a lab, engraved a stone with three Hebrew let-ters (the word for "king"), and coated it with patina to prove it could be done.

Goren had written that he "easily carved [his inscription] on a pre-polished surface of rock using iron tools that leave no traces of nickel, chromium, etc." He artificially "aged" the inscription by blow-ing fine quartz on the surface using an airbrush, creating a "weath-ered'" look that held up even under stereomicroscopic examination.

Goren then created the patina by "crushing another fragment of the same rock in an agate mortar (to prevent contamination) and in an ultrasonic bath (to disaggregate the stone), then producing a

watery solution of the powder." He coated the entire surface, including the inscription, and then let it dry. He aged the patina further with microwaves, which produced minute cracks and grooves. He used a gas burner to spray the object with gold. He also suggested implanting actual Iron Age charcoal—stored in archaeology departments—from an archaeological site into the cracks in the faked object. The whole process, he wrote, would produce an object that could elicit "exactly the same analytical results" as the GSI geologists had found on the Jehoash Tablet.

Although he did all this in the months before he was assigned to the IAA committee, Goren insists he wasn't out to prove the tablet itself was fake. "I just explained how such results or such materials could be used in the laboratory. My bottom line was that examinations are not enough for holding beyond any reasonable doubt that the Jehoash inscription was authentic. I didn't know that it was fake, but I felt [the GSI analysis] wasn't enough."

In creating his own fake though, he had already incurred the wrath of the GSI geologists who had originally verified the tablet. "Some of them didn't like the idea of me criticizing them in what they considered to be the media."

In any case, despite his early involvement in the question of the tablet's authenticity, or perhaps because of it, Goren found himself tapped by the IAA to be part of the materials committee examining both the ossuary and the tablet. His team members included the conservator Orna Cohen, who had once been asked by Oded Golan how to make fake patina. Other members included Uzi Dahari, deputy director of the IAA, geologist Avner Ayalon of the GSI, carbon dating expert Elisabetta Boaretto of the Weizmann Institute of Science, and Jacques Neguer, an IAA antiquities restoration expert.

The committees were convened for the first time on March 26, 2003. IAA director general Shuka Dorfman greeted the scholars and

explained their assignment: to determine the authenticity of the two items. He added a caveat about the impact and seriousness of their work. "These determinations will be of dramatic significance both from an ideological and financial aspect."

The government had prepared a special room at the Rockefeller Museum to house the two items, and for the scholars to work. Each member was given a file of digital close-ups of the two objects. The examining room was outfitted with extremely powerful lighting, ultraviolet light, an illuminated magnifying lens, microscopes, and binoculars. The committee members were to have access to the room at any time of the day or night, seven days a week. They were also granted access to other ossuaries and inscriptions in the IAA storerooms for comparison purposes.

As the scholars commenced their work, the provenance of religious antiquities was far from a public priority. The Middle East was at war. On March 19, the United States had commenced the "shock and awe" bombing of Baghdad, kicking off massive anti-American demonstrations in Cairo, Damascus, and Beirut. Israelis were sleeping beside their gas masks, prepared for Iraqi Scud missile attacks.

At this point, only the hard-core denizens of biblical archaeology were riveted by the news of the IAA's empaneling of scholars to investigate the validity of two of the most important finds in decades. In fact, Hershel Shanks's book on the ossuary had been published in the United States in March, with no mention of the IAA investigation into Oded Golan. The May–June issue of *BAR* reported newly published academic suspicions that some other high-value items of biblical archaeology, previously believed to be of major historical importance, were also fake. The items belonged to Shlomo Moussaieff, although how much he'd paid for them and from whom he'd bought them was not yet published.

In the same issue of his magazine, Shanks offered a prize of

$10,000 to anyone who could create a convincing fake. His "Fool the Experts" contest never found a winner. (Goren didn't bother to enter.)

✢

YUVAL GOREN is secular, but that doesn't mean proof of the First Temple leaves him unmoved. The national history of Israel and the ancient history of the Jews in Israel is deeply important to him. Both sides of his family came to what they then called "Palestina" from Germany in the 1930s, fleeing Nazi violence. His maternal grandfather, he says, had decided when the Nazis first came to power that he and his family "would leave when the first stone hit the window. And the first stone hit in 1936 and immediately they left." Goren's father, orphaned as a teen, also left Germany for Palestine in the 1930s, but joined the British Army and fought the Nazis in Europe in World War II, before returning to Israel and marrying Yuval's mother.

His mother abandoned her family's Orthodox tradition and lived a secular life, but the rest of that side of Goren's family remains strictly religious. "When I go to weddings," he says, "everyone is in black, and it's a different world. For me, I sometimes feel I can communicate more easily with Palestinians on the West Bank than with them. But I had no political, religious, or other agenda whatsoever in this, except for one thing: I think that people were not very cautious about things which we should be very cautious about. What drove me into the case without really knowing how it would develop—because had I known, I never would have been doing it—was the story of the Jehoash inscription, in which actually my discipline was used. And what they did with the Jehoash inscription was in my opinion just an abuse of my discipline."

Goren's initial response at seeing the Jehoash Tablet at the Rockefeller Museum was that it was perfect. "Wonderful," he recalled. "The tablet is beautiful. You don't see the gold in it with the naked

eye, but [the script] is very clear. And it's written in ancient Hebrew. It's not a type of script that somebody in the street will be able to read. But my daughter, who was ten years old at that time . . . one day when I came to examine it, she was with me. I brought a book about the ancient script. And after a very short exercise she managed to read it also, just by comparing the letters. It's very clear."

Goren and his colleagues on the IAA's materials committee conducted myriad tests on the box and tablet using both highly technical laboratory methods— stereoscopic microscopes with magnification powers up to 40X, high-resolution photography—and low-tech tests of the strength and density of the surfaces using toothpicks and scalpels and corundum (diamond tools). Goren examined samples of the patina petrographically, and using metallographic techniques.

Goren was selected to write the final report for the IAA on both the James Ossuary and the Jehoash Tablet. In a terse, four-page letter, he reported that both objects were fakes.

The committee decided that the tablet's stone wasn't even from Israel or its environs, as the GSI geologists had determined, but most likely from Cyprus. "It should be noted that there are no parallels for the use of exotic stones in the assemblage of rock-cut inscriptions of the First Temple Period," Goren wrote. But the most damning evidence was in the patina. The patina in the carved James inscription, he found, was inconsistent with the age of the box and the conditions—a dark, damp tomb—it would have been kept in for a couple of millennia. "This means that the patina is unlikely to have been created in the Jerusalem environment of that period," Goren concluded. The Jehoash Tablet also had a different type of patina inside its inscription than on the surrounding stone.

Genuine patina forms in ultrathin layers because of changes over time in the environment in which the artifact is buried, and neither of the objects exhibited these. The patinas in the inscriptions also

contained many more microfossils than the patinas on the rest of the two artifacts, or on other ossuaries (the natural "patination" process dissolves traces of ancient sea life within the limestone). The gold in the Jehoash Tablet's coating was even more suspicious. In addition to the unlikelihood that conquering Babylonians would have wasted all that loot in flames, it was impossible that a patina thousands of years old would have picked up nothing from the dirt in which it lay except microglobules of gold.

The fake patina on both the ossuary inscription and the tablet were also similar. "It appears to be an artificial mixture of ferruginous clay, powdered chalk, carbonized matter and microscopic particles of metal (gold?)," Goren wrote. "It appears that this mixture was first dissolved in hot water before the inscribed surface of the stone was heated in an oven in order to solidify the inscription coating. The temperature was no higher than 400 degrees C, since the carbon was not destroyed and the clay did not sinter." Goren later nicknamed the substance "James Bond," a play on the powerful and deceptive bonding of the modern substance to the ancient surface.

The GSI had simply not gone as far as Goren and the IAA scholarly team in its initial examination of the ossuary and tablet. Goren now says he believes the GSI scientists were lax in their initial review of the tablet, which was more obviously fake than the ossuary inscription, partly because of the carefully crafted beauty and soundness of the tablet and because of its historical significance as the first-ever archaeological link to one of the Hebrew kings.

But the government geologists could be excused a little because they had no way of knowing they were dealing with a high-tech forgery. The scholars were up against something new. Highly sophisticated methods had been used to fool scientific experts, not to mention scholars who might simply identify things by "feel" or using epigraphic knowledge.

A French author, Patrick Jean-Baptiste, who interviewed many of the scholars, wrote that the various techniques used by modern forgers are now so efficient that the experts often find themselves incapable of being certain that the object they have to study is a fake. "Highly sophisticated and expensive tests are required, and even those are not infallible if a knowledgeable forger plans ahead," he wrote. Thermoluminescence allows investigators to date ceramics but not stone. Carbon 14 also allows dating, but only for organic materials, like wood, ivory, and papyrus. Electron microscopes enable observation of possible mechanical abrasions which may have been used "to age" an inscription. The inscription itself may contain paleographic errors or suspicious stylistic new elements. "When we are dealing with an inscription on stone, however, only complicated methods can enable us to discover any possible trickery, and even then, only on the patina," the French writer noted.

The James Ossuary fared no better than the tablet under close inspection. The committee determined that the limestone box itself was probably genuine—made of limestone rock from which Second Temple period ossuaries were hewn. It was also coated with natural patina. So far so good. But under close inspection, the patina in the inscribed letters was different from the coating on the rest of the box. "The inscription was engraved (or at least, completely cleaned) in modern times," Goren wrote. "The inscription coating is not natural. It was made by grinding and dissolving chalk in hot water (possibly the powder resulting from the newly carved inscription), and spilling the paste onto the inscription and surrounding area, in order to blur the freshly engraved signs."

While he'd had his doubts about the tablet from the first time he'd read of it in the newspaper, Goren told me he was stunned by what he actually found on the James Ossuary. "Until then I was sure that everything was OK with the ossuary," Goren said. "I couldn't see

any reason to doubt it. The doubt came when we started examining it closely and, first of all, the odd thing was that even under a magnifying glass, but more under a stereomicroscope, one could easily see that the patina in the letters was completely different from what was around it. The letters were clearly cutting the biopatina, that is the patina that is on the surface."

And in the places where he found patina within the letters, Goren noticed that it didn't match or fill the letters. Further, there were scratches, near the letters or coming out of the letters, but not related to the letters.

Goren and the materials team had also noticed that one half of the ossuary appeared to be cleaner than the rest—an observation also made by Meyers, who looked at it behind glass at the Canadian Museum. Oded Golan would always contend the clean spots were due to the fact that he'd left the ossuary at his mom's for two decades, and she'd scrubbed it regularly with modern soaps.

The inauthenticity of the inscription on the ossuary was less easily provable than that on the tablet, which scholars thought was fake through and through. But Goren argued that the doubts he and the committee had raised should be enough to remove it from serious consideration as a historic object.

"You need to prove [authenticity when] something comes from the antiquities market, because you don't know the history of the item. You publish it. And you write books about it. And you display it in museums and you [influence] the belief of millions of people. Wouldn't you like it to be 100 percent, not 90 percent authentic? Now this story, of freshly cleaned or freshly cut or whatever, nobody knows, letters, coated by an artificial material, would you call it 100 percent authentic? This is the bottom line. I believe there was some money involved."

The materials analysis process was not without its problems—

at the time and later. While the scholars treated the objects with some care, the authorities behaved in an almost comically bumbling manner toward the evidence. Besides breaking the tablet, the police forensics team accidentally peeled away the fake patina when applying a sticky testing substance to the tablet. As for the ossuary, Goren had also applied a substance that peeled away some of the patina inside the inscription itself—again, probably another sign that the patina in that spot was not genuine. Later, the police hauled out the objects repeatedly for journalists and photographers to get a look, seriously degrading the legal chain of evidence. All this complicated matters for the materials team and left them open to charges of faulty science later on. And because the analyses themselves permanently altered the material makeup of the objects, scholars and prosecutors confronted a huge hurdle at the trial later.

In the months and years to come, Yuval Goren bore the brunt of criticism from believers who wanted the Jehoash Tablet and the James Ossuary to be real. He was accused of having a leftist political agenda, of lying, or mishandling the evidence. In a telephone interview later, the GSI geologist who first verified both objects, Amnon Rosenfeld—who has since resigned from the GSI and lives part of the time in New York—accused Goren of nothing short of being a traitor to Israel.

"I worked for forty years in the GSI and I got early retirement so I could talk about this," Rosenfeld said. "What the IAA should do is guard the national antiquities of Israel. They are not doing it. One and a half million artifacts were looted during the last two decades. Now in order to say they are doing their jobs they say this is forgery and now we want more money to open a new division for forgery. This is how they cover their ass. The IAA and Goren are not telling the truth. . . . I hate him. He really destroyed and twisted the history of the Jewish people and destroyed Israeli archaeology."

Faced with such vehement accusations, Goren looks pained, but defends himself. "I'm not minimalistic," Goren says. "I've never dealt with anything that has to do with that. The minimalists in biblical archaeology are located in the University of Copenhagen, and in Britain. Israel Finkelstein is not a minimalist. He's trying to prove that the period of David and Solomon, the United Monarchy, was not as prosperous as it was thought to be, and this is based on purely scientific details. So saying that I belong to this group is completely— It's not only evil. It's a lie because I never supported it. I never had any opinion about it, and I never wrote anything about it."

He concedes that the investigation into the tablet at least was initiated for political reasons. "The tablet was in a way like the excavations out near the Wailing Wall. It was a political bomb. And the IAA was in the eye of the storm, and it was supposed to function somehow to ride between the rocks, as we say. The tablet complicated the IAA with political problems. I think this is why they started to investigate this whole thing. They went after me, because I was the first one to shout that the king is naked."

Critics also accused Goren of manipulating the entire committee report, and seized on statements by some of the committee members that seemed to indicate doubt about the conclusions. One such member, Ronny Reich, a Haifa University archaeologist expert in the First and Second Temple periods, wrote that both the tablet and the ossuary inscriptions "appeared to me authentic." On the tablet, he wrote, "It was difficult for me to believe that a forger (or group of forgers) could be found that would be expert in all aspects of the inscription." Ultimately though, Reich wrote that he was convinced "after being shown the committee's data and material." The defense eventually called him as a witness.

Goren chalked the disagreements up to typical committee psychology. "Some of them didn't have anything to say, but they still

said something. And some of them did have a lot to say, but that's the usual thing with committees."

⊹

WHILE THE COMMITTEE on Materials was examining the ossuary and tablet with microscopes and chemicals in laboratories, the writing committee was working in the more subjective field of epigraphy and philology—examining the actual design of the letters, and the words and the content—attempting to determine authenticity based on comparisons with other indubitably authentic inscriptions of the same period. Among the eight members was Avigdor Hurowitz, a professor of ancient Middle Eastern languages. In his fifties, he emigrated from Philadelphia to Israel in the 1970s and now lives in Be'er Sheva, in the Negev Desert.

"Did you ever have a stone dropped on your toe?" he said. "When I first heard of the [Jehoash] inscription on the radio that's how it felt." Hurowitz teaches in the Bible Archaeology Department at Ben Gurion University. Between his location in the desert and his arcane work in the university, he had apparently missed the earlier report in *Ha'aretz* in early 2003, announcing the first rumors of the Jehoash Tablet's existence. He learned about the tablet in news reports after the IAA's seizure of the artifact in March 2003.

"They announced it on an early morning news program and later that night they actually showed it on Israeli television and read it. And when they read it, immediately it sounded like modern Hebrew. Anybody sensitive to biblical and modern Hebrew heard this." Hurowitz was a member of a Web list serve composed of experts in the ancient Near East and he soon posted his opinions. "I said as follows: 'The IAA announced today the most important discovery since the Shapira documents.'"

Near Eastern antiquities experts would have been familiar with

that reference immediately. Moses Wilhelm Shapira was a Jerusalem antiquities dealer born in 1830 in Europe, to parents who emigrated to Palestine. Shapira converted to Anglicanism in his thirties and operated a thriving shop that catered to Christian pilgrims in Jerusalem's Christian Quarter. His career as a forger began after the discovery in what is now Jordan of a legitimate inscription, a black basalt stone with thirty-four lines in the ancient Moabite language that is the most extensive inscription ever recovered referring to ancient Israel. The writing on the so-called Mesha stele apparently inspired Shapira to craft his own Moabite artifacts, including heads, clay figurines, and pots, all inscribed with the same Moabite writing. In 1873, the Berlin Museum paid a small fortune for seventeen hundred of Shapira's objects. But a French diplomat and scholar named Charles Clermont-Ganneau launched an investigation and determined that the objects were fakes, produced by a Christian Arab potter, under Shapira's direction. Shapira denied involvement, but he was haunted by the charges for the rest of his life. He committed suicide in a Rotterdam hotel in 1874. Ironically, some objects (not the Moabite material) from his collection that were deemed fake in his lifetime— including inscriptions he said came from the Dead Sea—are now believed to be authentic. Shapira's huge output of fakes is today considered of some value as art.

Hurowitz asked to be on the IAA committee and was selected because his experience includes work on so-called building inscriptions from the Second Temple period. Building inscriptions—of which the Jehoash Tablet would be considered one—were stones that ancient administrators erected describing orders for construction on or improvements to large, important buildings like temples or palaces.

Hurowitz has been studying ancient inscriptions for thirty years and he knows both the important ones and the lesser ones. He knows

exactly how rare it is to find anything that backs up Bible stories. "If it is authentic, it is of inestimable importance. It is the wet dream of every biblical scholar. It is firsthand evidence of what's written in the Bible and we don't have that!"

Hurowitz ticked off the major inscriptions that have "proved" or connected to Bible stories.

One of the greatest discoveries ever made was when George Smith discovered the flood story in the Gilgamesh epic. That was the first time a biblical story had been found in a different version, but that just shows there was a literary context for the Bible. We have a picture of Jehu, the king of Israel, in the British Museum. It's a black rock and it was found in Iraq. And we have various Assyrian royal inscriptions which mention Israelite kings. The most detailed thing is the inscription by Senecharib about the siege of Jerusalem and how Hezekiah paid tax to him—but there are lots of differences between what the Bible says and the Senecharib inscription. And all that is extremely important, but it's still not the Jehoash inscription, which tells of events in the Bible in the *same language* as the Bible. In the Bible, there are various accounts of temple building and repairs and this has resonances of all of them. That's one sign that it is a fake.

Hurowitz belongs to the if-it's-too-perfect, it-probably-isn't-real school of authentication. In his report to the IAA he wrote that the inscription "appears to be a combination of elements collected from various sources and pasted together ... each element attests to a lack of understanding of ninth century BCE Hebrew. All the elements together clearly prove that the text is a forgery."

Hurowitz says the tablet directly challenges the so-called mini-

malists in Bible scholarship, but also overturns years of mainstream biblical scholarship. "For the last fifteen, twenty years we have seen an erosion in the historical value of the Bible. There are scholars who will say the Bible has no historical value whatsoever, that it was written in the Hellenistic period with no connection to events. This tablet takes an incident, proves it happens, and the description goes back to the time of the event." If it's real, "then you can start saying maybe there is a lot of other stuff that is true, stuff we just don't have the evidence for. If it is authentic, then I have to turn topsy-turvy how I think about a whole bunch of biblical passages that have roots in ancient Israelite literature. For a biblical scholar, these things are just as important as the actual event."

Other members of the writing committee agreed that the inscription gave hints of modern Hebrew through grammatical constructions that were not common nine hundred years before the birth of Christ.

Because pictures of the tablet were available worldwide, scholars beyond the committee also opined on its validity—and their verdict was also not good. Joseph Naveh, the venerated Hebrew University epigrapher and Ada Yardeni's mentor—who had seen the tablet in the fall of 2001 before it went to the Israeli Museum—noted, among other flaws, that some of the letter shapes were more typical of seventh-century-BCE Aramaic and Phoenician scripts than of ninth-century Hebrew, when the tablet, if authentic, would have been inscribed. American epigrapher Frank Moore Cross, formerly with Harvard and the author of a seminal text on ancient Semitic, *The Development of Jewish Scripts*, weighed in that the Jehoash inscription used the Hebrew verbal noun *bdq* in a modern sense. Today it means "the repair of." In ancient times, the word had almost the opposite meaning, a "fissure." The reference to "creating fissures" was suspect usage in an inscription supposedly about repair work.

Working on the materials committee, staring down his micro-scope at the painstakingly man-made patina, Yuval Goren had ample time to ruminate on the motives of the forgers, and the limitations of scholars like himself when confronted with a well-crafted archaeo-logical fake.

The motivation for forgery in archaeology is in some cases money of course. They make something and then they try to sell it. But this is oversimplistic. It's not always only that. Sometimes it's a matter of prestige, which sometimes is trans-lated to money. Sometimes it is nationalism. Religion. There was, for example, this story in Japan, where a man actually invented the entire Paleolithic period of Japan, and he didn't earn anything for it. He was lecturing about it and he became very famous and it was written up in high school textbooks. But when he was asked why he was doing it, he said that there was some expectation, some pressure on him to find earlier and earlier sites. He was nicknamed God's Hands, because he was the only one who found these sites.

When you are dealing with Jerusalem, well, you only have to be in Jerusalem for one day to know the special experience of the place. There's something in this place that even when you're completely secular like me, you can feel it in the air. So when you deal with the First Temple and Jesus, and biblical kings, it [inspires] the imagination. Everybody wants to find the Holy Grail. Especially scholars. The Jehoash inscription, had it been authentic, it would have been fantastic, because in a way it doesn't end, but it addresses the very lively archaeo-logical debate about the history of the Bible in terms of the central role of Jerusalem before the exile. And if this story is true, if it could be truc, then it's fantastic.

✛

FROM LATE MARCH to early June 2003, Detective Ganor and Major Pagis dealt with other cases while the scholars worked behind closed doors in their labs and libraries. Oded Golan was also in the clear. Having turned over the ossuary and the tablet to the IAA, the collector was free to do business and travel as usual.

Sometime during the first week of June, Ganor's boss at the IAA, the former army general Shuka Dorfman, summoned him for a meeting. "He said to me, 'We have a problem. The two items are forged,'" Ganor recalled. And I said, 'Can't be.' He said, 'Why?' And I said, 'Because I worked for three months to find it! And it's a fake? Not possible!' I thought the stone was very important for education, for history. The ossuary is nothing to me, but the tablet is very important! It was for me, a real shock. And it was very depressing. I had hoped it would be real. It is very important for the Jewish people, to have evidence that records the First Temple."

The forgery report was not going to be made public for another week. In the meantime, Shuka Dorfman arranged for the scholars to present their findings to the detective and staff. As the scholars talked, Ganor thought about the boxes he'd seized from Oded's warehouse in March, containing tiny drills and labeled baggies of archaeological soil. He mentally kicked himself for not pressing the collector a little harder about that stuff. As soon as the scholars finished, Ganor went back to his office and drew up an application for another search warrant of Oded Golan's premises. And he dispatched some deputies to retrieve the now very relevant evidence boxes from the IAA storage warehouse outside Jerusalem.

Then he bought himself a plane ticket to London. It was time to meet Moussaieff.

The Workshop

Summer 2003

It's like a puzzle. You take a shape from one book,
letters from one book, a decoration from another
book. And you make a new one.

—AMIR GANOR

AVING TRAVELED IN steerage from Tel Aviv to London in his Lee jeans and work boots, Detective Ganor found Shlomo Moussaieff's Mayfair apartment rather royal. With reason. Jordan's King Hussein was the dwelling's previous owner. The late "plucky little king," as Western diplomats and journalists nicknamed him, had given the jeweler his Grosvenor Square apartment, worth millions of pounds, in payment of a debt. The interior is not trimmed in marble and gold, but it is palatial and, like Moussaieff's Tel Aviv penthouse, packed to the rafters with beautiful, ancient things. And, like the Tel Aviv penthouse, whenever Shlomo is in London, the apartment is a bustling indoor market for antiquities dealers.

The fact that a representative of the Israel Antiquities Authority was present on a morning in early July 2003 didn't deter business in the slightest. The scene stunned the government employee in charge

of regulating the trade back in Israel. "On the morning I spent with him, he bought antiquities from dealers all over the Middle East," Ganor recalled. "I think he spent 70,000 pounds in one morning. I was shocked. It was like a train station. Every five minutes someone came to his door and disturbed us, and he went to negotiate with them about selling or buying antiquities."

The detective's mission was to ferret out what Moussaieff had purchased from Oded Golan, whom the scholars and the IAA now suspected of having forged at least two major pieces. He sat patiently at Moussaieff's side, enveloped in the fumes of the ever-burning Marlboro Lights cigarette, while the old man reviewed the offerings from a steady stream of dealers.

Ganor found Moussaieff likeable enough—"like a grandfather"—but not especially helpful, and frustratingly digressive. The fraud detective—a third the age of the billionaire jeweler, and a fraction as sophisticated—was at a decided disadvantage in London. His English wasn't great, he had no jurisdiction or search warrant, he didn't know what things the old man might have purchased from Oded, and he couldn't compel Moussaieff to reveal anything. All he had was his status as a low-level Israeli government official who could theoretically penalize the old man for illegally taking antiquities out of Israel—antiquities that he had merely to lift his eyes up to the walls to notice. Ganor says he didn't use that threat, however, because he hoped that when he explained the IAA's suspicions about Oded Golan's collection, and showed him some evidence, Moussaieff might be moved to cooperate.

Moussaieff was in fact quite proud of his most recent acquisitions from Oded Golan, and he resented the suggestion that they might be forgeries. He had in the previous few years paid the Tel Aviv collector several hundred thousand dollars for two historically significant First Temple ostraca that were published in scholarly journals,

and had become known as the Moussaieff Ostraca, and a bulla (seal impression). He liked them so much that he had mounted enlarged color photographs of them hanging in his London guest room, and these he proudly showed to the detective. "He said, 'These are the three most important things that I have in my collection,'" Ganor recalled. Ganor saw the pictures, and made note of them. It would be several months before Moussaieff felt moved to send the actual objects back to Israel and the IAA for inspection—where they were determined to be fakes.

Moussaieff knew—but didn't tell the IAA fraud chief on that day in London—quite a bit about Oded Golan's fabulous collection and about how carefully the collector conducted business. Eventually he would tell authorities how much he paid Oded for several of his most prized objects. "I would have paid any price. I paid a million and a half dollars," he later said of one of his seal impressions (not from Golan), which he believed contained a notation from Ahaz Yehotam, a king of Judea. "For me, this is an autograph. It's an item that has survived from the king of Judea."

By extremely odd coincidence, Hershel Shanks, the American midwife to the James Ossuary, also happened to drop by Moussaieff's London apartment on the very same morning in early July as Ganor. The American lawyer and editor would later describe the chance encounter—and the IAA fraud chief's bumbling ways—in his magazine as "a surreal experience." Shanks wrote in the September–October 2003 issue of *BAR*, "My long-time colleague, Suzanne Singer, and I were in London . . . [and] we decided to pay a visit to Shlomo Moussaieff . . . When we arrived, Shlomo introduced us to a guest who had preceded us—a pleasant young Israeli who appeared to be in his early thirties. He was Amir Ganor, the chief fraud investigator of the Israel Antiquities Authority." Shanks of course knew of Ganor, since he had been following the IAA's investigation into the James Ossuary

with avid interest. "Shlomo quickly informed me, however, that I, too, was 'under suspicion' of being part of a group that had foisted this forgery on an unsuspecting public," Shanks wrote. He continued:

And that André Lemaire, the Sorbonne paleographer who was the author of the *BAR* article about the inscription, was also under suspicion. I laughed. But Ganor confirmed that I was indeed under suspicion and that when I would next come to Israel, I would become part of the investigation and would be called in for questioning.

I didn't know whether to go on laughing or to become out-raged. In the end, I "confessed." I told Ganor that I had orig-inally received a call from the owner of the ossuary (Oded Golan) and that he had offered me a thousand dollars a month for ten years if I would publish the article about the ossuary and its inscription. I replied that that was not enough money. I then received a call from André Lemaire urging me to accept the offer because he, too, had been offered a thousand dollars a month for ten years and he would not get his money if I refused to take Golan's money and publish the article. I told Lemaire that I would publish the article only if, in addition to the money I was to receive from Golan, Lemaire would give me half of the money he was to receive. Lemaire agreed—and that was how the article was published in *BAR*. It was clear, even to Ganor, that I was joking.

Shanks said Ganor also showed him drawings retrieved from Oded Golan's house of nonexistent ancient Hebrew seals, but appar-ently the evidence did nothing to put doubt in Shanks's mind regard-ing the ossuary, about which he had just published a book. "Ganor then asked me point blank: How much money did Golan receive

from the book that Ben Witherington III and I had written about the ossuary? I should have told him about the millions Ben and I would be sharing with Golan (and Lemaire), but momentarily went out of character and responded seriously: 'Not a penny,' I said."

When I interviewed him in 2006, Ganor said of Shanks, "He's connected. I don't know how. He's invested. There's a book." A year later, in 2007, Ganor would not elaborate on his suspicions, and would only say that Shanks is not under investigation, and that he "is a very good journalist."

<center>✛</center>

BACK IN TEL AVIV on a bright midsummer morning a few weeks later, Detective Ganor dispatched a pair of deputies to stake out Oded Golan's apartment building on Feival Street in Tel Aviv. Their orders were to watch out for the collector, and wait in the event the IAA and police chose that day to begin their third unannounced search. Ganor didn't have high hopes for the next search. He assumed that even though Golan didn't yet know the IAA had determined the tablet and ossuary were forgeries, he had had ample time to dispose of any incriminating evidence that might have remained in his apartment and warehouses. The detective did, however, hope to recover the James Ossuary. The IAA had given the ossuary back to the collector a few weeks prior, before the scholars determined its inscription was a modern forgery, because the law required them to return it after ninety days. "I argued with the police because they said, 'Now he's going to destroy the ossuary, and we will never find it,'" Ganor explained. "And I said to them, 'No, we're going to find it, because he thinks this is important to the Christian world. He won't destroy it.'"

On July 21, 2003, two IAA agents staking out the building let themselves in to the small, dark lobby and, passing the tiny two-person elevator, took the stairs up eight flights. They passed the third

floor, noting all was quiet in Oded's apartment—they knew the collector was out, they had watched him leave —but didn't stop. It was close and sweltering in the stairwell and hot down on the street, and to break up the time, they had decided to wander out onto the rooftop to try to catch the occasional sea breeze. From up high, they took in the view of Tel Aviv below, with its boxy apartment buildings and honking traffic. Far to the west, they could see where the pale sky melted into the darker rim of the Mediterranean Sea. They leaned out, smoked, and waited. On an idle whim, one of the men decided to peer into a loosely locked structure that appeared to be an unused laundry room. What he saw snapped him out of his smoking break. The chamber was piled to the ceiling with antiquities. The agent could barely contain himself when he phoned Ganor. "He calls and says, 'Listen, we have antiquities on the roof. Many!'" The detective still laughs at the memory of how his agent's unauthorized rooftop cigarette break led to what's known in archaeological digs as "a hoard," a cache of valuable old objects. "All good things come by chance," Ganor says drily.

Within an hour, the police had rounded up the collector—who had been out and about in Tel Aviv—and delivered him back to his apartment. Two defense lawyers quickly materialized as the search began. The authorities started in the apartment itself, where, Ganor noticed, many things he had seen there on previous visits were now gone. "Cleaned," the detective thought. Still the team found much that they considered evidence—chemicals and great quantities of wax, and book after book of sketches of Hebrew letters on seal impressions and ostraca, the pottery shards used by ancient scribes as Post-it notes, covered with Hebrew letters. However, the ossuary was not in the apartment.

"All the policemen were saying to me, 'See, he destroyed the ossuary.' I said, 'It cannot be.' So after we finished searching his apart-

ment, we said to him, 'You have another storage place.' He said, 'I don't have another space. You know everything. Please go!' And I said, 'No no, no, let's go to the roof.'" Ganor watched the collector's forehead knit up in consternation at the mention of the roof. Without further ado, the police, the IAA, the collector, and his lawyers ascended the stairs. Out on the roof in the noonday sun, Ganor pointed to the laundry shed and asked Oded what was in it. The collector claimed not to have the faintest idea. "He said, 'This is a public building!' And I said to him, 'It's not yours?' He said, 'No, and those are not my things. The roof is open. Anybody can climb in to see.' Well, we knew that anybody could climb onto the roof, because someone on my team was up there two hours before!"

The detective went to the small chamber and examined its lock, which he noted was an extremely simple one, easy to pick, like a bathroom door lock. Ganor asked Oded if he had the key. The collector replied that he didn't remember. Ganor picked the lock. Opening the door, he looked into the small, shadowy space and saw to his utter astonishment, directly across from him, the James Ossuary, perched on an old toilet. That was the point, the detective later said, when he finally accepted that the scholars were absolutely right. Up until then, he had held out hope that they might have been mistaken about the tablet from Solomon's Temple. Now he was convinced that both it and the sister relic he was looking at were fake.

"At this moment, I understood that everything was a fraud. Because a guy with logic would never, never, never put the ossuary on the top of the building, in the toilet, in the open chamber. Not reasonable. His apartment was full of electronic alarm systems—and he put the ossuary . . . !

"I said to him, 'Oded! What's going on here? You put the ossuary of the brother of Jesus on the toilet! Please! Go bring me a camera!' I said to him, 'Now I'm going to publish this picture all over the world

to show how you deal with this ossuary. All the Christians all over the world believe this is the ossuary of James, and you put it on the toilet on the top of the roof!'"

The collector didn't react at all well to the detective's threat. In fact, Ganor thought he was going to jump off the roof. "At this moment, I needed to put policemen on him. I was afraid he was going to jump and be killed. He never cried. But he was shaking and very depressed, because we took pictures of the ossuary on the toilet. And we kept our eyes on him."

The ossuary was the most famous, but not the most startling find in the little laundry chamber. According to the detective, Ganor and the police found blank and partially inscribed ossuaries without patina, and other antiquities in a half-made condition. They found a half-made wax cast of a Canaanite warrior, with holes in the top and bottom, apparently to make a fake figurine in bronze, using the so-called lost-wax method employed by ancient artisans. Along with the warrior figure, they found folders full of articles downloaded from the Internet on the lost-wax method. They found dentist drills and diamond-cutting tools, and receipts for more such tools. They found plastic baggies filled with half-finished replicas of ancient stone weights, some inscribed in ancient Hebrew and some blank. They found plastic gloves with which to handle caustic chemicals, and the chemicals themselves. They found tiny, bullet-sized bits of hematite, unfinished seals apparently, on which attempts had been made to carve ancient Hebrew letters. They found Tupperware containers with dirt identified by archaeological dig sites. They found blank, Iron Age building blocks, some "typical Megiddo," in yellow and dark yellow and some burnt black. Some had actually been burnt in the ancient era, it turned out.

"If you are going to make something and pretend it's something else, you need to use original material, because you know they will

check the organic things," Ganor said. The authorities believe the stones were ground down to make dust for specific patinas, in order to geographically link forgeries to specific Holy Land sites.

For Ganor, the "special prize" in all the material found in Oded Golan's hoard was a blank stele, an uninscribed slab of rock, which the detective refers to as "the brother of the Jehoash Tablet." The slab is in fact a piece of an ancient grindstone, used to grind wheat into flour. Authorities believe it was intended as the tablet for another inscription.

That afternoon, the police arrested Oded on suspicion of fraud and took him down to Jerusalem, where he was jailed for several days and interrogated. The police and Ganor videotaped the collector, who "confessed to some things," Ganor said. "It was," he claimed, "a very successful interrogation." At the time, Israeli law allowed defendants like Golan to be interrogated without lawyers present. For his part, Golan says he confessed nothing. He has since publicly complained about the time spent in the Jerusalem jail, "a dirty place where they also pack in the Palestinians." Later he told a Christian audience at a Michigan theological college that invited him to speak, "I had no idea I would have to undergo my own Via Dolorosa."

⊹

FROM JULY THROUGH SEPTEMBER of 2003, Ganor and Major Pagis worked on the case every day, piecing together a puzzle that grew ever larger and more complex. Using the bits of information they had extracted from Oded Golan about his business and work habits, and doing gumshoe detective work that involved tracking down people who didn't necessarily live on the surface of Israeli society, the police came to believe that Oded Golan's rooftop chamber was nothing less than a workshop, in which carefully crafted fake antiquities were fabricated.

What they didn't know, but now had to find out, was the scale of the operation. Had the collector just made the two big, notorious, world-famous objects? What about the other items in his collection, and what about his interactions with people like the dealer Robert Deutsch, or the collector Shlomo Moussaieff? Oded Golan had repeatedly insisted to them that he had never sold an antiquity outside Israel—but what about within the country? And could they even be sure he was telling them the truth about anything, given the scale of the deception they'd uncovered?

In the fall of 2003, they had a bit of a break. They learned about a corroborating witness—in fact, an accomplice. Between their interviews with Oded and interrogations of various of the collector's employees and associates, the police learned about a man named Samech Marco Shokri Ghattes who went by the name Marco. An Egyptian Coptic Christian, Marco had traveled in and out of Israel for years, through 2001, living on and off with Oded Golan. According to the detective, Marco apparently served as Oded's craftsman, earning between $500 and $2,000 per piece. In his last months working with Golan, Ganor said, Marco was sickened by one of the chemicals being used to make an elaborate menorah oil lamp, which Golan managed to present as a one-of-a-kind relic from the Second Temple, and sell for $100,000. While aging the stone item with a solvent of some sort, the Egyptian inhaled chemical fumes, which caused his throat to swell up so that he had to be hospitalized. When Marco was released, Ganor said, Oded paid for him to go back to Egypt, where he lives today. Ganor believes he may be partially blind in one eye from the experience.

In 2004, Pagis traveled to Cairo and interviewed Marco, in Arabic. Marco, according to a transcript of the taped conversation, basically admitted to creating inscriptions on stone, under Golan's direction, but denied involvement with the ossuary. Sections of the transcript follow:

MARCO: Sometimes he would bring me paper with text and ask me to engrave it on stone.

Q: Do you recall what the stone looked like?

MARCO: It was black, the size was about 80 cm and very thick (interrogator's note: he indicated with his fingers a distance of about 10 cm)

. . .

Q: I am showing you a picture of the Jehoash Tablet. Is this the stone?

MARCO: The stone was black and in this picture it's green. There is a crack in the stone and if I had worked on it, it would have broken. I can't remember exactly.

Q: How did you prepare the text?

MARCO: With a hammer and chisel, following the sketch. He printed out a sheet from the printer and gave it to me.

Q: Do you identify Oded in this photograph?

MARCO: Yes, that's Oded. What Oded is holding was bigger. It's very heavy. I did it seven or eight years ago.

. . .

Q: What did you do apart from engrave the text?

MARCO: Nothing.

Q: But it's clearly not ancient.

MARCO: That's right. It's new.

. . . .

Q: I am showing a photograph of the 7-branched menorah. Do you remember it?

MARCO: I saw it at Oded's place and he was very, very interested in it. He asked me if it would be possible to make something like that today because it's hollow inside and he asked me if I knew how it was done, how they would have done it.

. . .

Q: Did it ever occur to you that he was asking [about the decanter] so he could make something similar?

MARCO: That's his business.

Q: Do you know how the designs were added to the lamp?

MARCO: Possibly with dentist's tools or with a chisel. The difficulty would be to hollow it out from inside. He wanted to make something like it from wax but there was a problem how to make it hollow so he gave up on the idea.

Q: Would you know how to prepare something hollow like this?

MARCO: I can try and think but I haven't thought about it. I'd have to think about it. If you came to me at the workshop I'd ask time to think about it.

Q: So did you make something like this for Oded?

MARCO: No.

. . .

Q: Did Oded ever ask you to inscribe something on an ossuary?

MARCO: No. To engrave an ossuary is a lengthy job that would take three months and he paid me $2500 [a month] so it wouldn't have been worth it because you can buy an ossuary like that for less.

Q: How do you know it would take three months?

MARCO: It's an entire thing all around and you'd have to engrave all around. You'd have to clean off all the dust.

Q: The question is just about the inscription.

MARCO: No, he didn't ask me to write anything or add anything to an existing ossuary. The only thing I did, there was one like this lying in the kitchen, smelling, and I asked him if I could clean it and eventually he agreed and so I did just that.

Q: What did the ossuary you cleaned look like?

MARCO: The dog used to pee in it and it was covered in dust. After I cleaned off all the dirt, there was something written but I didn't pay particular attention.

. . .

Q: Did Oded say there was something special about this ossuary?

MARCO: No. When I cleaned it there was nothing special about it.

. . .

[*MARCO points at the photograph of the Jehoash Tablet*]

MARCO: About this stone. He asked me to coat it, smear it with clay.

Q: Why coat it with clay? Explain.

MARCO: He asked me to.

Q: What else was there in the mixture you put on the stone?

MARCO: It was a clay mixture that was runny—there was too much water in it.

Q: Was there charcoal in the mixture?

MARCO: I don't think there was charcoal—that would have turned the mixture black. It was very light.

Q: Were there pieces of gold?

MARCO: No. Not gold.

Q: Who prepared the mixture?

MARCO: Oded prepared the mixture and asked me to smear it on. It could wash off with water.

Q: Did Oded ask you also to coat the ossuary with the same mixture?

MARCO: No. That was the only item.

. . .

Q: What do you positively remember making for Oded?

MARCO: I made the black stone, and the seal from wax, and the wax soldier with a hat and other small statues, and a statue like a man sitting on a chair.

Q: Did you try to prepare bullae?

MARCO: No.

Unfortunately for the police, because Marco declined to come to Israel and testify, the transcript was not allowable as evidence at the trial.

The police tried to get Marco to cooperate, and even enlisted his ex-girlfriend, an Israeli named Penina Tooley, to phone him in Cairo and let the conversation be taped. Penina told police that Marco had once pointed out to her an object featured in one of the Israeli newspapers, owned by Moussaieff, and boasted that he had made it and lots of other things under Oded's direction. But Marco never repeated that assertion in the taped conversations. (He did admit to fabrication on a CBS *60 Minutes* program in March 2008, however.) And despite the official diplomatic relations between Egypt and Israel, Israeli cops have no jurisdiction to enter Egypt and interrogate an Egyptian citizen. And the Egyptian government has no interest in handing over an Arab citizen to Israeli cops.

"We needed him to come to Jerusalem as a witness," Ganor said. "We can speak with all the experts, and one of them can say this is good, the others can say this is fake, but he can say, 'I made it in the year ____,' and who brought me here, and how we planned to do it. Everything. We asked the Egyptian government to give him to us, and they won't."

Oded Golan contended that Marco was just a personal friend being framed and hounded by the Israeli cops. In fact, his concern for his Egyptian friend's well-being in the face of Israeli police harassment led to the police throwing Oded into jail in 2005 for tampering with a witness. "I just visited him," Oded told me during one of our interviews in his apartment. "Just to give you an idea what kind of good friend he is, I visited him more than forty times in Egypt, and he came here five times, if I'm not wrong. Every time he stayed here for about two months. And my girlfriend at that time gave him her apartment because she lived with me here

at the time, and we were very, very close. And I was really afraid for his life."

Golan claims Israeli agents illegally entered Egypt and pressured Marco to give evidence against him. "They went to Egypt. And I got some documents that indicate he was—how do you say—threatened. I wanted him to come to Israel to be a witness of mine. And now, I can't speak with him."

Interviewed in spring 2008 at his shop in Cairo for this book, Marco insisted he never made fakes for Golan. A forty-two-year-old musician and violin maker, Marco, who is single, said he originally went to Tel Aviv hoping to get work, and then returned because it was easier to procure casual sex there than in conservative Cairo. He said Golan had helped to set him up in a jewelry-making business in Tel Aviv. "Oded loved to make money. He sensed the artist in me and felt that I could help him with his work." Marco said he only made pharaonic jewelry under Golan's instructions, and that the collector never asked him to fake artifacts. "Oded had so many items laying around his apartment and when he tired of them he sold them."

After the indictments in Israel, Marco began fielding calls from journalists and police. He says armed Egyptian internal security forces turned up at his home, thoroughly searched his apartment, and then hauled him off for ten days of interrogation. "It was so humiliating to be dragged off like a criminal," he said. Eventually the authorities released him, and advised him not to go to Israel to testify, he said. "I insist that Oded is a good man and is innocent." He said he has been living in fear that he will be kidnapped either by the Israelis or by other foreign individuals. "I am unable to live nor work. I am extremely depressed and wish this nightmare to be over."

Marco said he had seen the famous ossuary in Oded's apartment, but that Oded's dog urinated in it so frequently that he (Marco) eventually moved it into the collector's bathroom. He said he was

astounded to learn later that the ossuary was actually worth millions of dollars.

✢

WHILE THE SCHOLARS were investigating the James Ossuary and the Jehoash Tablet at the Rockefeller Museum, doubts were being raised in the scholarly community about the authenticity of another First Temple relic—the Israel Museum's ivory pomegranate. There were some disturbing parallels: the scholar who had first interpreted the pomegranate as from the First Temple happened to be the French epigrapher André Lemaire, whose opinion also propelled the James Ossuary to stardom. And the first person to publish news of Lemaire's groundbreaking interpretation of the pomegranate had been Hershel Shanks, in *BAR*.

In September 2003, the venerated American Semitic epigrapher Frank Moore Cross, emeritus at Harvard Divinity School, went public with his concerns about the museum's pomegranate in a letter to a journalist. "If you had written to me in 1981, when the pomegranate first came onto the antiquities market, I would have answered saying that the piece was priceless, almost certainly from the Temple of Solomon," the scholar wrote. "I must now state my opinion concerning the ivory piece quite differently. I think the ivory piece itself is authentic (though we do not know certainly whether it is Israelite). The inscription . . . on the contrary is highly suspicious. The inscription has always raised serious paleographical problems. Now we are faced with a number of forgeries made by a highly knowledgeable crook: the so-called James Ossuary, the Jehoash Temple Inscription, and the Moussaieff Ostraca . . . and the next in line is the Ivory Pomegranate. I think the inscription is forged."

Israel Museum director James Snyder, an American, agreed to talk about the pomegranate at his office at the Israel Museum on Jerusa-

lem's West Side. The Israel Museum is financially very well endowed and contains a growing and well-regarded collection of modern art from around the world. It also houses a vast collection of ancient Holy Land archaeology. Parts of the Dead Sea Scrolls are housed on its compound, in a white, spaceship-shaped structure known as the Shrine of the Book. Nearby, through an outdoor sculpture garden filled with Greco-Roman classical statuary, is a large-scale model of ancient Jerusalem just before Rome sacked it in 63 CE. The model, built in the twentieth century for a Jerusalem hotelier, and based on scholarly research, gives a sense of how the ancient walled city was utterly dominated by the Second Temple, a vast pristine acreage of holy space built on the highest ground. Looking at the model, the centrality of religion to the ancient city is clear, and it is easy to understand how Jerusalem earned its reputation as a spiritual center in the classical world.

Snyder has a thick mane of pure white hair, and, wearing a lavender tie the afternoon we met, he projected a supremely silken, cultured air. He has no personal stake in the forgery debacle. He was not the museum's director when the pomegranate was first purchased for $550,000. He was director, though, when the museum reportedly nearly paid $4 million (or considered trading one of its Dutch masters) for the Jehoash Tablet—an event Snyder would not confirm. And he was not the director when museum officials decided to deploy Yuval Goren and a team of scholars to review the pomegranate in late 2003. He oversaw the museum's announcement late in 2004 that, while the ivory pomegranate itself dated to the Iron Age, the inscription on it was a modern addition, replete with fake patina. In the museum press release announcing the pomegranate's new status as an old object with a recent inscription, Snyder defended unprovenanced displays. "If one does not take advantage of opportunities to bring into a museum setting objects that don't surface in excavations, you might miss great objects."

In his report on the pomegranate, eventually published on the Bible and Interpretation Web site, Yuval Goren wrote that the initial microscopic examination of the letters on the pomegranate "revealed that traces of what seemed to be ancient patina, covering the surface of the object, were also to be found within the incisions. These traces were compelling for the inscription's antiquity and, therefore, its authenticity. The patina and the deposits on the artifact's surface and the inscription seem to have developed naturally during burial, as modern materials were detected." However, under new examination with newer equipment, Goren wrote that the patina had been faked—carefully and with great complexity. "The analytical results clearly demonstrated that prior to the process of patina deposition, a sharp tool was used to engrave the letters; in addition to an old break that diminished about a third of the pomegranate's body, the process of engraving the letters created new breaks. The inscription was then polished in order to give it an ancient look. The simulated patina that was then applied over the inscription contained a mixture of powdered calcite and limestone, charcoal, and some corroded bronze particles; modern silicone glue was used to adhere it to the inscription and the pomegranate surface. From these data," Garen concluded, "it is evident that the previous results were somewhat hasty."

In an interview, Snyder said the pomegranate turned out to be five hundred years older than Lemaire had initially dated it. And he denied that the Israel Museum ordered a new analysis of the pomegranate because of the official investigation into the James Ossuary and the Jehoash Tablet. Clearly, though, the epigrapher Frank Moore Cross's public questioning had some influence on the Israel Museum's curators.

"Our charter includes the mandate to exhibit the best of the archaeology of the ancient land of Israel, most of which is excavated," Snyder told me. He went on:

Most of the archaeology in the collections in the museum is documented to source of excavation. Our involvement with material not documented to source of excavation is pretty limited. The pomegranate is perhaps a signature in the category of works not documented to source of excavation. At the time that it surfaced in the marketplace, locally, it was examined, addressed, researched by any number of people before the opportunity to have it be bought as a gift for us came up. And when that was done, the best possible people at the time examined it using the best means available.

Because it isn't documented to source, from time to time we have examined it, always out of concern for verifying the authenticity of the inscription. We had in fact commissioned another analysis, because there had come a time when it was possible with a certain kind of microscopy to study it without having to invade the integrity of the surface of the object. And that was when we came to the conclusion . . . that there was modern material between the patina and the object. So that's when we decided to downgrade its inscription.

Snyder also denied any knowledge about the Israel Museum coming close to paying $4 million for the Jehoash Tablet, as was reported. He described how it *might* have happened, though. "The tablet was first sanctioned based on geological analysis of the stone. But we don't believe in just straight science, because we're a museum. We believe in connoisseurship. Feel."

Snyder said "feel" is an important element in museum curatorship, and he used an analogy to an art fraud involving Rodin drawings perpetrated when he was in graduate school. "You know, the paper can be from the period. The ink can be from the period. But your eye tells you that the line wasn't drawn by the same hand that

drew things that are known and cataloged and registered as being the master. So at a certain point, you're mixing science and connoisseurship—which is the expertise of the eye. You can get an ancient stone and get dirt from Second Temple time and smear it on the stone and everything will check out scientifically, but the trained eye of someone who studies inscriptions can tell you that something's wrong ... Frankly, there's always a story percolating about something that might or might not have been forged."

⊹

THE IAA and the Jerusalem police were keenly interested to hear that the museum's famous First Temple relic was now deemed a forgery. The use of a genuinely old object as a blank slate for a modern, biblically connected inscription was something rather novel. Some immediately suspected a link.

"I think Mr. Golan learned from this case," Ganor said of the ivory pomegranate. "This was the prototype for everything."

For Ganor, used to low-end antiquities frauds—cheap and obvious fake oil lamps and coins in the tourist market—the revelation that something as sacred and archaeologically important as the pomegranate was a forgery was unnerving. "You know, the pomegranate had appeared in every book. I learned about it in the university. This was something that dirtied science."

With Oded Golan under investigation and confined by court order to Israeli soil, and the evidence from his apartment and warehouses in police custody, Ganor and Pagis pored through the seized material. They felt a gnawing sense of urgency, because Golan now had a team of lawyers who were insistently petitioning the court for the return of his possessions. Over a period of months, the two investigators pieced together a picture of the collector's modus operandi.

In the beginning, Ganor said he did not believe Golan was knowledgeable enough to have made an inscription like the Jehoash Tablet, with its ancient Hebrew that fooled not all but some epigraphers. But after examining thousands of books and papers taken from the collector's home, he came to a different conclusion. "We found a lot of books, a lot of articles that he copied and a few of the books have his handwriting, he learned from them. He took notes, and with marker, he learned from them. He checked things and he put markers on top of the handwriting and wrote, "Change the . . ."

When the books didn't suffice, Ganor said the collector turned to knowledgeable people, and appealed to them for information for what appeared to be innocent reasons. Thus, Orna Cohen taught him how to make patina and Ada Yardeni unwittingly drew prototypical ostraca and bullae that he could transfer. "You can see how he used Yardeni in preparing fake things, without her knowledge," Ganor said. "She draws something, and he takes the shape and changes the letters inside and prepares a new seal." When Ganor showed Yardeni the drawings of bullae seized from Oded, the epigrapher was stunned. "She sees the papers, and says, 'Oh, I drew that, but this is not the right decoration or the right script,'" Ganor recalled.

He prepared all the pieces the same way. It's amazing. He's very clever. He's brilliant. He had his method. First he prepared something. Then, he wanted to check if it seems real or not real. So he took a picture of it. And he presented it to a few people that know about these things, and if they said, "Ahh, it's a fake," from the beginning, the thing would be in the garbage. He threw them in the garbage. But if they were to say, "Ahh, interesting, oh it's nice," he then continued on to others, professionals in this field, like Yardeni, like professors. He asked for an opinion, and the professors were very nice

and very cooperative and they said, "I will give you my opinion, but please, you don't mind that I'm going to publish it?"

He would say, "If you want to publish it, first you sign a secrecy agreement that you are not telling who the owner is, where you got it, or anything about it." Then he says, "OK, bring me your opinion," and they gave him their opinions. And when he got two or three opinions, the best thing to do was to publish it in a scientific article. And the professor who checked the object only from the picture, published a very impressive article.

He also collected laboratory reports. He used laboratory reports from all over the world with carbon 14 dating, things like that, in Syria, in Bangkok, in China, in Eastern Europe. They asked him how old he thinks it is, and he says, "800 BCE," and they say, "OK, 800 BCE." Then he prepared the albums, little books, and then he had something for the *BAR* to publish. And the value of the item rose. No one checked carefully, especially if they knew a collector wanted to buy it.

Shlomo Moussaieff is a very good example because it's like collecting baseball cards for him. He has all the cards but there is one he doesn't have. And they prepare the card that he needs. A full house. Everyone knew from the beginning that he was going to pay any price that they asked him. This is the mind of this guy. And when we understood the method, it was easy to see . . . everything.

As the method became clear to the IAA and police, it leaked out to collectors and museums around the world. Soon the formerly gullible were flocking home to roost at the IAA offices in East Jerusalem.

[CHAPTER 10]

The Gulls

Fall 2003

Return to the stronghold,
You prisoners of hope.

—ZECHARIAH 22:12

EORGES WEIL, A deeply tanned, British, divorced septu-
agenarian, was giving instructions to his pool cleaning
staff in a beachside town near Tel Aviv when I arrived
on a fall afternoon in 2007 to discuss an object near and dear to
his heart that he'd bought from Oded Golan some five years before.
He hadn't actually seen the object—an unusual carved stone oil
lamp with a menorah built into it, said to be used by Second Temple
priests—for some years, because it was being held by the Israeli
authorities as evidence in Golan's trial. And although Weil's house is
filled with extremely precious objects from his vast and eclectic col-
lection of East Asian antiquities and Judaica, he very much missed
his menorah lamp. Even though, or rather precisely because, the
authorities have told him it is a fake.

Weil is a very wealthy retired man, although he declined to
be specific about the nature of his business. "A mixture of jewelry

making . . . not interesting," he told me. Mainly, he considers himself
an artist and sculptor. His art usually refers abstractly to Judaica. One
of his paintings, hanging on a wall near his desk, was a modernist
portrayal of a *tallit*—a black-and-white prayer shawl—replete with
tassels. Weil moved to Israel when his ex-wife made *aliyah* (spiritual
and legal immigration to Israel) seventeen years ago. He would have
made *aliyah* himself, but he did business with Arabs and "I had to be
careful with my passport." Nonetheless, he prefers life on the Levan-
tine shore of the Mediterranean to life in London, and he has settled
happily near Tel Aviv.

Sitting behind his desk, with a 24K gold Japanese sake vase and
an eighteenth-century Tibetan teapot between us, he described how
he found and lost his menorah lamp—"the love of my life," as he
calls it. He pulled out a loose-leaf binder with photographs of his
lamp from various points of view. It was perhaps a foot in diameter,
with a handle and seven holes for light—hence the menorah—and
decorated with tiny, delicate carvings of seven fruits and plants—
what the Torah calls the *shivat haminim*, the seven fruits of Israel.
The carvings, he said, are what initially drew him to it.

"This was brought to me," he says. "I didn't find it." A local antiques
dealer and friend first brought it to his attention. "Small fish, lovely
guy, 100 percent honest, not a big shot, not a *shpitzer*, I've known him
a long time purely as a friend. He phoned me one day and said he's
got something in the shop, I've got to look at it. I said, 'What is it?'
He said, 'It's an antiquity.' I said, 'I'm not interested in antiquities.' He
said, 'Look, it doesn't hurt to have a look.' So he came with another
guy who I'd never met before called Oded Golan. And this thing was
wrapped in a French underwear box and newspaper. A lingerie box!"

Weil chuckles at the memory. "And I was very impressed by the
object. I know nothing about antiquities, but I do have what they
call a nose, a feel, whatever it is . . . an object actually vibrates to me

sometimes. And this rang every alarm bell in my head. This was *good*. I wouldn't have bought it, except for this." He tapped on the menorah part of the lamp with his finger. "That's why I bought it."

He says he "didn't need to be told" what era it came from. He just knew. "Second Temple, first century," he said. "My logic told me that without knowing too much about the field. The knowledge of things Jewish is so important here. It's obvious. It's like saying, what date is a Model T Ford in a thousand years. Somebody who knows nothing about cars or doesn't have the faintest idea will say, 'Ehh!' Same thing."

Weil asked to keep the lamp in his house for a few days, spend the weekend with it, and the dealer and collector agreed. At the end of a few days he knew he wanted it, but he had some queries for Oded.

I asked a hell of a lot of questions, like where does it come from. Here we're in very tricky territory. Now as far as I'm concerned, the merit of this object—the merit, aesthetically or otherwise—does not depend on where it came from, for me. Fact is, here it is. OK? For the authorities and for things like provenance, etcetera, this question is very, very important. Which is why I asked it.

And fundamentally I was told in the end, one story by Oded. My little fear about Oded—God bless him—and I dislike him intensely, by the way, is that he is not a friend of the truth. From the moment he walked in, I didn't like him. You know, you have that with people. I just didn't like him. I didn't like his toupee, and . . . I didn't like anything.

The story was, Oded being a very, very long-term, crazy collector, knows all the Arab suppliers of this field. And his story was that a leading Arab dealer offered it to him, and the Arab dealer had told him that it was found in a cave on

the east side of the Mount of Olives. That's the story. I don't believe it. But I will never know the truth. I asked Oded for the name of the owner, or can we go together, but all of that was blocked. Now this didn't raise any suspicions with me because I'd heard all of this stuff from Shlomo for years.

In the jewelry business back in London, Weil interacted often with Moussaieff and had had many opportunities to watch the old man indulge his obsession with biblical antiquities. "I used to be in his shop sometimes and this tatty-looking, creepy, fucking Arab would come in with something wrapped up in a paper bag. Shlomo would stop doing multimillion-dollar business, because he wanted to see what was in there. And the Arabs . . . they're digging all the time and it's a tragedy because really the culture, the area is being dissipated for peanuts, because the digger gets peanuts. But the Arab in Jerusalem—if that is where [the lamp] came from—he did not get peanuts. He knew exactly what he had."

So Weil paid handsomely, too. According to court documents, he forked over $100,000 for the lamp without asking for a receipt. For that price he owned a one-third share in the lamp. The plan was that after scholars authenticated it, he, Golan, and the local dealer would sell it again and share the profits. Only after Weil had actually paid $100,000 did he have the lamp checked out. Golan arranged for the two of them to send the lamp to a California-based restorer and authenticator named Frank Preusser, who worked at the Getty Museum and now works as a restorer at the Los Angeles County Art Museum. Preusser, a chemist who has worked in the field for thirty-five years, verified the lamp as authentic, and he told me he remained confident in his authentication. But he recalled that the types of detailed questions the owners asked him about it later made him suspect there was something amiss. "I remember that I talked to my

wife and said, 'Something is not right here. I think they are preparing to make some forgeries.' The questions were about layers on top of layers, very specific, the kind of questions I only get from chemists. It is not the first time I have had something like this occur." Preusser said the police never contacted him.

Weil didn't stop there, though. He had the lamp tested inside and out (experts found evidence of olive oil inside) and sent it to several other experts—all selected for him by Golan.

Everyone agreed the lamp was authentic Second Temple, first century. Weil was quite satisfied with his new purchase, until he read in the newspapers first about the James Ossuary possibly being forged, then the Jehoash Tablet being forged, and the IAA investigating Oded Golan. The news reports, combined with Weil's visceral reaction to Golan personally, sent alarm bells clanging in his head. Furthermore, he says, the market was suddenly rife with rumors about his lamp being a fake. "At that stage, the lamp was in a safe in London. I phoned up the police, or Antiquities Authority. I can't remember which. I think it was police. And I said, 'I have an item I bought from Oded,' described it, blah, blah, blah, and 'I wish to give it to you to help in your investigation.'"

Pagis and Ganor met Weil at the Tel Aviv airport in June 2003, and "grilled me heavily"—until four in the morning, Weil said. He then handed the lamp off to Major Pagis, who gave him a police receipt for it. He has not seen it since.

⁘

GEORGES WEIL WASN'T the only concerned buyer who called the IAA after Oded Golan's arrest in July 2003. Ganor and Pagis were soon overwhelmed with leads and tips. "It was something amazing," Ganor recalled. "Because between July and September 2003, the whole market woke up and everyone that had a story came to talk to us."

In three months, dozens of tips came in from all over the world, and the two investigators were overwhelmed with interviews and leads going in very different directions than what they sought, including crimes that had nothing to do with Golan. One of the most viable trails they pursued had to do with middlemen. Among these was the dealer Robert Deutsch, who had brought numerous objects from Oded to Moussaieff. These included a large collection of bullae (ancient seal impressions in clay), two very archaeologically significant ostraca—the "widow's plea" and "three shekel" that were supposedly types of legal documents from the First Temple period—and an engraved decanter also supposedly from the First Temple.

Deutsch and Ganor had a long-standing relationship because of Deutsch's semiannual antiquities auctions in Tel Aviv, and Ganor began bringing him in for interviews. The dealer was helpful up to a point. The going got rough, though, when conversations inevitably turned to the subject of money. Ganor knew that trying to track the flow of money in the Bible archaeology trade led to resistance and dead ends. He tended to avoid the subject when possible. "Money. That's not my business. I don't get involved in money. Many people are afraid. And we saw that if we were getting to the money part, many people would be silent. So . . . we put it on the side."

The IAA and the police leaned especially hard on Deutsch. "We knew Deutsch for a long time," Ganor recalled.

I respected him because he seemed to be an honest dealer. He has wonderful knowledge about archaeology, and he is expert in ancient Hebrew, so I thought that he was a harmless dealer. Harmless scholar. And when I sat with him in the interrogation, I could see that sometimes he was like a small child.

For example, someone told me he gave Deutsch a suitcase with $100,000. And he gave it to him in a certain place, at

an hour, in a room with three or four other guys. So we have some witnesses. And I came to Deutsch and asked him how he got this suitcase of money. And he said, "No, I never did that." Why lie in this instance, why? I said, "You know me. I've known you ten years." And there are many, many examples like this. He bought something from an illegal dealer in the West Bank. Some treasure. And we knew about it. And I sent one of my guys, my rookies, on purpose to take his declaration. And he played with him. He lied. After that I sent another guy who knew the material better. And he tried to lie, but there was a video camera in the room. And when he realized that we had all the evidence in our hands and that he was lying, he started to cry like a child. And he asked for mercy. So I said, "OK, OK, we know that you bought it. But why do you lie?" He behaved very strangely and I don't know why, because on one hand he is professional always, and on the other hand, he's like a small criminal!

In an interview at his shop in summer 2007, Deutsch maintained his innocence and denied any prior knowledge of Oded Golan's forgeries. In fact, he said he was one of the first to proclaim the Jehoash Tablet was a forgery, on Israeli television, after it was confiscated by the IAA. He called it a "childish" forgery. "I was always the bad guy for all the dealers in Israel because I can immediately tell you if a piece is fake or not. For me it's very easy. So nobody wants me to be the one who is seeing the stuff they offer." Deutsch said he warned Moussaieff about some of the fakes, and that the pieces from Oded Golan he did sell are real. "I sold to Moussaieff one piece, two pieces—one from Golan which was a decanter with the inscription which is million percent authentic, and a seal impression, which is not from him."

Deutsch said he was flabbergasted when the IAA showed him evidence that they thought linked Oded Golan to forgery making. "Nobody thought such thing! He was a collector. He was buying everywhere in every city, in every shop, in every village! I didn't believe it, then they showed me what they found in his house. I saw all these papers. He was taking my books. He cut out the ancient Hebrew letters and made new series of it. I published the seal impression of a king of Judea. He took this picture, he cut out the letters and he rearranged it, and he made one of [the king's] father! Unbelievable! I told everybody he must be insane—has two personalities! I don't understand it. It's not just somebody who doesn't like archaeology and doesn't care and wants to make money. He has the money and he loves archaeology. He knows his stories. He knows every piece."

Deutsch maintained that the authorities tricked him into telling them everything he knew, promising he'd be a witness, then turned him into a defendant. The judge declined his requests to be dismissed. He has promised to sue the IAA when the trial is over. "The judge must say that it was malicious fabrication. [In 2008, the judge rejected Deutsch's petition to call the charges exactly that.] Otherwise I will go to—even if I am acquitted—I will go to the high court. Because it must be stated that this was made by purpose, fabricated, and I want to sue each and every person who lied and fabricated things against me. I had told them everything I know! And instead of being a witness, I'm one of the criminals. Now the twelve years of work [in the university] is nothing."

Deutsch said the IAA went after him with a larger goal in mind— to shut down the antiquities trade in Israel. "They told me to my face, 'We will close your business.' They had the guts to tell me [that]. And why do they want to close my business? Because then 50 percent of the trade will vanish."

The investigators also found another key middleman—a Palestinian dealer named Fayez Al-Amleh. Al-Amleh was not as well-lawyered as Deutsch. He pled guilty early on to pretending to have discovered some objects that the police believe Golan forged. He was implicated as Golan's accomplice trying to sell Moussaieff a forged, gold-handled seal inscribed with the words in ancient Hebrew, "Menashe son of Hizkiyahu" (both are Judean kings named in the Bible) and a collection of bullae. The old collector paid $150,000 for the bullae and wrote a $1 million security check for the seal, which he then took for testing, with the understanding that if it was found authentic, Golan would keep the million. (It was deemed fake and Moussaieff kept his money.) Al-Amleh, who lives in the West Bank town of Beit Ullah, confessed in court that he had agreed to go with Golan to Moussaieff's and confirm that he had purchased the seal and bullae directly from site looters, when in fact, Al-Amleh had no idea where Golan had gotten them. He has since served time in jail for the crime, and been released.

Eventually, the detectives were able to determine the amounts paid by some of the buyers. Not surprisingly, the biggest spender who would discuss money was Shlomo Moussaieff. Why Moussaieff agreed to cooperate is not exactly clear. To hear Moussaieff tell it, he was proud of his purchases and simply didn't feel he had anything to hide. Rumors in the trade, though, are that the IAA threatened to pursue the old man for illegally removing objects from Israel—charges that would not be difficult to prove. It's also possible, as one of his friends told me, that while Moussaieff keeps a game face about forgeries being a part of the trade, he is privately furious at Golan and especially Deutsch, whom he had trusted to write and publish articles about his collection over the years. Whatever the reason, Moussaieff eventually told the police about dozens of items—including historically significant ostraca, bullae, and an

inscribed decanter, that could be traced, sometimes through Robert Deutsch, back to Oded Golan.

According to the indictment, Moussaieff told authorities he paid $858,000 to Golan and Deutsch for fakes. In a later newspaper interview, Moussaieff put the amount at far higher, estimating that he bought $7 million worth of antiquities from Golan and the other eventual defendants in the case. He maintained most of them were authentic. "Suppose they sold me a fake, it's my fault," he said. "I have nothing against them. I should know better. Every dealer has fakes. The world is full of fakers."

The underfunded investigators did not have the time or resources to follow other offshore money trails all over the world. "We stopped because we saw that this was a huge, huge process," said Ganor. "This is just the tip of the iceberg. And our manager made this decision to stop. Because even though we could have continued, I would need to spend all my life on this case. And it's not reasonable."

Pagis tried to answer the money question another way. "Oded is a very wealthy man. And his money doesn't come from antiquities. I once got a call to come to Tel Aviv airport, where they had searched a man and found $25 million in his suitcase. I said, 'What's the money for?' He says, 'I came here to have fun in Eilat! And I am going to have great fun!' There is not a chance in a million that he earned that money from hard work. He didn't have a job. Same with Oded Golan. He is very wealthy. I can't put my finger on illegal money transfers but I can follow the flow of money. He has several personal bank accounts outside Israel. If you hold up all the details, you get the picture."

⊹

ONE MAN who understands money and unprovenanced antiquities is Wall Street hedge fund billionaire Michael Steinhardt. Steinhardt

is short and rotund. And in profile, with his mustache and suspenders, he looks exactly like the Monopoly game banker. He agreed to talk to me in his Fifth Avenue office, although he asked to be quoted only on preapproved permission. Steinhardt is one of America's richest men, and one of the classical art world's biggest collectors and museum donors. His collection of sixth-century-BCE Greek art is on display at the Judy and Michael H. Steinhardt Gallery at New York's Metropolitan Museum. He is also a major funder of Jewish and Israeli causes, including the Israel Museum. As a big antiquities collector with strong ties to Israel, Steinhardt is often shown biblical-era material. He likes it, even though he describes himself as an atheist. "It's an attachment to the biblical era—some of it. If it provokes my imagination, if it somehow relates to me, if I can see something in it and say 'My God, this was made five thousand years ago. Can you imagine the sort of person who was living in 3000 BCE or 4000 BCE?'" He says he has "zero" interest in proving the Bible true, although he finds that aspect of the controversy interesting. "My very strong view is that they will never, ever come up with archaeological objects that will ever verify the most challenging stories of the Bible. They are, were, and forever will be beyond archaeological verification. And there will always be the illusion that there underneath some rocks, you'll find something that will really create a leap to confirm the Ark or the this or the that. Never going to happen."

Steinhardt is not as avid a collector of biblical archaeology as some other people in the antiquities market, but like Moussaieff, he buys what he likes, making judgment calls mainly by feel.

Steinhardt's never met Oded Golan, or bought anything from him that he knows of, although Israeli officials have charged Deutsch with selling Steinhardt a fake ancient glass vessel for hundreds of thousands of dollars, in an unrelated case. Steinhardt well under

stands how unprovenanced ancient objects find their way from the market into major museums worldwide. Using his private wealth, Steinhardt, like many other patrons of culture, has amassed a great collection of material, often purchased, as he will readily admit, without scientific or other scholarly testing. The pieces often end up as gifts to museums—New York's Metropolitan, for example, or the Israel Museum. The museums accept the gifts, and the donor gets a tax write-off.

Legal and national authorities have been trying to stop the donation of unprovenanced objects to museums. Around the world, major museums are reeling from the ripple effects of a major trial in Italy, where the former curator of California's Getty Museum, Marion True, has pled not guilty to charges of criminal conspiracy and illicit receipt of archaeological items. Museums are also on the defensive because nations like Greece, Italy, and Egypt have begun asking for the return of items related to their cultural heritage, claiming even pieces in long-term collections were illegally gotten. And museums have begun to yield. After much legal wrangling, for example, the Met in 2008 returned to Italy an ancient terra-cotta wine-mixing bowl known as the Euphronios krater, purchased for $1 million in 1972, which the Italians contended had been looted from a tomb.

In the course of searching Oded Golan's computer hard drive, Ganor and Pagis found hundreds of e-mails between him and potential buyers, including museums and universities in the West. The e-mails were so numerous that the overworked cops couldn't trace every lead. The Israeli cops reached out to these institutions, trying to retrieve objects that had come from Oded Golan for further testing. Pagis even traveled to New York to attempt to meet with one of the institutions, the Brooklyn Museum, and also contacted the Los Angeles County Museum of Art, with which Golan had had some

interaction. They hit dead ends. In the current climate of fear and distrust, museum officials are chary of any investigators.

The investigators were especially desperate to find a particular object they believed would clinch their case. The so-called Shishak bowl, answered the question of who sacked Megiddo in the eighth century BCE. From evidence found in Golan's papers and computer, the police suspected that around 2000 Golan had fabricated the bowl and then soon afterward circulated to museums information about it, including photographs. He did so under the guise of seeking an opinion about the bowl's authenticity, but with the ulterior motive of trying to get the museum to buy the historic object. The Brooklyn Museum refused to cooperate with Pagis.

"The great issue is who destroyed Megiddo and which date," Ganor said. "It's one of the questions that everyone wants to answer! It's a mystery! And there is a lot of argument among scholars all over the world about it. So if someone could find a bowl with an inscription that describes this destruction and dates it—it solves the problem. We have a picture of the bowl. We know that the bowl was in the possession of Oded."

And yet, the object had disappeared.

"He sent it to laboratories, and we found a book on his shelves about ancient methods of producing stone vases. And on how to make the things seem to be old. He sent the inscription to an Egyptian epigrapher to get her opinion and asked her to sign something declaring this is real. We know that this is a fake inscription, 100 percent fake because we know who made it."

When I interviewed them in 2006 and 2007, both Ganor and Pagis were obsessed with locating the Shishak bowl before the end of Golan's trial. They even asked me, as an American journalist, to inquire about the bowl with museums and curators in the United States who might have seen it. A curator at the Brooklyn Museum

told me that while he had never seen the object, it was theoretically possible that museum officials simply would not cooperate with Israeli police because of the current climate around ill-gotten national antiquities.

For his part, Golan never denied to me having had the bowl, although he did deny fabricating it. He would only say, coyly, that it has been purchased "by a wealthy collector in California" who prefers to remain anonymous.

From their review of Golan's correspondence, the Israeli authorities believe other forged pieces, still not identified publicly, have been sold or donated by wealthy patrons to the collections of museums including the Los Angeles County Museum of Art, the Brooklyn Museum, and the British Museum, and even found their way into Sotheby's. None have said they own anything possibly forged by Golan. "Some said, 'Don't speak with us. We don't want to be involved.' Some of them didn't respond. At all," Ganor recalled.

None of this surprises Oscar White Muscarella, a longtime curator in ancient Near East art at New York's Metropolitan Museum of Art. Muscarella has written extensively about forgeries in museum collections, including a book published in 2000 called *The Lie Became Great: The Forgery of Ancient Near Eastern Cultures*. In his bombshell book—for which he nearly lost his job at the Met—Muscarella charged that museums collude in "a forgery culture" involving scholars, curators, wealthy donors, and museum directors. "The forgery culture is stratified and multi-faceted. It has a kinship system, a hierarchical structure, systems of gift exchanges, laws, a coded language, judges and juries (usually the same), a police force. Its inhabitants include professors, curators, scientists, museum officials and trustees, dealers, smugglers, auction house employees, collectors, and forgers."

In his book, Muscarella compiled an extensive list of specific inci-

dents he knew about, in which museums hid or even promoted forgeries within their collections. Among them:

- In rare instances a museum curator will inform the Director that an object on exhibit is a forgery and should be removed. The indignant director orders the object to be left in place.
- Museum curators will refuse to remove from exhibition an object they know is a forgery because of loyalty to a predecessor who hired them, to their institution, to the wealth of the forgery's owner.
- Museum files registering information on a recognized forgery that was either purchased or deeded will contain private notations expressing one or all of the following: no one is to be allowed to examine it; no one is to be given photographs of it with correct information about its age; no reference is to be made that it is a forgery.
- Curators at several museums have refused requests for nondestructive laboratory testing on suspicious material in their collection.

⁘

OSCAR WHITE MUSCARELLA implicates scholars in the worldwide forgery culture he describes. But, in the Oded Golan case, while numerous scholars authenticated the alleged fakes, police have not indicted any of them. The most involved was André Lemaire, who discovered both the ivory pomegranate in the 1980s and the James Ossuary in Oded Golan's collection.

The French scholar's prominent role in both great finds certainly brought him under suspicion. At one point, Ganor told me, "He's not innocent. You know I don't know if he's guilty or not. But saying the first time it's a mistake, OK. The second time, maybe it's a mistake.

But the third time, it's not the case. And he was mistaken over the years, day after day?"

Lemaire, though, could be as much of a gull as the fleeced buyers. One aspect of the genius of the forger in this case is that he carefully selected the scholars from whom he sought authentication. Ada Yardeni's loneliness and need for money was only one example. Many scholars are desperate for something even more ephemeral than cash—a little outside validation, after years of poring over a few lines of ancient text in hard library chairs. Lemaire, a fallen-away Catholic priest, is an extremely ambitious man who was always openly seeking the rare find. In some ways, he was the perfect mark. "Lemaire I know very well and he's a very good scholar," Israel Finkelstein told me. "I think Lemaire wrote about tons of forgeries. Inauthentic inscriptions. The way I understand it, you see, it's part of his wishful thinking. It is part of his background. Not anything more than that. It is part of his cultural background, to see things in the Bible as historic."

Emile Puech is a French priest and epigrapher who has spent his whole professional life at the Ecole Biblique in Jerusalem, a block away from both the Albright Institute and the Garden Tomb on Nablus Road. Puech was one of the first scholars to question the James Ossuary (a fact the ossuary's supporters attribute to his Catholicism). A gentle, bearded man in his early sixties with preternaturally babyish skin, Puech has known Lemaire since they were both seminarians. Lemaire, Puech said, is motivated by ambition and fame. "If the ossuary inscription was only James, son of Joseph, brother of Jesus, you can do nothing. You can write two lines and you cannot be famous because it's nonsense. But if you say this is the *one* James, brother of *the* Jesus of Nazareth, then it's something. He wants to enter into the College de France [the premier national science society]. At the time [of the James Ossuary's announcement] he was on TV in France and very famous." Puech also said Lemaire has an ax to grind with

the Catholic Church. "This was a way to say he was more of a theologian than the theologians. I think he planned a scientific career to be famous, a scholar of religion. And if you stay in the Church, if you are not a bishop or pope, you are a poor guy like me."

I met Lemaire at his modest home in suburban Paris, and we chatted over his dining room table draped with a plastic, flowered cover. When I interviewed him, Lemaire was defending himself against all attacks and was in the process of publishing in scholarly journals new essays on both the ivory pomegranate and the James Ossuary, which he does not accept are fakes. He snorted at Puech's comments, and chalked them up to "a problem of jealousy between colleagues—you know, a clear case." Refusing to name Puech, Lemaire says "a colleague in Jerusalem" simply wishes he'd discovered the James Ossuary himself.

"There was this rumor that the ossuary had been seen in Jerusalem only with the first part of the inscription, not the second part. You know who was at the origin of this rumor, who was repeating it? A French colleague in Jerusalem was spreading the rumor that he saw the ossuary in the old city of Jerusalem! Then Eric Meyers, a good professional, is spreading the rumor too. And it was repeated on the Internet. So Hershel Shanks called him. And the colleague did not want to [admit it]. In this affair there are many rumors. Things start with rumors, repeated with rumors. After that, officially the scientists have only to confirm the rumor, you know. This is not serious. But I have serious information that when this affair started there was a meeting of three French colleagues to discuss how we can destroy Lemaire's scientific reputation. And one of them, you can guess who it was."

✢

ISRAELI AIR FORCE jets thundered overhead as I approached philologist Chaim Cohen's suburban Be'er Sheva house on an otherwise

quiet street at twilight. When they passed, the distant sound of a muezzin's call echoed over the barren hills from somewhere beyond a guarded checkpoint. While most street signs in Israel are in Hebrew and English letters, in the enclave called Omer where Chaim Cohen resides, not a single street or commercial building sign is in anything but Hebrew script, and I was challenged to find his house, since he is also a classic absentminded professor, incapable of giving directions by phone. Be'er Sheva is a true desert outpost. To drive to it from the east, one passes for hours through the great yellow void of the Negev, an inhuman, waterless landscape of sand and towering rock. Like America's Phoenix, nothing green grows in Be'er Sheva naturally, but is the product of man's best efforts to exist in an inhospitable habitat. Somehow, Bedouin live outdoors in the stark beyond, and a few minarets in the distance attest to the presence of settled Palestinian villages nearby.

Like Ada Yardeni, the philologist has a soft heart when it comes to homeless cats, and his front yard was inhabited by many happy felines. A fluffy dog named Doofus had pride of place on a couch indoors. Cohen, sixty, is a Brooklyn native who made *aliyah* to Israel in 1973 ("on the second day of the war," he tells me) and raised two children there. His daughter has a natural talent for micrography—infinitesimal writing. Among her framed projects on his wall, she wrote the entire Book of Esther on a single piece of paper, in letters smaller than grains of couscous.

Cohen agreed to talk to me on a Sunday afternoon about why he thinks the scholars are all wrong about the Jehoash Tablet. He believes it is a groundbreaking inscription, with never-before-seen grammatical constructions that will change some of the basic assumptions philologists have about ancient Hebrew. He was about to publish a sixty-five-page defense of the tablet in a scholarly journal, which he'd worked on for a year.

Cohen studied Assyriology at Columbia, and learned biblical Hebrew and Akkadian, and he became an expert in comparing the two ancient languages. He teaches philology at Ben Gurion University and is every inch professorial. A balding, expansive fellow who recently underwent bariatric surgery to drop some of the four hundred pounds he'd been carrying most of his adult life, he was wearing black pants and crocs, had four different colored pens tucked into in his left breast pocket, and wore a *kippa* (skullcap). He is observant and Orthodox.

Cohen has only seen the Jehoash Tablet in pictures and videos, and he will only speak to the philology—the language—not to its physical or geological properties. He works in the same university as Avigdor Hurowitz, one of the members of the IAA committee who examined the tablet's writing and found it historically unsound. Cohen says that he was "excited" when he first heard about the tablet, but didn't express himself on it until after Oded Golan—whom he'd never met—asked for his opinion in 2004, after Golan had been indicted for forgery. He went on to say:

> The reason why he called me the first time was that an amateur who knew Golan had visited me and showed me a copy of the tablet inscription and said he had some ideas. I told him he was wrong. Then I got a call from Golan. He said, "What do you think?" And I said, "With all due respect, I don't know you, and I'm not willing to talk to you until I'm convinced you're not a forger." I said, "I am not willing to tell you things that you may use in your defense." So, I asked him about the forgery tools and he convinced me he was not the forger. I don't think he has the knowledge. I don't know if he's honest or dishonest. I don't have an opinion about what's going on. But I do want people to know there have been many cases in

the past of good inscriptions that have been dealt with in an illegal manner, and the fact that they have been dealt with illegally does not mean they are forgeries.

Cohen eventually analyzed at the tablet and based on his knowledge of comparative ancient languages, he found the word usages perfectly consistent with seventh-century-BCE grammar. Cohen claims that the term *batqu*, cognate with Hebrew *bedeq* in the tablet, is used in Akkadian texts to refer to making renovations:

Now, my claim is that the word in this inscription means "to renovate." OK? I have some evidence in biblical Hebrew for it. But my main evidence is Akkadian. OK, it's a totally different word in Akkadian. But it's a very clear link to this word in biblical Hebrew, semantically . . . Semantics also includes the comparison between similar genres and again there are no other building inscriptions as such in biblical Hebrew, so we have to go outside biblical Hebrew to find the same genre. When we do that, the greatest number of building inscriptions, royal building inscriptions in the ancient Near East come from Mesopotamia and are written specially in the Semitic language. They're also written in Sumerian, but the main ones for us in discussing the Jehoash inscription are in Akkadian. And once you do that, you see the main term for renovation is in fact the same word.

Cohen worked out a complex and extremely detailed analysis of the inscription of the Jehoash Tablet, and his critique was published by Sheffield Press, in England, the same press that routinely publishes works by so-called minimalists who debunk the entire Bible as fiction. "I have *never* said it is definitely not a forgery but *if* it's a

forgery it's brilliant. He chose to work in a genre that didn't exist in biblical Hebrew! He also chose to write sixteen lines of text! Why in heaven's name sixteen lines? The ossuary was one line. The pomegranate was half a line! Now the scholars I debate about this say he did that because he wanted me to think it's authentic."

Cohen admitted he was thrilled when he first heard about the tablet, because of its implications about the First Temple. I asked Cohen whether he was letting his religious beliefs color his scholarship in this regard. He denied it. "I would tell you this. This goes to my own persona here. I am a religious Jew. I certainly do not hide that by any means. And I'm Orthodox in my practice. I completely separate my religious faith from my scholarship. The scholarship in Israel is basically conservative—and not accepting, for the most part, postmodern ideas. That's what [conservative] has come to mean these days. There's a lot of postmodern research going on outside of Israel. And Israeli scholars—not all, but most—find themselves resisting postmodern trends, mainly on the basis of language. In other words, what we have learned is to be very appreciative from the scholarly point of view of the biblical consonantal text. Not the vowels. The vowels are late. But the consonants."

Later he gave me a tour of his basement library, where he has twenty thousand volumes, among them his most prized possession, a rare nineteenth-century volume of early Assyriology. His store of knowledge is clearly immense. He has no ax to grind. He's a mild-mannered professor, with a point of view that his colleagues simply can't understand. He says it comes down to the fact that it is extremely hard for him to turn away from a sixteen-line inscription in ancient Hebrew, provenanced or not.

"I have seen and I know all the inscriptions from Israeli excavations," he says. "Almost all are provenanced, but I use them all. I use the Moussaieff inscriptions in my classes. I have grave doubts that

they are forgeries. Philologically, in some ways they are more beautiful than most. From the point of view of biblical Hebrew, the Moussaieff ostraca—the widow's plea and the three shekel contribution—are two of the most beautiful inscriptions in the language."

Cohen eventually testified for the defense.

⁘

CHAIM COHEN'S SIXTY-FIVE-PAGE ESSAY in defense of the Jehoash Tablet formed the basis of some of the defense questioning, according to other linguists who were prosecution witnesses. Did Oded Golan really come across him, as Cohen believes, by pure coincidence? Or did the collector do his homework and decide that, of all the respected philologists in Israel, the Orthodox, kindly, and deeply learned gentleman from Brooklyn, who gave up New York and made *aliyah* to dwell in the remote desert town of Be'er Sheva, who has trucked twenty thousand books, many quite rare, into the basement of his humble suburban house, like a real-life Fitzcarraldo, would be perhaps a good prospect for a sympathetic interpretation of his tablet?

That is what Israel Finkelstein and Detective Ganor would propose. For them, the carefully thought out selection of scholars was part of the forger's genius. "I'm telling you, they are the cleverest people, the most sophisticated people, because they knew how to exploit people like this," Finkelstein said. "I think that all of them were puppets played by those people. They wouldn't come to me to authenticate something. They went to the people who they knew in advance would be willing to do this because of their convictions. That's the trick there, you see? It's a highly sophisticated game. I would be extremely surprised if there was more than that here."

Yuval Goren, another scholar who was never asked to authenticate any of the suspect objects, published his own theory about

why scholars participated. He suggests that they suffer from a scholarly species of the psychological condition known as Jerusalem syndrome, which has been seen to render tourists in Jerusalem temporarily insane. The Jerusalem syndrome was first identified in the 1930s by Dr. Heinz Herman, one of the founders of modern psychiatric research in Israel, and a later study involving 470 tourists confirmed it. In an article he published in 2004, Goren wrote:

> The Jerusalem Syndrome is a temporary state of sudden and intense religious delusions, brought on while visiting or living in Jerusalem. The clinical symptoms usually begin with a vague and extremely intense excitement. The patients often perform "biblical" or otherwise eccentric activities, having a strong feeling of mission. They typically adopt a lifestyle of religious observance and attach unusual significance to biblical relics. The most interesting feature, considering the extreme behaviors associated with the Jerusalem Syndrome, is that the subjects sometimes have no prior history of psychiatric difficulty and exhibit none afterward. These patients, if they recover, are typically embarrassed by their behavior, which they cannot explain.
>
> Recently, I had the dubious pleasure of examining a seemingly endless line of fake biblical texts of various kinds. There are dozens, if not hundreds, of such forgeries referring especially to the time of the first Temple. It would not be an exaggeration to say that the disciplines of biblical history and archaeology have been contaminated to such an extent that no unprovenanced written source seems to be reliable anymore. To put it even more bluntly, the sciences of Hebrew epigraphy and philology are nothing but a fool's paradise.
>
> As we all still hope that most of the scientists involved

in this saga were motivated only by true scientific purposes, we must ask how some of them could be so naive, ignore any sense of objectivity, and be trapped in the crude pitfalls set by the forgers? Considering the nature of the fakes in question, the answer to this question may lie in the domain of psychology. The forgeries discussed here are not merely fakes of ancient artifacts. They are relics, intended to manipulate the emotions of scientists and the public alike by using the attribution to biblical events. These forgeries were intended to infect collectors, museums, scientists, and scholars with the Jerusalem Syndrome in order to boost their market price and attract public attention.

Accused

Fall 2004

*This was an attempt to change the history of the
Jewish and Christian people.*

—GIL KLEIMAN, ISRAELI POLICE SPOKESMAN

*We only discovered the tip of the iceberg. This spans
the globe. It generated millions of dollars.*

—SHUKA DORFMAN,
DIRECTOR OF THE ISRAEL ANTIQUITIES AUTHORITY

JUST AFTER CHRISTMAS 2004, the Jerusalem district attorney
submitted Criminal File 482/04 with the District Court of Jeru-
salem, charging one collector, three dealers, and a retired cura-
tor with creating a series of forgeries and scheming to sell them. Not
all the defendants were involved with all the counts. Most frequently
cited was the collector Oded Golan. The other defendants included
dealers Robert Deutsch, Shlomo Cohen, Fayez Al-Amleh, and retired
Israel Museum curator Rafael Brown.

"Over the course of the past twenty years," the indictment began,
"numerous items of archaeology, made to appear as antiquities, were
sold or offered for sale in Israel and the world. These 'antiquities,' many
of which were of enormous scientific, religious, sentimental, politi-

cal and financial value, were produced originally for the purpose of fraud. The forgery of these antiquities, some of which were published extensively in scientific literature, also caused a distortion of the study of history and archaeology, in addition to financial damage."

At a press conference announcing the indictment, police and prosecutors and the IAA didn't shrink in describing the enormity of the crime. "Oded Golan played with our beliefs. The beliefs of Jews and Christians. This is why it's the fraud of the century," Pagis said.

Golan was not surprised by the indictment, having spent nearly a year in aggressive legal maneuvers trying to force the IAA and police to give him back his stuff. His legal maneuvers had actually pushed the prosecutor to cut the investigation short and indict him, because in Israel the law sets a limit on how long evidence can be held without an indictment. Golan immediately issued a statement denying guilt. "There is not one grain of truth in the fantastic allegations against me," he said, adding that he was sure of acquittal.

The international press played the story as a massive conspiracy, because of the way the authorities were talking, and because the indictment at first glance appeared to link all five men in an enterprise of some duration, described in the very first sentence as covering "the past twenty years." On closer examination, though, the indictment did not allege that all men were linked to all objects, nor even to each other. And during the trial, prosecutors shared no evidence that forgeries were on museum shelves worldwide, or even that items had been sold outside Israel. Brown, the former Israel Museum conservator, was only accused of having had a hand in the fabrication and sale of one ostracon and one bulla, both of which went to Moussaieff. He was also reportedly believed to be behind the famous ivory pomegranate, but he was saved from charges for that by the statute of limitations. David Green, writing in the *Jerusalem Report* after the indictment, said of the pomegranate: "Sadly, it too

was exposed as a forgery this winter, sixteen years after its purchase by the museum. Dahari and company, however, are not saying it was Golan's handiwork. The fake inscription on the tiny ivory artifact is being attributed to antiquities dealer and former Israel Museum conservator Raffi Brown."

The dealer Cohen was only accused in one count, involving an object purchased by Moussaieff, and he was soon dropped from the case. Deutsch was accused of having had a hand in some forgeries. And the Palestinian dealer Al-Amleh was only accused of having participated in an alleged Golan scheme to persuade Moussaieff to pay $1 million for an allegedly forged seal of the biblical king Menashe.

As for the victims, only Moussaieff was consistently named, although Georges Weil figured in one count.

By the time of the indictment, the case had taken a toll on all involved. The mild-mannered professor Yuval Goren had been under open attack from Hershel Shanks, the GSI geologists who first validated the ossuary and tablet, and others for more than a year. He found himself in the thick of a political storm, being accused of everything from being an Arab sympathizer to being a minimalist out to prove the Bible false.

The cops themselves were not unscathed. Even Ganor's mother had asked him to leave the objects alone. "The pomegranate was the first [proof] that the Temple of Solomon actually existed. Now we don't have that evidence at all. Many people don't like what I've done. My mother told me, 'You made a mistake.' My own mother! She said, 'You made a mistake! Why do this? Leave it alone!' And she is not religious."

During the course of the two-year investigation Pagis's marriage fell apart, partly, though not solely, he says, because of his consuming obsession with the case, and the long hours he put in chasing leads and forming theories. He and his wife share custody of their three young children, and he is out of the Jerusalem police fraud

unit (where his superiors had also criticized his obsession), and now oversees the Arab Affairs Division.

The accused of course fared the worst, and worse was yet to come. Within months after the indictment, Deutsch lost his Tel Aviv University adjunct teaching post. His reputation was tarnished, but he continued holding his semiannual auctions.

Golan lost his business, was jailed temporarily, and then confined to his parents' house without a passport. His older brother died, then his beloved dog.

The case went to trial in September 2005 and lasted several years, an astounding duration perplexing to Westerners who regard speedy justice as a birthright.

The length of the trial was only one of the anomalies in the Israeli jurisprudence system. There are no jury trials in Israel. The country simply cannot afford them. Almost all court cases are decided by a single judge, although major cases are sometimes tried before a panel of three judges. Partly because there is no jury, Israeli trials are scheduled according to the availability of judges, lawyers, and the accused. Judges are notoriously weak in standing up to lawyers who do not want to block out weeks at a time on a single trial—the opposite of the procedure in the United States. In the forgery trial, Deutsch's lawyer Rafi Siton refused to participate in more than two sessions per week on the grounds that it would paralyze his other cases. The judge acquiesced. The trial only met once or twice a week, and sometimes there were months-long hiatuses.

For Western observers, the Israeli legal procedure seemed extremely sloppy. Visitors were shocked at the informality of the court hearings and the lack of regard for what would normally be considered due process. For example, indictment number twelve against Deutsch and Golan accused them of faking an inscribed decanter in 1995, when it had already been photographed and published in a book by 1994, and marked as coming from the Moussaieff collection. In the United

States, the charge would have been thrown out on the basis of a technical mistake in the indictment. In Israel, the blunder was treated as allowable human error that did not prejudice the accused.

The authorities also displayed a seemingly slapdash attitude toward the chain of evidence. The court was told how items described in the indictment were handed from lab to lab, from Goren to the Rockefeller Museum and back to the Israeli police forensic lab, without proper notes taken of who had them and when. Besides accidentally peeling the original patina off the objects, the police forensic scientist testified that he did not have full notes of what exactly was done to the items in his lab, what materials were applied to what places on the items, and what their condition was before and after they were examined. In addition, the IAA on several occasions brought the evidence forward and shared it with journalists, including me.

The prosecution chose to lead its case with dozens of scholars, who ascended the witness stand and laboriously explained why they thought the objects were fake. It would take an entire book to recount the minutiae of the scholars' various testimonies, on everything from the proper curve of a Hebrew letter in the first century CE, to whether ancient menorahs were usually ten inches or eight inches high. Each scholar spoke from his or her area of expertise, usually in the didactic style they would use lecturing students or colleagues. The tall young prosecutor, Dan Bahat, prodded them with questions, and the scholars painstakingly, digressively laid out their points of view. Then high-paid defense lawyers would question them, and the ivory towers would often crumble, revealing a vulnerable core of subjectivity.

Oded Golan's lawyer, Lior Bringer, a bullet-shaped man with a shaved head, quick wit, and a sharp eye for discrepancy, would lead each scholar back through his or her testimony. Invariably, under questioning, he found some discrepancy in the good professors' points of view. The scholars, used to the politely raised hands of rev-

erent students, were completely flustered by the rapid-fire question-
ing and invariably stepped down from the witness stand (they were
forced to stand, not sit, customary in Israeli courtrooms) broken,
defeated, even questioning their own scholarship.

Even Yuval Goren suffered this fate. Goren, who was so sure of
his analyses that he had nicknamed the glue that held the fake patina
onto the various objects "James Bond," found himself cornered and
reconsidering certain aspects of his testimony. After a particularly
brutal day of questioning, Goren actually asked the judge for permis-
sion to come back and revise his testimony, to concede that in fact
there might have been real patina in one of the ossuary's letters.

Goren looked extremely pained as he recalled the experience.
"There was a whole debate about patina curving into the letters
or not and at some stage, I brought my microscope with a digital
system, close-up with camera, into court, and projected everything
on the wall, which was quite bad because of course the resolution
wasn't so good. You couldn't darken the room. We debated mainly
whether there was patina curving into the letters in two main places.
One of them was one of the letters of the word for 'brother of,' before
the last word, and in two letters in the word 'Jesus.'"

The defense had hired a German geologist as expert witness, who
took pictures of the ossuary and identified points where it seemed
there was patina in the letters of the second half of the inscription. In
court, Goren was asked to look at the German expert's photographs.
"And I said, 'Maybe, maybe there was patina—because I looked at
the pictures and some of them were convincing.'" Since his original
testimony had been that there was absolutely no patina in the second
half of the inscription, Goren was effectively contradicting himself.

When I took my pictures—first of all it was in 2003. In the
antiquities authority in some dark room, I was using my own

microscope, which has an oblique elimination, and so some parts can be shadows . . . and actually many of the things that they thought were patina sliding into the letters were shadows. Now, in many cases, if you are experienced in microscopy, you can distinguish between shadows and patina. But after this, I asked the district attorney if it were possible to look again at the ossuary. Because it had been five years since I saw it.

So they said yes, and then I went to the antiquities authority and I looked at the ossuary. Now what happened between 2003 and today was that the forensic team—part of the police—made some putty of silicone, they pushed it into the inscription, then pulled it out in order to get a negative of the inscription, of the engraving. By doing that, they pulled out the "James Bond," you know, the soft patina-like material coating the letters. And this of course caused some problems.

But then, Goren found a trace of genuine patina in the last letter of the inscription and he started looking for explanations.

He sent various hypotheses to the prosecution, which the defense quickly subpoenaed, charging that the star witness now had doubts. "I raised a hypothesis that it may be that such patina could be created in a short period of time, if this ossuary was standing on a balcony in the rain, in Tel Aviv. If you go out to my house, you can see just by my car, some Bedouin statues made exactly ten years ago. They are made of chalk, the same as the ossuary, and it's all covered with bio-patina, so I thought that this might be a possibility."

Goren didn't testify about that, though. Instead, he proposed that the little bit of genuine patina in a line of the part of the inscription he believed was fake could have been simply a preexisting ancient line that the forger took advantage of by incorporating it into his

new letters. It is possible, he says, that somebody used an old line and just added two new standing strokes.

In any case, Goren decided he had to go back into court and express his new hypotheses. The defense lawyer, Bringer, seized on Yuval Goren's "doubts" as proof positive that the entire ossuary inscription was in fact ancient. Hershel Shanks later wrote whole articles on Goren's testimony, shredding him for having a supposed agenda. Goren was shaken to the core. "I said there in court, you know this cross-examination of me, it was like a test of my methodology. If I ever need a lawyer, I think I'll take Bringer. Made an enormous impression on me. I was left with doubts. I had two possible explanations. Of course, it doesn't mean that the whole inscription is real. It means that there is one part that is real, there might be one word that is real. But all the rest is really a matter of interpretation."

⁜

GOREN HAD WARNED the prosecution early on that scholarly analyses should not be the basis of the forgery case in the first place. "When I first met Dan Bahat, I asked him if he was going to base the indictment on expert opinions like mine or others. And I told him, 'Listen, if you're going to do that, you're going to lose.' Because everybody's an expert. There are many professors willing to give their name, some for money, some for reputation, and there are many more who are not willing to say anything or get involved in it. And so you bring professor A, and they bring Doctor B, and no judge whatsoever will intervene in such a debate, because it becomes a scientific debate."

Epigrapher Avigdor Hurowitz, also a prosecution witness, who testified that the Jehoash Tablet is a fake, had the same instinct:

I am 100 percent sure the inscription is a fake but it's a scholarly issue. I testified in court and the lawyers asked some

questions which were good questions, other questions were to discredit me. They did what lawyers do. Their purpose I think is to plant doubt in the judge's mind. I was asked essentially to present and then defend the fifteen-page report which I had written. They went through it point by point and asked some questions informed by what Chaim [Cohen] had written. My gut feeling is that if there is not forensic evidence—actually a witness or some sort of hard physical evidence—the judge will decide between me and Chaim Cohen. I will be vindicated in the scholarly world but in the court how do I turn around and say Chaim—my friend and colleague—doesn't know what he's talking about? That's something I don't want to say in court.

Indeed, the defense had no trouble bringing doubt into most scholars' analyses. The few scholar-witnesses who were not impeachable on the stand, whose testimony admitted of absolutely no doubt, were few and far between. Within months it became clear to the tiny group of regular observers in the courtroom that, as one eminent archaeologist who was watching the trial put it, the science of archaeology itself was on trial.

In the end, the trial might not have changed anyone's mind at all. In the world of biblical archaeology, belief is an element of science. For most people, even many scientists involved, a pile of rocks on the ground is just a pile of rocks, until someone with the voice of authority decides it's actually an ancient Jewish purification bath or a piece of Solomon's palace or the first Christian church.

Shanks and others have organized numerous seminars and published debates on the allegations involving the three main objects (while leaving the damning charges against the lesser objects, and the cache of tools, drawings, and other evidence curiously unre-

marked), inviting scholars from both sides to weigh in. All the debates merely hardened each point of view. No one's mind was changed. As recently as 2007, André Lemaire was still publishing defenses of the authenticity of the ivory pomegranate, arguing that Goren and the others had erred, and seizing on new analyses finding that at least one of the letters previously deemed fake was in fact crusted with ancient patina. Meanwhile, Goren and the scientists on his team steadfastly maintain that modern hands carved most of the pomegranate's inscription.

American archaeologist Jonathan Reed has written several books on the archaeology of early Christianity and is a field archaeologist who has worked in Israel for several decades. Subjectivity, he told me, is the soft underbelly of his field:

Most archaeologists, most historians, don't claim absolute truth. In a court case you're innocent until proven guilty. But for archaeologists, we take these unprovenanced artifacts and most of us say they're guilty until proven innocent. You're dealing with the past, and you're interpreting and you're reconstructing. We're always asking, "Is this possible? Is it plausible or is it probable?" And almost all historical facts, like did Herod exist, did Jesus exist—you know, if you're an absolute skeptic, you can raise doubts and reasons and why it really wasn't Herod who built all this stuff. It was actually his son. Same thing with Jesus. Jesus never existed. He was made up by his disciples as a mythological figure. Well, there's all kinds of historical evidence that made that improbable. And it's very probable that Jesus existed. Can you *prove* that Jesus existed? Proving something, that calls for really strict criteria. So we're taking this ossuary, putting it in court, and now suddenly the criteria of the law is applied to the ossuary. And

that's not right. I mean, I can say it is highly probable that this is a forgery. Can I prove it? No, but I would almost never expect to prove it because anytime I say, look there's water from Tel Aviv in the patina, well, that's because Mom washed it. OK, so there goes that, you know?

What I think the Oded Golan trial should be about is not the James Ossuary, but whether or not Oded Golan has tools and has forged other objects and has a workshop that's involved in forgeries and that is connected to people who buy forgeries and sell forgeries. And if he's guilty there, I don't have to talk about the James Ossuary anymore.

Israel Finkelstein predicts the trial could have profound effects on the field of archaeology itself.

"Once the trial is over, in a year or two, you'll see, you know, inscriptions from the time of Solomon, from the time of David, the T-shirt of Moses, the crown of King Solomon, the sandals of Abraham, and so on and so forth. That's the future, if there is an acquittal," said Finkelstein. He went on:

That is very dangerous. In my opinion, whoever did this—it's all psychology. He said to himself, "Well, I managed to be cleverer than X. I was cleverer than Y and cleverer than Z. If I go to the top and mislead this guy, I am the greatest of them all. I am then the biggest epigrapher on the face of the earth." That was the ultimate test! And he failed at the last moment, because he took the tablet to [Joseph] Naveh. It was a tragedy. This was a big tragedy if you wish to look at it from the point of view of psychology. It was almost perfect. The ossuary had, you know, been authenticated and would have been bought and this and that and everything would have been great . . . OK. Again, the

mistake was that after a very short period of time, they came up with the Jehoash inscription, and the most terrible mistake was to go to Naveh. That was the beginning of the end.

I'm not a psychologist. I come from a small town. In my town, to solve a conflict, it's—let's meet at this time in the afternoon. Punch each other, until one is on the ground flat, you know. We are not sophisticated people of psychology.

<p style="text-align:center">⁜</p>

BACK AT MORTY'S DELI in Washington, D.C., in the fall of 2007, Hershel Shanks, who watched trial developments avidly for years, remained totally unconvinced that the tablet, pomegranate, or the ossuary were fakes. He was still punching away at adversaries in print, using his magazine to ever more vociferously criticize the investigation and Yuval Goren in particular. He still had significant scholar power to draw on for his claims, Lemaire and Chaim Cohen among them. According to Shanks, the IAA and the Israeli police have an agenda—to kill the private trade in biblical-era antiquities. Shanks contended some scholars have signed on to that agenda too. "I don't say that there's a conspiracy, I don't say that they're in cahoots. I'm just pointing things out," said Shanks. "I think it is natural that field archaeologists would like to think that things that come out of the field are more important than things on the market. You have to understand that I am an ignoramus. What I'm an expert in, is assessing the value of someone else's judgment. When André Lemaire tells me something, and Rochelle Altman tells me something, I know who to believe. All I can say is very, very good people on both sides are sure. We all have our prejudices. We all have our backgrounds. And the most we can do—and I think all these people do that—is try to recognize your inclinations and your prejudices and not let them enter your scientific work."

Shanks doesn't believe the ossuary and tablet are forgeries mainly because he can't imagine a forger smart enough to make them. "You'd have to be extremely knowledgeable. And he has to use other people. He has to know where the stone is, how to engrave, how to make the fake patina. I don't believe it. If you have this quote 'industry' going on, I'm willing to say, 'OK, it's a tight group. They're not going to rat.' But I do think there's something else. And that is the underlings want to get into it. There would be a lot of very bad, obvious fakes. This guy sees his boss trying to do it, I'll do it too! And the only thing you have are perfect fakes. So . . ."

Shanks's faith in the financial power of belief remained unshakable. He offered to pay half a million dollars from his Biblical Archaeology Society to purchase the forged ivory pomegranate from the Israel Museum and put it on display in the United States. After all, he told a journalist, there are still a lot of people here who believe it's real.

In the mass media, though, the tide has turned against him. In March 2008, the Discovery Channel Canada, which had once aired Simcha Jacobovici's documentary, named the James Ossuary number four in a list of the ten greatest hoaxes of all time.

⊹

ISRAEL IS A SMALL, relatively new, and profoundly challenged nation that has literally defined itself through its religious and cultural heritage. Archaeology in Israel has been called "a national hobby," and for some Israelis, it may even rise to the level of a solemn duty. The discovery that some of its citizens might have profited by exploiting and falsifying this heritage is deeply painful. For individuals to alter the national heritage for personal gain undermines much of what Israel has stood for in terms of national unity and a cohesive, binding ideology. While scientists believe they have proven the objects are forgeries, there are significant numbers of Christians and Jews

who disagree with them, or at least wish they had left well enough alone.

For true believers—Christian and Jew alike—the stakes are high and the revelations difficult, for other reasons. Some believers have already accused the scientists and detectives involved of advancing the cause of atheism, or at least deliberately disproving the Bible. They see the scientists as yet another generation of materialists, like Darwin, who would like to invalidate God's Word. No amount of science will persuade faith-based people, and the fact that scientists will try to do so by examining artifacts with high-powered microscopes only further alienates the believers from modernity.

The forger or forgers had more personal motives than national pride or blind faith. Greed was part of it, surely, but something else was at work too. Human life is finite, while history is, if not eternal, relatively so. To create bits of the ancient past is to become, perhaps, something more than mortal. For some of those who can, it might be impossible to resist the temptation to sneak a tiny yet indelible fingerprint onto the vast canvas of yesteryear, and forge a personal link with an ancient temple priest or pharaoh, before our short time on earth comes to an end.

Forgers, like the poor, we will have always with us. In the work of this particular forger, however, we confront the limits of both faith and science in understanding human history and the material world. Those who put their stock in the power of science to answer questions about the ancient record of human life are forced to concede that certainty is not achievable. The faithful—those who believe a higher, supernatural power leaves a material record of itself for man to literally hold and behold—must also confront and grapple with the painful presence of doubt.

Sources

Most of the people I spoke with extensively were on the record and are quoted. I also conducted numerous interviews with people who preferred to remain anonymous in Israel and in New York, and they are not named below, nor are many people I spoke with but whose conversations are not quoted in the text. Without those interviews, and numerous books, articles, blogs, and transcripts on the Web for background, I would not have been able to conduct the research. The Web sites Bible and Interpretation and *BAR* contain vast documentation of the various scholarly disputes, and for readers who want to delve more deeply into the scientific issues, I recommend those sites.

PROLOGUE

Ada Yardeni, author interview, Jerusalem, June 2007. Naveh quotes from "Jehoash Tablet said found near Muslim cemetery," by Nadav Shragai, *Ha'aretz*, Nov. 14, 2005.

CHAPTER 1

Moussaieff quotes and descriptions, unless otherwise noted, author interview, Tel Aviv, October 2006. Moussaieff and Arab sheiks anecdote, author interview with an American antiquities dealer who requested anonymity, and the Israeli filmmaker Aran Patinkin, producer and director of a film about Moussaieff called *Diamond Wiz*. André Lemaire, author interview, Paris, October 2007. Robert Deutsch, author interview, Jaffa, June 2007. Oded Golan, author interviews, Tel Aviv, October 2006 and June 2007. Hershel Shanks, author interview, Washington, D.C., November 2007. "Saul Bellow character" from David Samuels, "Written in Stone," *New Yorker*, April 12, 2004 (hereafter, Samuels).

CHAPTER 2

All quotes from and descriptions of Amir Ganor are from author interviews, Jerusalem, October 2006 and June 2007. James Ossuary press conference and its coverage, October 21, 2002, Washington, D.C., from various sources including, *All Things Considered*, NPR transcript, October 21, 2002; Jeordan Legon, "Scholars: Oldest Evidence of Jesus?" CNN.com, October 22, 2002; Guy Gugliotta, "Looted Box Viewed as Link to Jesus," *Washington Post*, October 22, 2002; *Canada AM*, CTV transcript,, "Archaeological Discovery Linked to the Brother of Jesus," October 22, 2002; John Noble Wilford, "'Jesus Inscription' on Stone May Be Earliest Ever Found," *New York Times*, October 22, 2002. Information about CUFI, Max Blumenthal, "Birth Pangs of a New Christian Zionism," *Nation*, August 8, 2006. Bill Berkowitz, "Pastor John Hagee Spearheads Christians United for Israel," Media Transparency, www.mediatransparency.org.

CHAPTER 3

Dave Howell, author interview, Jerusalem, October 2007. "Jesus-haunted culture" quote from Ben Witherington III, "Top Ten New Testament Archaeological Finds of the Past 150 Years," *Christianity Today*, September 1, 2003. History of biblical archaeology from various sources, including William G. Dever, *What Did the Biblical Writers Know & When Did They Know It?* (Grand Rapids, MI: Wm. B. Eerdmans Publishing, 2001). Joe Zias, author interviews, Jerusalem, June 2007. Megiddo observations, author visit, October 2007. Norma Franklin, author interview, Tel Aviv, October 2007. Gary Frazier quote by Craig Unger, "American Rapture," *Vanity Fair*, December 2005. Nazareth Village observations, author visit, October 2007. Seymour Gitin, author interviews, Jerusalem, October 2006 and June 2007. Rami Arav, Emmitt Wilson, Nicolae Roddy, author interviews, Beth Saida, June 2007.

CHAPTER 4

Oded Golan, except where noted, author interviews, Tel Aviv, October 2006 and June 2007. Quotes from Rifka Golan, Matthew Kalman interview, Jerusalem, January 2008. Magen Broshi quote, Nadia Abu El-Haj, *Facts on the Ground, Archaeological Practice and Territorial Self-Fashioning in Israeli Society* (Chicago: University of Chicago Press, 2002), p 5. Golan's description of Yadin anecdote and his dream of the palace, Samuels. Morag Kersel, "From the Ground to the Buyer: A Market Analysis of the Illegal Trade in Antiquities," in *Archaeology, Cultural Heritage and the Antiquities Trade*, N. J. Brodie, M. M. Kersel, C. Luke, and K. W. Tubb (Gainesville: University of Florida Press, 2006). Lenny Wolfe, author

interviews, Jerusalem, October 2006 and June 2007. Hamdan Taha, author interview, Ramallah, October 2007.

CHAPTER 5

Simcha Jacobovici, Samuels. Canadian museum officials' quotes, Jonathan Gatehouse, "Cashbox," *Maclean's*, March 28, 2005. Rochelle Altman quotes, Ian Ransom, *Mary and the Ossuary* (Philadelphia, PA: Xlibris, 2003). Rochelle Altman, "Official Report on the James Ossuary," www.bibleinterp.com/articles/Official_Report.htm, and e-mails from Altman to the author. Meyers, Lemaire, Shanks, and Golan quotes are from a transcript of the meeting of the Society for Biblical Literature in Toronto, November 2002, provided to the author by the SBL. "Lying Scholars," cover story, *BAR*, May–June 2004. Catholic Answers quotes, Jimmy Akin, "Burial Box of St. James Found?" http://www.catholic.com/library/Burial_Box_of_St_James_Found.asp. Witherington quotes, Hershel Shanks and Ben Witherington III, *The Brother of Jesus: The Dramatic Story & Meaning of the First Archaeological Link to Jesus and His Family* (San Francisco: Harper, 2004), 94. Eric Meyers quotes, author telephone interview, 2005. Orna Cohen, author interview, Jerusalem, June 2007.

CHAPTER 6

Masada, author visit, June 2007. El-Haj, *Facts on the Ground*, 1. Joffe, *Journal of Near Eastern Studies* 64, no. 4, October 2005. Israel Finkelstein, author interview, Tel Aviv, October 2007. Sylvain Cypel, *Walled: Israeli Society at an Impasse* (New York: Other Press, 2007), 111–112. Tzipi Livni, Roger Cohen, *New York Times Sunday Magazine*, July 8, 2007. Shuka Dorfman, IAA *Summary Report*, June 20, 2003. Patrick Jean-Baptiste, *L'affaire des fausses reliques* (Paris: Albin Michel, 2005). Golan on Via Dolorosa, Lecture at Cornerstone University, Grand Rapids, April 2004. Full transcript on Web at http://209.85.165.104/search?q=cache:R8q-iThT-RqsJ:www.bib-arch.org/bswbOOossuary_Golan_Cornerstone.pdf+oded+g olan+cornerstone&hl=en&ct=clnk&cd=1&gl=us&client=safari. Yusuf Natsheh, author interview, Jerusalem, October 2007. Yuval Goren, author interviews, Tel Aviv and Jerusalem, October 2006, June and October 2007. Jonathan Pagis, author interviews, Jerusalem, June and October 2007.

CHAPTER 7

Ganor and Pagis, author interviews, Jerusalem, October 2006, June and October 2007.

CHAPTER 8

Uzi Dahari and scholars' comments, Uzi Dahari, deputy director, IAA, *Final Report of the Committees*, http://www.bibleinterp.com/articles/Final_committees_reports.htm. Goren, *Final Report of the Committees* and author interviews with Yuval Goren, as cited above. Amnon Rosenfeld, author telephone interview, September 2007. Avigdor Hurowitz, author telephone interview, May 2006.

CHAPTER 9

Description of Moussaieff's London apartment, Ganor and journalist Matthew Kalman. Shanks on meeting Ganor, *BAR* September–October 2003. Ganor and Pagis, author interviews, as cited above. Golan, author interviews, Tel Aviv, October 2006 and June 2007. Marco anecdotes, Ganor and *60 Minutes*. Police transcript from Pagis interview of Marco in Cairo, translated by Matthew Kalman. Marco quotes, interview with Amany Radwan, Cairo, May 2008. Frank Moore Cross letter to a Canadian journalist, dated September 13, 2003, shared by Cross with Christopher Rollston, ancient-Semitic epigrapher, Emmanuel School of Religion. James Snyder, author interview, Jerusalem, October 2007.

CHAPTER 10

Georges Weil, author interview, Tel Aviv, October 2007. Frank Preusser, author telephone interview, April 2008. Ganor, author interviews. Jerusalem, October 2006, June and October 2007. Deutsch, author interview, Jaffa, June 2007. Michael Steinhardt, author interview, New York, September 2007. Oscar Muscarella, author interview, New York, April 2008, and his book, *The Lie Became Great: The Forgery of Ancient Near Eastern Cultures* (Boston: Brill Academic Publishers, 2000). Emile Puech, author interview, Jerusalem, June 2007. Chaim Cohen, author interview, Be'er Sheva, October, 2007. Yuval Goren, "Jerusalem Syndrome in Archaeology: Jehoash to James," January 2004, Bible and Interpretation Web site (http://www.bibleinterp.com/articles/Goren_Jerusalem_Syndrome.htm).

EPILOGUE

Gil Kleiman and Shuka Dorfman quotes, Eric Silver, "Israeli dealers accused of antiquities fraud," *Independent,* December 30, 2004. Indictment details, *Unofficial English Translation of Antiquities Forgery Indictments*, Israel, December 2004, published by *BAR*. Also, Matthew Kalman, journalist, trial coverage for the author, Jerusalem. Kalman also provided the oversight of Israeli jurisprudence. Jonathan Reed, author interview, Jerusalem, June 2007.

Index